The Film Buff's Guide

A Humorous History of Cinema

David Barry

Published in 2023 by
Acorn Books
acornbooks.uk

Acorn Books is an imprint of
Andrews UK Limited
andrewsuk.com

*In memory of my mother and father
and the Royal Cinema, Amlwch*

The cinema, like the detective story, makes it possible to experience without danger all the excitement, passion and desirousness which must be repressed in a humanitarian ordering of life.

Carl Jung (1875-1961)

Contents

Introduction

Cinema has always been about images rather than words. Which doesn't mean you can now abandon the subject, buy some popcorn, sink into a luxurious seat at the local multiplex, and desert your intellect whilst watching genetically modified humans wreaking havoc on computer enhanced images of a city that looks suspiciously like downtown Birmingham. No, far from it. The subject of cinema is vast, probably far greater than many other topics. Take, for instance, art. Impressionist painter George Seurat's *An Afternoon at La Grande Jatte,* is very like a scene from a film. But once you have learnt how the artist composed this painting, the form and the structure, that is probably the end of the matter. But suppose it was a scene from a film? Keen cinema historians might be expected to know the name of the cinematographer who received an Oscar for his brilliant lighting, why the director's film failed to get a *Palme d'Or* at Cannes Film Festival, and who replaced the composer who was credited with the film score, and which then little-known film star played a cameo role.

I hope this history will encourage the reader to catch up on some of the films mentioned here. However, I should at this stage point out that any actual film attendance will require you to remain in the auditorium long after the rest of the audience has shuffled out, until the final credit has thanked the inhabitants of Orkney or Outer Mongolia for their support in making the film, thus enabling you to know who was responsible for looking after the leading lady's wigs.

To become part of the growing army of film buffs, it will be useful to digest what might seem like useless information. In other words, trivia. But you must understand that erudition in cinema can be as much about the ability to reveal the name of the seventh actor in *The Magnificent Seven* as knowing what Alan Resnais' *Last Year in Marienbad* was all about, which even hardened film critics found baffling, rather like attempting to decipher a government paper on Financial Deregulation and Variation in the Exchange Rate.

But beware: if you happen to be a fan of the interminable *Star Trek* films, never under any circumstances be overt in your appreciation, as it will reduce your film buff status to that of Trekkie, geek or sad anorak, which are one notch above serial killers and disgraced MPs.

The Birth of Cinema

A cine camera takes a rapid sequence of still photographs, so that each second of a feature film will contain 24 frames (pictures). You can imagine how many photographs there must be in *Gone With The Wind*, which is 3 hours 42 minutes long.

In the early days of cinema, before the advent of sound, cine cameras ran at 16 frames a second, which meant that everyone captured on film appeared to be rushing everywhere at great speed, which may explain why no archive material exists from the silent days showing council employees at work.

Never confuse film with video, which is an electronic means of recording pictures onto magnetic tape and is to be looked down on by aficionados of cinema, just as Baron Rothschild might regard a glass of plonk.

It is helpful to know a little of the origins of cinema, so a short history of the early days should suffice.

In The Beginning...

...there was light. It was projected through a Magic Lantern throwing images onto a wall or screen. This was probably as exciting as watching cable television but it may have impressed people in the late 19th Century. And there was a gadget called a Zoetrope, where the viewer observed different pictures through slots, giving the impression that the pictures were moving. Eadweard Muybridge experimented with moving images of photographs, such as one naked man leaping over the other, the precursor of the soft porn movie.

Opinion is divided over who should take credit for inventing cinema as we know it, but it is generally believed that a lion's share of it should be given to Auguste and Louis Lumière, who made the first films to be shown in cinemas in 1895, cute little scenes of their family at tea, a train entering a station, a game of cards outside a Parisian café. So they can also be credited for being about 100 years ahead of their time by inventing the docu-soap. Thomas Edison, an American, who invented as many gadgets as most people have hot dinners, was

also reputed to have invented the celluloid film. He patented his invention in 1909 and he and a syndicate ran a movie studio, but the nickels and dimes that trickled in from the showings convinced him that there was very little commercial benefit to be had from cinema. This was also the case with the backers who financed John Travolta's *Battlefield Earth,* from a novel by Scientology founder L. Ron Hubbard, starring Travolta who invested $5million of his own money in the project, which came to be known as the biggest bombing film of all time and has only a 3% rating on Rotten Tomatoes.

The Silent Films: 1895–1927

USA

Between 1908 and 1910, sunshine was discovered on the west coast of America and Hollywood was born. The light was perfect for filming and soon movies were big business, earning fat bucks for all concerned, except maybe cinema usherettes. Out of work musicians found employment thumping the ivories to heighten the action of the films and got a pain in the neck. Cinemas sprang up everywhere like wildflowers, though they smelled nowhere near as sweet, except to the burgeoning Hollywood moguls, who could smell the heady scent of the green and folding stuff.

The Great Train Robbery, made by Edwin S Porter in 1903, was one of the first westerns. It told the simple tale of bandits being shot after successfully robbing a train. To date, there have been 2,000 remakes of this western using a different title! What was almost ahead of its time in this picture was the way a character breaks the fourth wall. At the end of the picture one of the bandits, who has been shot and killed, is in a head and shoulder shot staring at the camera lens as he raises his revolver to shoot at the audience, and as it was one of the earliest moments of cinema storytelling, the audience would have been unnerved and shocked by that.

As far as movie-makers were concerned, they now tried to outdo one another with sheer spectacle, like the 1907 version of *Ben-Hur: A Tale of the Christ* which was made by a New York-based company. The film lasted no more than 15 minutes, ending with the definitive chariot race. Then in 1925, it was remade by MGM, directed by Fred Niblo, at a staggering cost of $4 million and took $10.7 million at the box office. It was 141 minutes long and the chariot race was spectacular, although the winners were not shown to douse themselves in champagne at the close of the race – that wouldn't happen for another two-thousand years.

In 1915 D. W. Griffith, the most innovative director of his day, made *The Birth of a Nation,* a racist epic which justified the actions of the Ku Klux Klan, and became famous for making the first non-politically correct film. If you

were to make a comparison with his racist epic and making a film these days, it would be like making a costly feature film honouring the National Front or BNP. But as far as Griffith was concerned, his devotion to cinematography was instrumental in making him the first director to use a dramatic close-up, tracking shots and cross-cutting. He was famous for many reasons, everything from using montage (see glossary) to wearing funny hats to discovering actresses. Two of his discoveries were Dorothy and Lillian Gish. Although both sisters were equally famous in their day, it is Lillian most people recall. This may be to do with the fact that in England she has become cockney rhyming slang for the famous British food that is served with chips.

Most people working in Hollywood were migrants, mainly from Europe and Russia. Charles Chaplin, escaping a childhood of poverty, came from England, and with his rags-to-riches rise he soon became the highest paid screen star of his time. He appeared to walk extremely fast. He was probably dodging the tax inspector.

From Mexico came one of the great romantic screen idols, Ramon Navarro. His father was a dentist so at least he came equipped with a good set of teeth. He took charioteering lessons and drove one as *Ben-Hur* (the 1925 version).

Another debonair screen romantic was the swashbuckling actor Douglas Fairbanks, who never used the front door, and always entered through the window, presumably to buckle his swash. In 1924, his most renowned film was *The Thief of Bagdad,* directed by Raoul Walsh, although Fairbanks was producer, writer, star and stuntman and loved showing off his bare chest. Especially when he appeared in someone's window.

One of the earliest sex symbols was Theda Bara, about whom not many of you may have heard. Her film *A Fool There Was* (1915), is perhaps one of the few relics of the actress's career, most of which have not survived. She was born Theodosia Burr Goodman, and like many Hollywood film actors, her name was changed by the studios for whom she worked.

Paramount's biggest earner was Clara Bow who made a film called *IT,* probably a description of a person who has a great deal of sex appeal and magnetism. Consequently, Clara Bow became known as the 'It girl', as that had loomed large on her film poster. Nowadays, of course, we dread to think how a film poster like that could become defaced!

Mary Pickford, known as America's sweetheart, played lots of poor little girls, and became a very rich poor little girl. But the greatest screen idol and male sex symbol was Rudolph Valentino from Italy. The Latin lover made women swoon, which made men sick with jealousy. He died young, and his funeral was a huge box office hit.

Erich von Stroheim, was another migrant from Germany, who made *Greed*, an epic film shot on location in San Francisco, and was the first film to be shot entirely on location. His first cut of the film was almost as long as a Covid lockdown. It was nine hours long, and with a friend he managed to cut it down to about four hours. But the executives at MGM took it away from him and it was cut down to 140 minutes.

It was difficult for actors and directors to fight these movie moguls, people like Louis B Mayer of MGM, and Carl Laemmle, who in 1920 founded Universal Pictures. He handed his son the post of Head of Production as a 21st birthday present, and at one time or another had pretty much all of his family on the payroll, proving that nepotism was about to rule in Hollywood.

But the silent films we can all still enjoy in the 21st century are the comedies. Because there was no dialogue, although now and again an intertitle would be flashed up on the screen with a short speech one of the characters was speaking, they were mainly slapstick. And some of these were spectacular, as in director Mack Sennett's *Keystone Cops* with trains that collided with cars, and cars that fell apart, and characters who ran around like headless chickens, looking almost as bad as rail travel in Britain in a bad winter.

Two of the most innovative performers of comedy in the silent era were Harold Lloyd and Buster Keaton, who thrilled audiences with their comedic stunts. Lloyd's most iconic moment was hanging high above the street from a clock face in *Safety Last*, and Buster Keaton made some inspirational features such as *Sherlock Jr.* and *The General*. In the former he plays a cinema projectionist who in a dream sequence becomes an onscreen great detective. In *The General* he plays an engine driver and performs astonishing stunts, all with his trademark deadpan face. Unfortunately for both these comic geniuses, they did not transfer well to the 'talkies'.

Unlike Charlie Chaplin, who made the transition with a certain amount of ease, although it wasn't until 1940 that he shot his first sound picture *The Great Dictator*, and his earlier contribution in the era of the early 'talkies' was *Modern Times*, which he shot with no dialogue, but with sound effects and music.

Chaplin had been in at the beginning of Hollywood's growth, when he was signed by Mack Sennett's Keystone Studios. His rise to fame came when he invented his little tramp character, complete with bowler hat and cane. His film *The Gold Rush* was the biggest grossing film of 1925 and two years earlier he had a success with *The Kid*, despite co-starring with a child actor.

There is only one thing that will kill the movies and that is education

Will Rogers 1879-1935

France

A Trip to the Moon, made by Georges Méliès in 1902, was probably the first science fiction film. Using trick photography, like a rocket in the eye of the man in the moon, this ambitious film played to thousands of customers in makeshift cinemas. Prior to his film career Méliès was a stage magician and illusionist, and when he saw the Lumière films, he was instantly converted into making films himself, and was hugely experimental and used much trick photography. In one of his films he shows his disjointed head on a table which he blows into a massive size through a bellows. The running time for *A Trip to the Moon* was only 14 minutes. Unfortunately, for modern parents who have had to suffer the mega-decibels of their children's alien movies, a trend was not established.

In 1915, director Louis Feuillade made *Les Vampires*, which was not about the blood-sucking creatures we all adore but featured a gang of Parisian criminals by that name, and were led by a female gangster called Irma Vep (an anagram of vampire). *Les Vampires* was hugely popular and became a long-running film series. It is notable as probably the earliest film to spawn a remake, and in 1996 it was made by Olivier Assayas as *Irma Vep*, and then in 2022 *Irma Vep* became an HBO mini-series.

One of the most innovative of French directors was Abel Gance, and his 1927 film *Napoléon* was technically ahead of its time with its use of lighting and special effects, split screen, jump cuts, dolly shots and hand-held camera work. It told the life of Napoléon Bonaparte in several films, ending with a screen triptych as the emperor celebrated his victory of the Italian campaign, and the triptych behind the actor (Albert Dieudonné), showed the French tricolour flag, the red and the blue having been hand-painted onto the film.

Russia

Sergei Eisenstein was an innovator. But you will be relieved to know that he was not a prolific director, so I need only refer to his most prestigious film *Battleship Potemkin*, famous for its rhythmical montage, and the Odessa steps massacre. There were not many laughs in this picture.

However, his Odessa steps massacre has influenced many contemporary film-makers, especially Brian de Palma, whose Grand Central Station scene in *The Untouchables* pays homage to Eisenstein and has the audience holding its breath as a pram with a baby in it is about to hurtle down the steep station steps while the gangsters slug it out with Elliot Ness and his men.

Britain

The first motion picture film in Britain was *Traffic Crossing Leeds Bridge* made by Louis Le Prince in 1888. But as Britain is the home of the Bard of Avon it was considered essential that Shakespeare was seen in cinemas, It had nothing to do with the fact that no writer's royalties had to be paid. Stage actor Johnston Forbes-Robertson starred as the first *Hamlet* in 1913. Because it was silent, there were no lines to learn. A contemporary remake in the same style would prove to be extremely popular with both actors and schoolchildren.

But most film stars in Britain were badly paid compared to their Hollywood counterparts. To some (i.e. producers), it may be comforting to know that this tradition is still kept alive.

Germany

Director Fritz Lang shot *Metropolis*, an epic sci-fi film which was released in 1927. It was a tale of woe featuring a horrendous city, robotically controlled, with thousands of workers suffering long slave-like hours ruled by unsympathetic bosses. A bit like certain online retailers today.

But the German silent era was mostly famous for Expressionist cinema and I must confess to a certain dubious enthusiasm for this genre with its theatrical scenery, bizarre camera angles, psychopathic killers, evil masterminds, blind fury, weird costumes and sets that reflect madness. I can also toss in a few names like the directors Fritz Lang, F.W. Murnau, Robert Weine, not to mention actors Conrad Veidt and Werner Krauss. Probably the most famous of these films are *The Cabinet of Dr Caligari*, or *Nosferatu, A Symphony of Terror,* inspired by Bram Stocker's *Dracula*. And there you have the bright and breezy little films of the German Expressionist school.

Italy

Cabiria directed by Giovanni Pastrone was shot over six months and released in 1914. It was an historical epic, set in the 3rd century BC, and ran to almost three hours, with an enormous cast of 5,000, 1,000 horses, 200 elephants, 200 camels in at least 1,200 scenes. Can you imagine how much the location catering would have cost? The film ran to almost three hours, when most of Hollywood's output at that time was mainly short films.

Surrealism

Andre Breton, the founder of surrealism, saw it as a movement leading to the power of dreams, unleashing the unconscious and thought that cinema was the perfect way to liberate the mind. *Entr'acte* was an early surrealist film featuring cameos by surrealist artists like Man Ray and Marcel Duchamp (he of a urinal called 'Fountain' fame). Some of these surrealists have been portrayed in Woody Allen's *Midnight in Paris* (see page 44).

But the most well-known surrealist film was directed by Spanish director Luis Bunuel, *Un chien andalou* which was shot in Paris, and artist Salvador Dali was a co-collaborator on the film, which showed the iconic close-up of a woman staring straight at camera, and a hand holding a cutthroat razor slicing her eyeball. Not one for the squeamish.

Many surrealists influenced film directors in later years, and Dali produced the dream sequence for Alfred Hitchcock's *Spellbound.*

I seldom go to films. They are too exciting

John Berryman 1914-72

The Sound Revolution 1927—

Of course, we all know that it was Warner Brothers' *The Jazz Singer*, starring Al Jolson, that was the springboard for the splash of sound which became known as the 'talkies'. And you can guess that it probably paved the way for BBC Television's show which featured masses of Jolson clones singing syrupy songs. But who remembers who directed the Jolson film, the first feature that talked? Who on earth remembers poor old Alan Crosland?

The first talkie in Britain opened in 1929. It was *Blackmail* by Alfred Hitchcock, and the posters induced audiences to 'See and Hear It. Our Mother Tongue as it Should be Spoken'.

The talkies gave the world's number one star his first big break. The squeaky voiced and squeaky clean rodent, Mickey Mouse, who first piped up in *Plane Crazy* and then in *Steamboat Willie* in 1928 using his master's voice, Walt Disney. Since then, we've had a pied piper plague of the little rodent. It's called merchandising.

Before the sound revolution, actors like Charles Chaplin, Gloria Swanson and Buster Keaton managed to run the business side of things and were accused of being the lunatics in charge of the asylum. Then in 1930s Hollywood, as movies became vast money-spinners, even bigger lunatics took over. These were the movie moguls. Men like Sam Goldwyn of MGM (famous for saying: 'You can include me out.') created a studio system where actors signed long contracts agreeing to complete so many pictures a year whether they liked the scripts or not. This led to many tears before bedtime. But it's an ill wind, as they say, and some of these studio chiefs ended up on celluloid themselves, in some surprisingly good pictures. It is worth knowing that Harry Cohn who founded Columbia pictures – and boasted that he didn't have ulcers, he gave them – was the inspiration for Rod Steiger's portrayal of the studio boss in *The Big Knife*. Previously mentioned Louis B Mayer was another studio boss who had a fearsome reputation and would even resort to physical violence if he didn't get his own way. But if they gave an Oscar for Most Feared Producer, Harry Cohn would have had a mantelpiece full of them. At his funeral in 1958, which was well attended, it was said that they wanted to make certain he was dead. And

comedian Red Skelton commented, 'Harry always said give the public what they want and they'll come out for it.'

To play a ruthless producer as Kirk Douglas did in *The Bad and the Beautiful* it was handy to have a cleft chin.

Producer Louis B Mayer established the Academy Award System in 1929, and the first ceremony was during that year. One of the Oscar winners was the First World War aerial combat film *Wings*, the most expensive film ever shot at that time. *Wings* was a silent movie, but they later added synchronized sound effects and music. It has been said, by Ricky Gervais I believe, that actors portraying characters with a disability are often in the front-running for a Best Actor Oscar, like Tom Hanks for *Forrest Gump,* John Mills for *Ryan's Daughter,* Cliff Robertson for *Charly* and Daniel Day-Lewis for *My Left Foot,* and there are dozens of others too numerous to mention.

Short Films

Short films were extremely popular in the silent era, especially the comedies, where Buster Keaton and Harold Lloyd risked life and limb with their crazy stunts. But the most successful of these to adapt to the sound era were Stan Laurel and Oliver Hardy, who often shared the same bed, and eventually Morecombe and Wise paid homage to them by also sharing a bed.

Short films continued well into the 1960s. In fact visits to the cinema were not just to see a feature film. The evening began with the newsreel, because there was not much TV around until well into the sixties, and so our visual news was given either by Movietone or Pathé News, and the voice-over was a study in stentorian fear-mongering when describing what was happening during the Korean War. The trouble was that the strident voice-over used was the same when giving news of the Royal Family or French Fashion. After we had seen what was happening in the rest of the world, we were often treated to a cartoon, either Disney's *Donald Duck,* or the more radical Warner Brothers' *Tom & Jerry.* Instead of a cartoon we were often entertained by a short *Three Stooges* film, featuring mainly Larry, Shep and Moe, three middle-aged men suffering from arrested development, and these men-children entertained us by sticking fingers in each other's eyes, or bashing each other on the head, which was the slapstick farces we all enjoyed back then. Other short comedies we enjoyed were the Joe McDoakes films, which dealt with everyday problems, and had titles like *So You*

Want To Give Up Smoking. These shorts or cartoons were invariably followed by the B-movie, and many of these were cheaply made British films, running at around 40 minutes. Many were part of a series like the *Edgar Wallace Mysteries, The Scales of Justice* and *Scotland Yard.* The latter ran from 1953 to 1961, and was presented by crime writer Edgar Lustgarten, who signed off at the end of a film, in these years before capital punishment was abolished, with his doom-laden voice stating that 'he was hanged by the neck until dead.' Though what another outcome from a hanging might be was anybody's guess, especially as auto-erotic asphyxiation was unheard of back then.

Following the B-movie, the auditorium lights would come on and the ice cream lady would walk backwards down the aisle, and there would be a rush to purchase these treats before the main feature.

Musicals

You're going out a youngster,
But you've got to come back a star.

 42nd Street

This is a genre that was once in danger of dying out, and any serious movie student should proceed with caution when dealing with this subject. It is perfectly acceptable to show a fondness for old backstage musicals like *42nd Street* and *Golddiggers of 1933* because tap dancing will never be passé, and the overwhelming noise of some 100 blonde bombshells tapping together should be marvelled at, and thanks be given that they didn't have quadraphonic Dolby Sound in those days.

Busby Berkeley musicals (*Ziegfeld Follies, Golddiggers of 1933*) are worthy of adulation for their sheer spectacle, with their precision choreography, high camera angles and bird's-eye view photography. Comparisons are often made with the way he transformed his dancers into abstract patterns perhaps inspired by the cubist movement of the 1920s and the European avant-garde, although that seems a little pretentious. The stories usually centred on smart chorus girls trying to attract wealthy men, a bit like the wags of Premier League football club players.

For style and pizzazz, the old time favourite was *Top Hat* (1935), starring Fred Astaire dancing cheek-to-cheek with Ginger Rogers. The plots of their musicals were derivative. Boy or girl start out hating each other, then sanity is restored in time for the tap routine. Although these musicals were simple love stories, they rarely kissed. They remained as frigid as a night in eastern Siberia. The big heat was saved for the big number.

Perhaps one of their best films was *Swing Time* (1936), directed by George Stevens, which had some great songs written by Jerome Kern and Dorothy Fields, including 'Pick Yourself Up' and 'The Way You Look Tonight', which Astaire sang at the piano to Ginger Rogers while she washed her hair in the bathroom. And Astaire's dancing in this film was absolutely brilliant.

Musicals in Colour

Technicolor had arrived by the mid-thirties, used mainly for adventure and fantasy films. *The Wizard of Oz* (1939), one of MGM's costliest musicals, shot in monochrome with the Oz adventures in colour. 'Toto, I don't think we're in Kansas anymore.' This musical extravaganza was not an immediate success with the public. But then Mozart and Vincent van Gogh died paupers, so what do the immediate public know? Judy Garland's 'Over the Rainbow' became a classic, sung to Toto the dog, who did everything he could to upstage her.

Babes in Arms (1939), directed by Busby Berkeley and *Strike Up The Band* (1940), were the high school musicals which starred Mickey Rooney and Judy Garland and are recognized for their almost kitsch-like qualities, where enthusiastic youngsters capitalise on the germ of an idea, use a little ingenuity, a dab of paint, some scenery, and suddenly they have improvised their way into the most fabulous, show-stopping number. And all from nothing but high energy.

One of Judy Garland's greatest musicals was *Meet Me in St. Louis* (1944), directed by Vincent Minnelli, as this often veered from almost high camp musical numbers like 'The Trolley Song' to melodramatic scenes, such as quite dark moments with a Halloween sequence.

There have been four versions of *A Star Is Born* films over the years, kicking off with William Wellman's 1937 version which starred Fredric March and Janet Gaynor. And then in 1954 came a remake starring Judy Garland and James Mason. Almost two decades later Barbra Streisand and Kris Kristofferson starred in their version in 1976, and finally in 2018 we have a more country version with Bradley Cooper and Lady Gaga. The story throughout these versions remained roughly the same, about a male star's alcoholism and his wife overshadowing him and becoming the bigger star. For me the definitive version was Garland's 1954 film directed by George Cukor, in which she sings 'The Man That Got Away' and 'Born In A Trunk', and James Mason is superb as Norman Maine, when he drunkenly interrupts her Hollywood award ceremony.

Anyone who has never seen Gene Kelly doing his puddle-splashing rain dance in *Singin' in the Rain* (1952 – co-directed by Kelly & Stanley Donen) must have lived in a Himalayan monastery since the 1950s. If, by any chance, you *have* lived a cloistered existence and missed this gem, it is often referred to as 'the musical as art', with the dizzy heights having been reached, a witty script about the film industry adapting to sound and some great numbers, all of which sounds like hyperbole from a Hollywood PR person. And who could

fail to be impressed by Donald O'Connor singing 'Make 'em Laugh' where he is (literally) driven up the wall.

One of Gene Kelly's greatest films was the 1951 *An American in Paris* in which he dances an 18-minute ballet sequence halfway through the film. The film was directed by Vincent Minnelli and the story was built around George Gershwin's hit songs, giving Kelly and his co-star Lesley Caron a great dance sequence by the banks of the Seine with 'Our Love is Here to Stay'.

It's a curious cliché, but whenever Hollywood had an interior scene in Paris, the Eiffel Tower could always be seen from any window. Likewise Big Ben or Tower Bridge in London scenes.

Whenever having a serious conversation about film, with my tongue firmly in my cheek, I always express an interest in Esther Williams, a champion swimmer who splashed around in watery musicals that have come to be regarded as high camp. I can't provide you with the title of one of her films, lest people think I'm really serious.

Following the theatre successes of Richard Rodgers and Oscar Hammerstein in the forties and fifties, inevitably their musicals transferred to film. *Oklahoma* was an immediate success, becoming an audience firm favourite. It starred Gordon MacRae and Shirley Jones, and audiences loved the songs. Though not many people questioned or even knew within its fragile story the rather dubious history of the Oklahoma Range Wars where lawlessness was out of control and vigilante justice verged on lynch law as ranchers fought the cattlemen, and murder and arson happened on many occasions. This bloody period of American history was summed up by the cheerful ditty: 'The Farmer and the Cowman Should be Friends'. Is that what one might call irony?

The two stars of *Oklahoma* teamed up again for the 1956 musical *Carousel* which had many memorable songs, including 'You'll Never Walk Alone', which became a hit for Gerry and the Pacemakers and is now the Liverpool Football Club anthem.

South Pacific (1958) was another big Rodgers & Hammerstein hit, which always succeeds in reminding us optimistically that 'Some Enchanted Evening', you might just see that stranger across a crowded room who will become the love of your life.

In the early 1960s the Sharks and Jets battled it out, and danced along some of the streets of New York. *West Side Story* based on *Romeo and Juliet* transferred successfully from stage to film, with music by Leonard Bernstein, lyrics by Stephen Sondheim and fantastic choreography by Jerome Robbins. It starred Natalie Wood and Richard Beymer, and their songs were dubbed by other singers, but Rita Moreno, who played Anita, sang most of her songs. Sixty years

later she appeared in the 2021 remake of the film as Valentina, in the version directed by Stephen Spielberg. Many critics, likening it to the original 1961 version gave it the thumbs-up, and many said it was actually far superior to the original film. I'd go along with that to a point, especially as the actors have more street-cred, but somehow the ending of the Spielberg version is not as moving as the original, perhaps because it over-indulges by lengthening the finale.

Another stage hit that transferred to film was *My Fair Lady*, written by Lerner & Loewe, and based on George Bernard Shaw's play *Pygmalion*. The stage show opened on Broadway, starring Rex Harrison, Julie Andrews and Stanley Holloway, and then transferred to London's Theatre Royal Drury Lane with the same cast. I heard a story about Rex Harrison coming out of the stage door after the show one night, and refusing to autograph a woman's programme, so she rapped him on the shoulder with it as he got into his chauffeured car. Stanley Holloway, who had been exiting at the same time and saw this incident, told Harrison the next day that he had made theatrical history. When Harrison asked Holloway what he meant, he was told: 'Well, for the first time the fan has hit the shit!'

Incidentally, *My Fair Lady* was so successful both on Broadway and at Drury Lane Theatre that Richard Rodgers and Lorenz Hart wrote a line about it in Ella Fitzgerald's hit recording of 'Manhattan', which went 'And My Fair Lady is a terrific show they say, We both may see it close some day.'

When Jack L Warner of Warner Brothers produced the film version, although he cast Rex Harrison and Stanley Holloway as Higgins and Doolittle, he substituted the part of Eliza with Audrey Hepburn, whose songs were dubbed by Marni Nixon, a soprano who dubbed dozens of films, including Natalie Wood's songs in *West Side Story*. She became a legend as a ghost singer, and *Time* magazine called her 'The Ghostest with the Mostest.' But as far as the general public were concerned, they remained in ignorance of these dubbed film stars, and the producers kept it quiet in case it harmed the box office. *My Fair Lady* became an enormous success and received eight Academy Awards, but Deborah Kerr who was dubbed by Nixon in *The King and I*, openly made it known that she had been dubbed for the songs and gave Marni Nixon the credit she deserved.

Strangely enough, Harry Belafonte and Dorothy Dandridge known mainly for their singing were dubbed in the 1954 film musical *Carmen Jones*. This was written by Oscar Hammerstein II, based on the nineteenth century Bizet opera, but instead of being located in Spain, this version had a contemporary setting in the US southern states with an all-black cast. It had opened on Broadway in 1943 and ran for 500 performances. Instead of Carmen's love of a bullfighter

in Bizet's version, the contemporary version changes him to a boxer. The film was directed by Otto Preminger, and the only artist not to be dubbed was Pearl Bailey, who sang 'Beat Out That Rhythm on the Drum', one of the film's highlights.

If Julie Andrews was disappointed by being overlooked for the part of Eliza Doolittle, she more than made up for it by her starring role in *Mary Poppins*, playing opposite Dick van Dyke as Mary's friend Bert, a cockney jack-of-all-trades and chimney sweep, whose accent gave everyone in the UK an opportunity to become a mimic. The film was notable for not only some great songs, but a combination of live action and animation. It was the highest grossing film of 1964, became Walt Disney's highest grossing film ever and received a total of 13 Academy Awards.

But *Mary Poppins* was not the first feature to use live action/animation. *Anchors Aweigh* (1945), starring Frank Sinatra and Gene Kelly had a brilliantly choreographed sequence in which Kelly sings and dances with Jerry the Mouse, and even Tom the Cat puts in a brief appearance as a butler, offering to serve the mouse a platter of cheese. This sequence can be viewed on YouTube and it is well worth watching.

Before the coming of rock 'n' roll, and teenagers playing air guitar, it was the crooners and jazz singers who were popular. Bing Crosby and Frank Sinatra appeared together in the musical *High Society* (1956), a remake of George Cukor's *Philadelphia Story*, with Grace Kelly in the leading female role before she fairy-taled it to Monaco and became a princess when she married Prince Rainier. Bing Crosby made *White Christmas*, so that we can watch it on television once a year, and Ol' Blue Eyes had one of his biggest hits in *Pal Joey* when he sang 'The Lady Is a Tramp'.

Sinatra's 1955 musical *Guys and Dolls* (directed by Joseph L Mankiewicz) was not only filled with some great songs, lyrics and music by Frank Loesser, and a good plot (based on two short stories by Damon Runyan), but it was also crammed full of resentment and hatred between its two male stars. Sinatra reckoned that he should have got the part of Sky Masterson instead of Brando, and he upset the other actor by referring to him as 'The Mumbler'. But despite their offscreen rivalry, the film was a huge success, and Jean Simmons, Vivian Blaine and Stubby Kaye gave fantastic performances.

The mid-1950s was the beginning of the jukebox musicals, kicking off with *Rock Around the Clock,* a vehicle for Bill Haley & the Comets. The film also starred disc jockey Alan Freed whose commitment to more integrated music was echoed in the film and showed white, black and Hispanic musicians performing together, and the all-black group The Platters performing two of their hit singles

'Only You' and 'The Great Pretender'. Not long after the success of Haley's film came *The Girl Can't Help It* with an even bigger line-up of singers and musicians, including Julie London, Little Richard, Gene Vincent, Eddie Cochran, Fats Domino and the Platters. The lead actors were Tom Ewell and Jayne Mansfield, who was a Marilyn Monroe type of actress only not as highly regarded.

But of course, the biggest hit of that era was the young Elvis Presley, who at first shocked the League of Decency members by his suggestive hip movements. But young fans adored him and Colonel Parker took him under his wing and made him a film star. Two of his most notable films were *Jailhouse Rock* and *King Creole,* both shot in black and white. But after performing in later films, after his National Service in the army, Presley was self-knowing enough to state, 'There is only one thing worse than watching a bad movie and that's being in one.'

You can be sure that if Cole Porter wrote a musical, almost every song would be memorable. *Can-Can* (1960), starring Frank Sinatra, Shirley MacLaine, Maurice Chevalier and Louis Jourdan, directed by Walter Lang, produced a string of hits including, 'You Do Something To Me', 'C'est Magnifique', 'Just One of Those Things', 'I Love Paris', 'Let's Do It' and 'It's All Right With Me'. The film received not a single Academy Award nomination. Unlike the 2017 musical *La-La Land* which received dozens of awards. But audiences having watched the film, find it difficult trying to remember any of the songs.

Personally, I would go for Cole Porter any day.

In 1960, USSR President Khrushchev visited the 20th Century Fox studios during the filming of *Can-Can.* Shocked by what he saw, he described American culture as 'depraved' and 'pornographic'. But as we were galloping into the Swinging Sixties, someone should have given him a line from *The Jazz Singer* and told him, 'You ain't heard nothing yet.'

One of the most successful musical artistes whose album sales at the time were only beaten by Elvis Presley and The Beatles, is Barbra Streisand, whose musical films include *Funny Girl, A Star Is Born, Hello, Dolly!, On a Clear Day You Can See Forever, Funny Lady,* and many more, including all her other non-musical film roles. She has been awarded so many honours for stage and screen that she has spent more days accepting them than Liz Truss spent in her days as Prime Minister (this is true, it isn't a joke!).

In 1965, if you thought of seeing a film with lovely Austrian scenery, nuns and cute kids in another Rodgers and Hammerstein's musical, you might have avoided *The Sound of Music.* But director Robert Wise, from the moment he gave us a helicopter shot of the mountains and then zooming in close on Julie Andrews singing 'The hills are alive,' he established an extravagant mood for a

film that was going to deliver music and a great score, with some unforgettable tunes.

Although the interiors for *Fiddler on the Roof* were shot in Britain, this 1971 US film starred Israeli actor Topol. When it was first released, as it ran to nearly three hours, perhaps the distributors thought about the demographics, and showed it with an intermission in the middle, thinking that this movie, perhaps aimed at a more mature audience, needed a comfort break in the middle, and then the oldies could trot to the loo singing 'If I Were a Rich Man'. And once that song enters your head, you have trouble getting rid of it.

There was a return to the backstage musical with *Cabaret* in 1972, which starred Liza Minnelli, and was considered more grown-up than most musicals because it was set in pre-war Berlin and heralded the sound of jackboots, and director and choreographer Bob Fosse may have been influenced by Bertolt Brecht. Everything was seedy but with a high entertainment value, a bit like watching American wrestling.

But as the century wore on, the musical became almost obsolete. Possibly because the cinema is ever striving for realism, and people suddenly bursting into song strikes a false note (forgive the pun) and may go some way to explain its demise in the latter part of the 20th century. Greater realism was achieved with the narcissistic disco scene in *Saturday Night Fever* (1977), which made John Travolta into a star the first time around. And then a year later came *Grease,* one of the most successful of all modern musicals, starring Travolta and Olivia Newton-John. Although the story wasn't vastly different from earlier Fred and Ginger plots – boy meets girl, they fall out and then fall in again – what made the film so successful was the sexually liberated feelings of the ageing high school kids, some great rock 'n' roll numbers, reminding some of the older women in the audience of their own feelings when the young cast sing 'Tell me more, tell me more, did you get very far?' in 'Summer Nights'.

1979 was the year of Bob Fosse's *All That Jazz,* a semi-autobiographical story based on his own experiences as a choreographer and director who spends too much time burning the candle at every conceivable end. The lead role was played by Roy Scheider as the womanizing Fosse, who pops pills and drinks heavily, and then when he has to wake up and face the music, so to speak, he puts eyedrops in his ravaged eyes, looks in the mirror and says, 'It's showtime, folks!'

Fast forward now to 1984 to when *Footloose* (directed by Herbert Ross) reached our screens starring Kevin Bacon and Lori Singer, a story that was loosely based on a small town in Oklahoma that had banned dancing since 1898. Releasing the music from the soundtrack prior to the film's opening was

a smart move and meant that audiences were already familiar with the songs, adding more of an emotional charge when audiences got around to viewing the film. Nothing new there then. It's what theatres had been doing for decades. Kevin Bacon got rave reviews for his performance, but many critics dissed it, and some called it 'trashy teenage cheese.'

Towards the end of the eighties (1987 to be precise) came *Dirty Dancing*, starring Patrick Swayze and Jennifer Grey. It was written by Eleanor Bergstein, based on her own childhood.

Dirty Dancing was a mega hit, the highest grossing film of that year, and was one of the most successful movies of the decade. So what did some benighted producers do? Yes, you've guessed it. A remake in 2017. It has received a paltry 3.9 out of a 10 rating on Rotten Tomatoes. That always makes me, and many other sensible people, wonder if producers should leave well alone, but if they feel a need to prove themselves, wouldn't they make better progress by remaking unsuccessful films, because then they might stand a chance of improving them, instead of demonstrating their crass stupidity.

Over many decades, right up to the present time, there have been dozens of musical biopics, but I feel they deserve a section all to themselves, coming to a page near you soon.

An exception to the strike-up-the-band-I-feel-a-song-coming-on syndrome as seen at a cinema near you, was the Andrew Lloyd Webber and Tim Rice extravaganza *Evita,* directed by Alan Parker and starring Madonna, in which no one suddenly bursts into song. They sang the entire film. But it was Julie Covington's single 'Don't Cry For Me Argentina', from the *Evita* concept album, which reached the number one slot in the UK.

Most musicals are written starting off with the book or the story. But someone got the bright idea of creating a jukebox musical using many of the successful ABBA songs and writing a story around them. The story of *Mamma Mia!* was written by Catherine Johnson and was a successful stage musical in 1999, and became an equally successful film in 2008, directed by Phyllida Lloyd. *Mamma Mia!* (the movie) had the stellar leading cast consisting of Meryl Streep, Pierce Brosnan, Christine Baranski, Julie Walters, Amanda Seyfried, Dominic Cooper, Colin Firth and Stellan Skarsgard. It was a co-production between Germany, the UK and USA, and was shot on location on the island of Skopelos in Greece, and interiors were shot at Pinewood Studios. It received mixed reviews from the critics, who criticised the casting of inexperienced singers, and Pierce Brosnon was singled out for the most opprobrium in the reviews. Critics said his singing was like 'a donkey braying' or 'he sounded like a wounded raccoon', and one smart-aleck critic said, 'He choked out the lyrics like he was having a prostate

examination'. But the public thought otherwise and it became one of the highest grossing films of all time, with the DVD the fastest selling of all time – apparently one in four households in Britain owned a copy. So, I guess when the producers looked back at the mediocre reviews, they might have used the Liberace line when he received derogatory criticism of his act, 'I cry all the way to the bank!'

And naturally, following its success, a sequel was forthcoming, titled *Mamma Mia! Here We Go Again,* with mainly the same cast, although Cher joined this ABBA sequel romp. Most of the reviewers were now chastened, probably because of the mega success of the first outing, and gave it favourable reviews. Mark Kermode in *The Observer* gave it five stars and wrote, 'This slick sequel delivers sharp one-liners, joyously contrived plot twists and an emotional punch that left our critic reeling.'

> *I've always had an innate ability to dance, but I'm not as spiffy*
> *as those cinema legends like Gene Kelly and Fred Astaire.*
>
> John Travolta

British Musicals

Even though these were the poor relations compared to Hollywood, any serious student of cinema should regard them with a fondness one might reserve for small treasures and other memorabilia.

Pride of her alley was Gracie Fields in the 1930s. Affectionately known as 'our Gracie' in her native Lancashire, this rather loveable, northern Joan of Arc sang as she marched proudly in *Sing As We Go,* followed by scores of turbaned, patriotic factory girls.

Throughout the war years, George Formby strummed his ukulele, sang about his little stick of Blackpool rock, grinned his toothy grin, ending his films with a furious finale in front of obvious back projection, before concluding with his catchphrase 'It's turned out nice again!'

The man who brought more style and glamour to the British musical was Victor Saville, who directed Jessie Matthews in *Evergreen* (1934), stripping while she sang about her garments and her world weary cares going over her shoulder one at a time.

I feel confident, though, that in abandoning entire decades of the British musical, nothing will be missed. I have often shown a little affectionate contempt for the decade that is tarnished by the label 'swinging'.

But there have been some hugely important British musicals. And I know some of you are going to question my veracity when I include *A Funny Thing Happened on The Way to The Forum* (1966) as a British film, especially as it starred Zero Mostel, Phil Silvers and Buster Keaton in his final role. But I often think of this film/movie as a joint effort, if you like. A bit like the sixties disc jockeys with their mid-Atlantic accents, halfway between the two. This version of the Broadway stage success was directed by Richard Lester, another American, and was shot in Spain. The music and songs were by Stephen Sondheim, and the original concept and book for the stage version was by Larry Gelbart and Burt Shevelove based on comedies by Roman playwright Plautus (251 – 183 BC). Many of Sondheim's songs were dropped for the film version, and only six or seven remained. The cast also included Michael Crawford, Michael Hordern, Roy Kinnear, Annette Andre, Pamela Brown, Frank Thornton, Alfie Bass and

many other British actors, so we can safely count this one as a British musical, seeing as how the Brits outnumber the Americans in the film. That's my excuse, and I'm sticking to it!

Many films made in the UK relied on American distributors and their dollars, but still managed to retain their British identity. One such film, based on the successful stage version written by Sandy Wilson was *The Boy Friend*, which Ken Russell made as a film, released in 1975. He wrote much of the material himself, setting it in a theatre, so that the *Boy Friend* story became a show within a show, and starred Twiggy. The Americans who financed the project, made massive cuts to the film, and Russell commented about the editing, 'A gorilla in boxing gloves wielding a pair of garden shears would have done a better job.' A 1987 version of the film was re-released with the 25 minutes of cuts restored.

But the Ken Russell Film was a great deal more successful on its original release than *The Rocky Horror Picture Show* which was released the same year. It was directed by Jim Sharman with a screenplay by Sharman and Richard O'Brien, who wrote the book, music and lyrics for the successful stage show. The show was both a parody and a tribute to the many sci-fi and horror B-movies from the 1930s to the early seventies, and the *Rocky Horror Show* features many memorable songs such as the 'Time Warp' and 'Science Fiction/Double Feature'. The film starred Tim Curry as Frank N Furter, with Barry Bostwick and Susan Sarandon as Brad and Janet, two innocents abroad whose car breaks down and they find themselves in Frank N Furter's androgynously populated castle being converted into a sexually hedonistic lifestyle. Richard O'Brien performs in the film as Riff Raff, a hunchbacked handyman, with Patricia Quinn as his sister. Charles Gray plays the criminologist/narrator and Meat Loaf plays Eddie, a delivery boy, who makes his entrance on a motorbike. Despite the lukewarm reception to begin with, a New York cinema began showing midnight screenings and word of mouth took it to another level. The spoof caught on in a big way, and soon fans were dressing up like the characters to attend screenings and there was much audience participation. It now holds the record for the longest theatrical run of any film, and has been shown in a German cinema each week for more than 29 years. Let's do the Time Warp again, and again, and again...

Probably the most successful British musical of all time was Lionel Bart's *Oliver!* based on the novel by Charles Dickens, The film was directed by Carol Reed, and starred Mark Lester in the title role, with Ron Moody as Fagin and Jack Wild as the Artful Dodger. Both were totally believable in these roles as they picked a pocket or two! And Ron Moody's performance could so easily have shown Fagin to be a cruel and nasty Jew; instead. his interpretation brought to the character a degree of humanity and humour. The Dickens

Oliver Twist is a much darker story, about child poverty and crime. But as a musical it has to appeal to adults and children and become a family treat, and Bart's songs are very upbeat and memorable, even the hungry children in the workhouse as they imagine delicious grub and sing 'Food Glorious Food'. But the darkest moments in the film are provided by Oliver Reed, a truly brutish Bill Sikes who murders his girlfriend Nancy (Shani Wallis) and is betrayed by his dog Bullseye.

And what happens to Fagin? In Dickens's novel he ends up being hanged, but in Bart's musical he decides to mend the error of his ways and goes off singing, 'I am reviewing the situation'.

The film deservedly received many Academy Awards, and was seen and enjoyed by millions of audiences worldwide.

The rock 'n' roll years produced an epidemic of teenager musicals, mostly with the same plot. A middle-class dad, an old square, doesn't comprehend youth culture, but when he hears his son and pals strumming electronically, he is instantly converted into a warm, hand-jiving human being.

One notable exception to these youthful folk tales was *A Hard Day's Night*, directed by Richard Lester. Shot in black and white, using a semi-documentary, cinema verité style (see glossary) it starred The Beatles and featured some great songs. The script was by Liverpudlian writer Alan Owen, and he wrote some memorable lines, like when a disapproving middle-class man tells Ringo Starr, 'I fought the war for the likes of you,' To which Ringo replies, 'I bet you're sorry you won.'

When the Fab Four attended the premiere at the London Pavilion, Piccadilly Circus was cordoned off and the fans screamed and screamed and screamed until they were sick.

Most, if not all musicals are shot with the performers having had their songs pre-recorded, and then they lip-sync to playbacks of their voices. But recently this tradition was changed with the musical film of *Les Misérables* (2018). Director Tom Hooper's cast sang live on the set to piano accompaniment, which meant that the singers could take an emotional moment to change the pace in their delivery. The orchestra was then added in post-production. And, like the earlier *Evita* film, this also had a score that ran through the entire film with dialogue that is sung. The original French lyrics and music for the stage production were by Alain Boublil and Claude-Michel Schönberg, with English lyrics by Herbert Kretzmer, and the screenplay was also credited to William Nicholson. Convict Valjean was played by Hugh Jackman, who in the early scenes of the film had to lose 30lb in weight to give himself an emaciated appearance, and so too did Anne Hathaway, who shed 25lb to play Fantine. Her daughter Cosette was

played by Amanda Seyfried. The film was a huge success and early on after its release it had taken $441 million.

French poverty has never been so profitable.

France

The most distinctive French musical was *The Umbrellas of Cherbourg* (1964), written and directed by Jacques Demy, with music and lyrics by Michel Legrand. The film won the Palme d'Or at the Cannes Film Festival and was nominated for five Academy Awards, and it is operatic inasmuch as it has a continuous score with the plot advanced through sung dialogue. It starred Catherine Deneuve and Nino Castelnuovo as two star-crossed lovers who are soon torn apart in this romantic musical, but unlike their Hollywood counterparts – and this being French – they have sex. Eat your heart out Hollywood!

French new wave director Jean-Luc Goddard also made a romantic musical comedy released in 1961. It was called *A Woman Is a Woman*, starring Jean-Paul Belmondo, Anna Karina and Jean-Claude Brialy, with Michel Legrand supplying the music and lyrics. One might think that a musical comedy was an unusual subject for Goddard, that rather radical filmmaker, the darling of the nouvelle vague, who experimented in so many ways and influenced many other directors. Maybe he was trying to avoid being typecast.

India

There are so many Bollywood musicals they deserve an entire book to themselves, especially as they are so spectacular, with their energetic choreography, colourful costumes and plots which are usually derivative. So I will confine myself to mentioning just the one film.

Janwar (1965) a Hindi language movie was directed by Bhappi Sonie. The film's plot, which is quite a common theme in Bollywood films is about parental disapproval of the relationships of two sons. One of the songs in the film is 'Dekho Ab Toh Kisi Koh Nahin Hai Khabar', and unless you are Hindu you wouldn't recognise the song title or lyrics, but you would recognise the tune right away. The Beatles 'I Wanna Hold Your Hand'. This number in the film is a parody, a send-up of British rock 'n' roll films with the Indians wearing mop-tops as they strum their guitars, and a dancefloor of manic dancers twisting away. Of course, as in those corny old pop films, we see some old squares reluctant to participate,

but who are eventually won over by the exuberance of the performers, and are soon twisting away as if their lives depended on it. Google *Janwar* and 'I Wanna Hold Your Hand' on YouTube and you will be in for a treat.

Ireland

In 1991, Alan Parker directed *The Commitments*, based on a Roddy Doyle novel about a group of Dubliners forming a blues band. The film was believable, realistic and gritty, which meant that the cast swore a great deal.

Australia

Baz Luhrmann wrote and directed the 1991 film *Strictly Ballroom* which was a huge hit, and the director went on to make the over-the-top *Moulin Rouge!* ten years later. This to many people who went to see it because they may have been attracted by the actors Nicole Kidman and Ewan McGregor, came as a great surprise as they soon discovered it was a stunningly original jukebox film, with bright colours and music that yelled at you in a 'Nobody sleeps while I'm performing' kind of a way. It's flashy style was showy and loud, with violent colours and a plot that zoomed along at a rapid pace. Although it was probably a visual feast, many people loathed it, while most fell in love with it. It was what one might call a Marmite Movie.

Musical Biopics

The word biopic is a portmanteau word formed from biographical and picture. But you already knew that, didn't you?

Many musical biopics are about famous musicians who have met with an untimely end. Such as the 1954 film *The Glenn Miller Story*, which tells the story of the trombone-playing bandleader's rise to fame and fortune with his big band sound, up to his demise during World War Two. James Stewart played Miller and June Allyson played his wife, and there were also appearances by many jazz musicians, such as Louis Armstrong and Gene Krupa. The story follows Miller's life when he became a huge success, his swing band selling millions of his compositions, and his becoming an army Major during the war, and leading the army big band. The final poignant scene is when his wife hears on the radio that his plane has disappeared over the English Channel and he is missing presumed dead. Cue the big band sound over the radio and closing titles. Miller's great compositions included 'Moonlight Serenade', 'Tuxedo Junction' and 'Little Brown Jug'. But you have to be 'In The Mood' to enjoy this picture. Geddit?

If you have a penchant for nuns, watch the 1966 film *The Singing Nun* starring Debbie Reynolds in the title role that tells the story of Jeannine Decker, a nun based in Belgium who had a chart-topping record with 'Dominique'. I can't admit to having seen this picture but I can hum that tune.

Musicians with drug addictions and difficult upbringings were also popular and garnered many awards. Diana Ross played Billie Holliday in the 1972 film *Lady Sings the Blues* (directed by Sidney J. Furie). Early on in the film, it flashes back from one of her concerts to her turbulent early life, and her heroin drug addiction. Diana Ross performs many of her songs including 'Lady Sings the Blues', 'What a Little Moonlight Can Do', 'God Bless the Child' and, when she sees lynched black people when touring in the southern states, she includes 'Strange Fruit' in her repertoire. The film closes with her sell-out concert at Carnegie Hall, just before she is again arrested for drug addiction, and dies soon afterwards at the age of 44, although this is revealed by newspaper headlines so that the audience is left with the memorable impression of Holliday's Carnegie Hall triumph.

The reviewers raved about Diana Ross's performance, although many said that despite loving the film, they thought that factually it was a fraud. I suppose that's a bit like people who voted for Boris Johnson because they said they liked him even though they knew he was economical with the truth!

Clint Eastwood, as a lifelong fan of jazz, made *Bird,* released in 1988, and told the story of saxophonist Charlie 'Bird' Parker, who also had a grave addiction to heroin, dying at the age of 34. It starred Forest Whitaker in the title role. Much of the Parker's own bebop sound that Eastwood wanted to use in the picture created problems because the musician's original recordings were in mono and not of a good enough sound quality for a feature film. Then Eastwood managed to get recordings of Parker from his widow, Chan Parker, and a sound engineer managed to electronically isolate Parker's solos, and then the other musicians filled in the backing tracks on modern recording equipment.

These clever technical tricks, though, meant nothing to the general public and the film lost a lot of money. But can you remember what I said earlier on about Mozart and Vincent van Gogh dying flat broke? So perhaps one day *Bird* will resurface as a cult classic.

If it's comparatively easy to milk drama out of Billie Holliday and Charlie Parker, due to their excesses, it seemed as if it would be an uphill task to squeeze a drop of drama out of a singer who died at the age of twenty-two, and lived a clean life, devoted to performing and writing great songs and music. Buddy Holly died in a plane crash on 3 February 1959, along with fellow performers Richie Valens and the Big Bopper. Yet a credible story about Holly's short life was released in 1978. *The Buddy Holly Story,* starring Gary Busey as Holly, had much of the drama focusing on the early problems he had with his band The Crickets becoming rock and roll performers when Texan white boys were expected to sing only country songs. The actors in this film played their own instruments and did their own singing, and Gary Busey got a Best Actor Academy Award for it.

Not all musical biopics were made years after a singer's death. Based on Tina Turner's own autobiography *I, Tina,* published in 1986, *What's Love Got to Do With It* (1993), directed by Brian Gibson and Kate Lanier, told her own very dramatic story, from her early singing in a gospel choir as the very real Anna Mae Bullock, and later joining Ike Turner's blues band and being renamed, followed by years of abuse by Turner. Angela Bassett played Turner, and although she was lip-synched to the singer's own pre-recorded material, she gave an impressive performance and expertly captured Turner's dance gyrations, and Laurence Fishburne was also nominated for many awards as the villain of the piece. Tina Turner said of the film that she didn't like being portrayed as a victim and Ike

Turner said the film ruined his reputation. They both claimed the film was filled with dozens of inaccuracies.

How unusual. Hollywood making changes to real-life events!

Musical biopics continued well into the noughties and proved to be just as popular as they had been in the latter half of the twentieth century. Another performer who was still going strong during the pre-production of a film about his life was Ray Charles, whose script for approval came written in braille. The film *Ray* (2004) was produced and directed by Taylor Hackford and starred Jamie Foxx as the man himself, who worked closely with Charles who assisted him, and although it was Charles's own voice and compositions the audiences would hear, Foxx apparently could play the piano to a high standard, and unlike Eric Morecombe could play the notes in the right order! The Ray Charles story was hugely dramatic, even tragic in places, as and when he witnesses his brother drowning in a tub, and then is struck blind at the age of seven and, in his successful years, his long fight with heroin addiction. He eventually overcame his addiction, and having had problems in Atlanta, Georgia, about performing before segregated audiences, towards the end of the film, when he discovers the rules about playing to segregated audiences have been lifted, the state of Georgia now reveals that Ray Charles's song 'Georgia On My Mind' will be their official song. Which I guess was more flattering to the memory of Hoagy Carmichael who wrote the song, although most people could be forgiven for thinking of it as a Ray Charles song. But his was actually a cover version.

Ray Charles planned to attend a screening of the completed film but sadly died a few months prior to the premiere.

As the twenty-first century marched on, we were treated to many true – although sometimes one might say 'true-ish' – stories of musical performers, and some of these were exceptionally good. Joaquin Phoenix played Johnny Cash and Reese Witherspoon was June Carter in the 2005 film *I Walk The Line*, in which, yet again, drugs and alcohol addiction play a major part of the drama. Phoenix and Witherspoon sang Cash and Carter's songs, and Phoenix's rendition of 'Ring of Fire' was truly memorable. Although it was not a song, that has been suggested on many occasions, about the consequences of eating vindaloo curry.

From France came the biopic about Edith Piaf, *La Vie en Rose*, (2007) starring Marion Cotillard as the 'Little Sparrow', who led a tempestuous life, but she sang as though she meant it when she sang 'Je ne regrette rien', a song many of us are already familiar with, although we may not be able to concur with the lyrics as we all have regrets and think of what we might have done better.

Actor Rami Malek was exceptionally good as Freddie Mercury in *Bohemian Rhapsody* (2018), as was Taron Egerton in *Rocketman* (2019) about Elton John's musical career, with Jamie Bell as his lyricist Bernie Taupin.

Both these films were controversial in some countries, and were banned in many Muslim countries because of showing scenes depicting gay men. In fact Russia cut five minutes out of *Rocketman,* which was also banned in countries like Egypt and Samoa. And *Bohemian Rhapsody* had 10 scenes cut out of it in China, and Malaysia cut 24 minutes from the film. It makes one wonder what these countries are afraid of. Do they think their morality is goodness? As Oscar Wilde wrote: 'Wickedness is a myth invented by good people to account for the curious attractiveness of others.'

We have waited a long time for this next musical biopic. It is of course about the king of rock 'n' roll, Elvis Presley. Released in 2022, *Elvis* was shot in Australia and directed and co-written by Baz Luhrmann, with Austin Butler as Presley and Tom Hanks as Colonel Tom Parker. The film was shot during the Covid pandemic, and was held up at one stage because Hanks and his wife had tested positive. But I can truthfully say it's a film that was well worth waiting years for. In fact, with all these movies about singers and musicians there are literally dozens I haven't mentioned, but that would have taken up a volume all of its own.

Earlier on, when I mentioned Barbra Streisand's albums only being outsold by Elvis Presley and The Beatles, it got me thinking: we've now had the *Elvis* film, so I think that leaves one more major band to go with their musical autobiography. Yes! The Beatles. And I hope, dear reader, you are not one of those idiots who are in the Rolling Stones supporters camp and will not have any truck with The Beatles, which I always think is a bit childish, and somehow tribal like Manchester football supporters who are either City or United. Get a life, please. And don't forget the Stones first Chart Number One hit was 'I Wanna Be Your Man' written by guess who? That's right, Lennon and McCartney.

But what a story a Beatles biopic would be as there were so many contrasting and dramatic events in their history. But for all I know negotiations may be under way for the film rights as I write this. Or they may already have been sold and bought.

But with all these major projects, it's always a question of casting, finding a gifted actor with the ability to play a talented singer or musician. And all those who end up playing so many of our iconic artists, they were not necessarily the first choice of the production companies. Many actors who were top of a producer's list, and first considered for a role, may have been dropped or turned it down. And we never really know why. Usually a PR person says that person dropped out because of 'creative differences'. Which is a bit like falling back on that overused phrase: 'Due to unforeseen circumstances.' It could mean almost anything.

Westerns

When I was a kid, if a guy got killed in a Western
movie I always wondered who got his horse.

George Carlin

Although the Western has largely been dismissed as a serious subject, it is worth bearing in mind that a great injustice has been done to this genre. Might I suggest that you approach the Western with a degree of concern in your attempts to give it the importance it deserves?

Disparagingly referred to as the Horse Opera, the Western was overlooked mainly by the very people to whom it brought an opulent lifestyle for many years. Since the first Oscar ceremony in 1929, no Western got a Best Film award until *Dances With Wolves* in 1990, starring Kevin Costner, and closely followed by Clint Eastwood two years later for *Unforgiven* (*Midnight Cowboy*, which got an Oscar in 1969, was not a Western).

Westerns were usually set between the mid-nineteenth century and 1900, and many real cowboys became extras or stuntmen in the films, usually in Westerns.

In the early days of course, Westerns tended to be unsubtle stories of revenge, with scenery so familiar it became tedious, covered wagons with wheels that turned backwards (an optical illusion), rampaging Indians and petulant gunslingers. They were mostly B-Movies, and these were what was known as Poverty Row movies, which was American slang for cheaply made films to fill the double bill requirement. The Row in Poverty Row is not pronounced as the synonym meaning argument, otherwise you might confuse it with our Prime Minister's Question Time. No, it referred to a line of studios in Beverley Hills that churned out cheap movies.

But someone had to ride to the rescue. It was director John Ford who did 'what a man's gotta do' and transformed the Western. Using the spectacular Monument Valley, Arizona, for his locations, his *Stagecoach* was to become a classic of the genre. And it was the making of John Wayne, who was possessed

of a laconic drawl and a shambling walk that convinced audiences that here was a man who was at home in the saddle.

His saddle-bum drawl may have been a bit of a hindrance when it came to the religious film *The Greatest Story Ever Told* in which he had a cameo role, just one line as Longinus the Centurion who looks up at the crucified Christ and says, 'Truly this man was the son of God.' The (maybe apocryphal) story has it that when he uttered his one line, director George Stevens yelled 'Cut!' Took Wayne aside and advised him to say the line with a little more awe. 'Gotcha!' Wayne said. And then for the second take, he said 'Awe, truly this man was the son of God.'

Not to be outdone in laconic drawls the same year that *Stagecoach* was released, James Stewart starred in *Destry Rides Again,* playing opposite the sultry siren Marlene Dietrich. 1939 was the year of the laconic drawl.

In Dietrich's comedy Western *Destry*, in which she plays saloon gal Frenchy, Dietrich sang 'See What The Boys in The Back Room Will Have', which became a hit when it was released by Decca Records.

John Ford also made Celtic Westerns, like *The Quiet Man,* where John Wayne slugs it out with bone-breaking sound effects to the background music of jolly Irish jigs, and *How Green Was My Valley,* with Roddy McDowell, Walter Pidgeon and Maureen O'Hara suffering in this salt-of-the earth Welsh mining community, even though they all sound as if they come from somewhere west of Phoenix, Arizona.

Most critics agree that John Ford's greatest Western was *The Searchers,* (1956) in which John Wayne as Ethan Edwards plays a rather obsessed man searching for his niece who has been kidnapped by the Comanches. It reveals how Ethan is not so much driven by a heroic mission to rescue his niece Debbie (Natalie Wood) as much as a man with a racist hatred of the Indians, and feels he wants to murder his niece as she has become sexually contaminated by her Comanche captors. As much as revealing the white settlers' racist hatred of Native Americans, the film is stunning in Ford's filming, the way he shows Ethan as part of the stunning scenery, a lonely man who has become part of the rugged terrain.

John Wayne appeared in more than 150 films, but his first Academy Award for Best Actor came in 1970 for *True Grit,* released the previous year and directed by Henry Hathaway. The Coen brothers remade it and their 2010 film starred Jeff Bridges. Many audiences and reviewers consider the film to be superior to the original.

In the 1950s, Henry Fonda, Randolph Scott and Gregory Peck appeared in dozens of Westerns and discovered their only friend was a six gun or tin star, and Gary Cooper in *High Noon* (1952), directed by Fred Zinnemann, tried to renounce both of them after he got married at 10.35, and by midday was

slugging it out with some brutish killers, who were determined to save him money for the reception. The diminutive Alan Ladd was the archetypal saddle tramp in *Shane*, who having vanquished the town from Jack Palance's reign of terror, disappeared over the horizon for no good reason.

Carl Foreman wrote the screenplay for *High Noon* but was summoned to appear before Senator McCarthy's House of Un-American Activities Committee because he had been a communist. He admitted he had joined the communist party as a young man but had become disillusioned with it and hadn't been a member for ten years. But when he was asked to reveal names of other writers, actors or directors who were members, he refused to name names and was blacklisted. As he could no longer work in America, he came to Britain.

John Wayne called *High Noon* un-American, mainly because it portrayed a scared townsfolk unwilling to help out the sheriff and fight against the bad guys. He also said he did not regret helping to run Carl Foreman out of the country.

Wayne had made *Red River* (1948) for director Howard Hawks, who also disliked *High Noon* for similar reasons. In 1959 he made *Rio Bravo* with Wayne, Dean Martin, Ricky Nelson and Angie Dickinson, and Dimitri Tiomkin wrote the music. Because they had cast two singers in the film, they naturally brought a singing interlude into the piece, with Dean Martin singing 'My Rifle, My Pony and Me' and Nelson singing 'Get Along Home, Cindy'.

But the toughest Westerns of all were made by Sam Peckinpah, whose *The Wild Bunch* (1969) gave the manufacturers of fake blood a healthy life-style. It has been suggested by many people that the blood bath at the end of the film was allegorical, especially as another very real blood bath was taking place at the time in Vietnam.

In *Cat Ballou* (1965) Jane Fonda brought a touch of comedy to the western, aided and opposed by Lee Marvin, who played dual gunslinger roles and fought a battle against himself. George Roy Hill paired Robert Redford and Paul Newman in an early 'buddy movie', *Butch Cassidy and the Sundance Kid*, where Newman has an interlude in the middle of the picture to ride a bicycle, accompanied by a song about raindrops.

Spaghetti Westerns, in spite of this label, were mostly shot in Spain, but were produced by the Italians and director Sergio Leone. Clint Eastwood was a man in a poncho with no-name, and not many lines to learn for most scenes. In the first of these films, *A Fistful of Dollars* (1964) directed by Sergio Leone, Eastwood's character helped boost the cheroot industry, while shooting people who deserved to die because they looked as if they hadn't bathed for a decade. The films were accompanied by Ennio Morricone's memorably haunting, rattlesnake score.

Next came *For A Few Dollars More* (1965) and the following year *The Good the Bad and the Ugly* which was set during the civil war, and had Eli Wallach and Lee van Cleef, with a shootout in a graveyard between the three of them. This picture had a much bigger budget and you can see that in not only the length of the picture but the spectacular civil war battle scenes. Clint Eastwood went on to produce and direct his own Western with *High Planes Drifter* (1972), in which he plays a ghostly avenger who materialises mysteriously out of the distant landscape to rescue a town from tyranny.

There have been some successful modern Westerns. Set in West Texas in the 1950s *Hud* (1963) had a different sort of battle in this picture, between a father, played by Melvyn Douglas, and his son, played by Paul Newman.

A Kirk Douglas film, and one he himself considered one of his best film roles, was the modern Western *Lonely Are the Brave* (1962) in which he plays a ranch hand who feels out of place in the modern world, and escapes from prison on a horse, first having to dangerously cross a traffic-busy road before escaping to the high mountains on horseback.

The film was directed by David Miller, with a screenplay by Edward Abbey and Dalton Trumbo, who had from 1947 until 1960 also been blacklisted by McCarthy's House of Un-American Activities Committee, and wrote many successful screenplays under pseudonyms, but it was Kirk Douglas who acknowledged his screenwriting role with a screen credit in his own name for *Spartacus*. (Bryan Cranston stars as *Trumbo* in the 2015 biopic.)

Possibly the most brutal Western ever made was the 2012 *Django Unchained*, which director and writer Quentin Tarantino may have partly found inspiration from the 1966 Spaghetti Western *Django* which was directed by Sergio Corbucci and starred Franco Nero. Although that Italian Western was violent, it was like a walk in a vicarage garden compared to Tarantino's homage to the Spaghetti Western. It far exceeded the usual quota of deaths and blood splatter, as it told the story of a freed slave (Jamie Foxx) who joins forces with a bounty hunter (Christoph Waltz) and heads towards a southern plantation to free his enslaved wife from the villainous owner (Leonardo DiCaprio). That's when the fun really starts as an almost stylized and balletic gun battle rages, keeping those manufacturers of fake blood in clover.

Finally, the Western which was inspired by the 1954 Japanese film *The Seven Samurai*, directed by Kurosawa Akira was *The Magnificent Seven* (1960), starring Yul Brynner, Robert Vaughan, James Coburn, Charles Bronson, Steve McQueen and Horst Buchholz. The seventh one was Brad Dexter, who went on to suffer from an inferiority complex, although he did have a successful career as a film producer.

Comedy

All I need to make a comedy is a park, a policeman and a pretty girl.

Charlie Chaplin 1889-1977

USA

There were some comic geniuses in the years of the early talkies. One of those highly original performers created as his character a very misanthropic, hard-drinking, curmudgeonly rascal who was irritated by and loathed dogs and children, and had a wild, almost cruel streak when he confronted people with whom he had issues. But his humour was often so surreal and inventively original that audiences soon adored his brand of eccentricity. He was born William Claude Duckenfield, and began his showbusiness career as a hugely talented juggler. When his career took off he changed his name to W. C. Fields. He made many silent short films, some of which have been lost, but one survivor from the early silent days is *The Pool Sharks* in which Fields shows off some great comic dexterity from his juggling days. He was an avid reader and loved the works of Charles Dickens, especially the unusual names of the characters. Fields himself used idiosyncratic names for himself, some of which were unique, like Mahatma Kane Jeeves, which is like Bertie Wooster asking his butler to hand him his hat and cane!

Fields' love of Dickens paid off when he was delighted to be offered the part of Micawber in *David Copperfield* (1935), directed by George Cukor, replacing Charles Laughton, who suggested Fields as his replacement. There is a story, which may well be apocryphal, although I like to think that it's further evidence of Fields's dry humour. The actor suggested to Cukor that he wanted to include a pool shooting scene. He was told by the director that Dickens didn't write a pool shooting scene. To which Fields replied, 'Well, maybe he forgot.'

His rebellious humour was always in evidence off the screen. One day, epic director Cecil B. DeMille's assistant phoned Fields to say that her boss would like a game of golf with him. Fields replied, 'Listen, if I want to play with a prick, I'll play with myself.'

In many of his films he revelled in his love of liquor. And it wasn't confined to the screen, he was a heavy boozer in real life. Producers were worried that between shots he would fortify himself with swigs from a flask, which he claimed contained pineapple juice. When he was working on a scene, another actor tipped the gin from his flask and replaced it with pineapple juice. When Fields next took a sip, he spluttered disgustedly and said, 'Who's been putting pineapple juice in my pineapple juice?'

In 1940 his and Mae West's film *My Little Chickadee* was released. They did not get along, mainly because he received equal billing for the writing, and West claimed that she had written most of the film and he had only contributed to one bar scene; although Fields did improvise some very funny lines in the film, usually to do with booze. Like this one: 'I never forget one time we were stuck out in Afghanistan, lost our corkscrew and had to live on food and water for a week.'

One of his best movies was his last starring feature *Never Give a Sucker an Even Break* (1941). It was directed by Edward Cline and the original story was by Otis Criblecoblis (another of Fields's pseudonyms), and began with Fields playing himself, attempting to sell a film script to a studio who are reluctant to shoot this rather surreal offering, but we the audience are treated to the story as it takes off with Fields accompanied by singing star Gloria Jean as his niece. They go on an aeroplane trip, with an open viewing platform at the rear of the plane, from where he bails out in pursuit of a bottle of booze he has accidentally knocked out. Prior to his fall through the sky, Gloria Jean asks him why he never married. Fields replies, 'I was in love with a beautiful blonde once, dear. She drove me to drink. That's the one thing I am indebted to her for.'

Fields's fall through the air has him landing safely on a mountain top where he meets Mrs Hemeglobin, played by Margaret Dumont, who was the perfect foil for Groucho Marx's humour and appeared in many Marx Brothers comedies.

The brothers honed their comedic skills in vaudeville and on Broadway, then Groucho, Harpo, Chico and Zeppo made five films for Paramount, the greatest being *Duck Soup*, directed by Leo McCarey, with a screenplay by Bert Kalman and Harry Ruby, and it was released in 1933, but strangely enough this was the least successful film as far as box office takings were concerned. Paramount cancelled their contract, and so they then made films for MGM, including *A Night at The Opera* and *A Day at The Races*. A classic line from the latter has Groucho saying, 'Either he's dead or my watch has stopped.'

But what was it that audiences missed at that time that has made *Duck Soup* the most memorable and funniest of their films, and is listed by so many film

critics as one of the top ten comedies of all time? Perhaps it was because of its very surreal satire at a time when several European countries had become fascist states. Benito Mussolini banned the film in Italy because he took Groucho's role as dictator Rufus T Firefly as a personal attack. Nothing could have pleased the Marx Brothers more.

Louis Calhern plays Ambassador Trintino who wants Firefly's state of Freedonia for himself, and hires Harpo and Chico as his intelligence agents, which leads to some hilarious comedy set pieces between the three comedians, especially when Groucho dons a nightgown and nightcap and meets himself played by Harpo, dressed identically complete with cigar and painted on moustache, and they try to catch each other out in a brilliantly staged mirror routine, tagged by a third Groucho played by Chico.

Zeppo had always been the straight man and wasn't involved in much of the comedy, and *Duck Soup* was his last movie with his brothers. But the dignified and upright Margaret Dumont remained the perfect foil for Groucho's outrageous putdowns ('Remember you're fighting for this woman's honour… which is more than she ever did.').

When a town in New York called Fredonia complained about the close use of its name in the film, the Marx Brothers shot back: 'Change the name of your town, it's hurting our picture.'

Although they had some brilliant writers like S. J. Perelman, Groucho's wit was excellent.

He wrote to a club once, 'Please accept my resignation. I don't want to belong to a club that will accept me as a member.' And when the scandal magazine *Confidential,* that published exposés of celebrities, published a scurrilous article about Groucho, rather than threatening to sue, he responded by writing to them: 'Gentlemen: if you continue to print slanderous articles about me, I shall feel compelled to cancel my subscription.'

Most of these comedies uplifted audiences in the Depression era. But the biggest star of all during those difficult years was Mae West, a great comic actress who almost parodied sexuality, and audiences flocked to see her films, loving her double entendres. Like many stars at that time she began her career in vaudeville, and even in what was considered to be slightly lower than that – burlesque. But she became so popular with her risqué dialogue, that Hollywood soon beckoned. Her first film, *Night After Night,* was with George Raft, and has that legendary exchange between her and a hatcheck girl who observes, 'Goodness, what beautiful diamonds.' To which West replies, 'Goodness had nothing to do with it.'

Mae West later used her reply as the title for her autobiography.

Another famous line of hers many people seem to remember was, 'Is that a gun in your pocket or are you just pleased to see me?' But you would be wrong in thinking this was one of her lines from her golden years of stardom. This line came from the 1970 film *Myra Breckinridge,* in which she received top billing after an absence from pictures of 27 years. This film was directed by Mike Sarne ('Come Outside') and was a stinker, and Sarne was never again asked to direct another Hollywood movie.

But her most popular films were with Cary Grant as her co-star. First was *She Done Him Wrong* (1933) in which she revived her stage character of Diamond Lil, but for the film renamed her as Lady Lou, and then came *I'm No Angel.* Some of the suggestive lines she wrote for many of her films were censored by the Hays Code. But the first film she made with Cary Grant was so successful that she rescued Paramount from bankruptcy, and years later they acknowledged this debt by naming one of their studio buildings after her.

She was also honoured by the American navy who nicknamed a life jacket a Mae West. I'll leave you to work out the connection.

The 1930s was a spectacular decade for American film comedies, especially the more surreal and zany ones. Not long ago I happened to mention Stan Laurel and Oliver Hardy to someone and they said they much preferred Abbott and Costello. Had there been a custard pie handy, that person would have got it bang in the face!

Like many comedians of the time, Stan Laurel and Oliver Hardy refined their talents in the theatre. But when this double act began making films they took their comedy to another level and – unlike Abbott and Costello, whose act consisted of one funny and one straight man – they were both hilarious and have been a great inspiration to many more recent double acts. One of their most famous short films *The Music Box* (1932) was directed by James Parrott, and this simple story has them delivering a mechanical player piano, which proves to be anything but simple, as they struggle to heave it up the steepest flight of steps, only to be told by a postman that they needn't have struggled up the steps but could have driven up the hill in their lorry. Using perverse logic they struggle to take the piano back down again just so they can drive it to the top again. Naturally, as often happens in their films, their hats get mixed up, Ollie's much too big for Stan, and Stan's hat perched on Ollie's head like a pimple.

The Music Box won the Academy Award for Live Action Short Film. Short films then were any films which were under forty minutes long, and Laurel and Hardy's short was around 30 minutes.

Another one of their great shorts was *Laughing Gravy* (1931) which was the name of the dog they are trying to conceal from their landlord on a snowy

night. The film was written by H.M. Walker and Stan Laurel (uncredited). The eponymous name of the dog was a metaphor for liquor as Prohibition didn't end until 1933.

One of their greatest full-length features was *Sons of The Desert* (1933), directed by William A. Seiter, who also directed the Marx Brothers in the 1938 comedy *Room Service*.

But you could be forgiven for thinking the Stan and Ollie film was shot in some arid location. The title refers to a strange fraternity, not unlike the freemasons. As the two inept friends struggle to conceal from their disapproving wives a plan to visit Hawaii, it all predictably goes wrong, and whenever Stan puts his foot in it, Ollie invariably breaks the fourth wall and stares straight at the camera. His expression can be read and we can almost hear the voice in his head declare, 'You see what I have to put up with.' And later on, when Stan again does something stupid, another look to camera and we can almost hear Ollie saying, 'What did I tell you?' And he really does declare from time to time, 'And that's another fine mess you've gotten me into.'

Their comedies were brilliant inventions for the camera, and *Sons of The Desert* can still be enjoyed ninety years on from when it was first shown. As can many of their other features, like *Chumps at Oxford, Babes in Toyland, The Flying Deuces* and *Way Out West*. In the latter there is a Wild West bar scene in which they sing, 'The Trail of The Lonesome Pine', with Stan Laurel dropping his voice to a bass tone, until he is hit on the head with a mallet by Ollie, and then sings falsetto. Their song was rereleased in 1975 and reached No 2 in the UK charts. No small achievement for a song they recorded in 1937.

The thirties paved the way for the screwball comedies. By far the wittiest of these was *Bringing Up Baby* (1938) and Katherine Hepburn and Cary Grant's lines were delivered at the speed of light, a bit like hip-hop written by P. G. Wodehouse. The film was directed by Howard Hawks, and although it is now considered a classic comedy, it ended Hawks's contract with RKO pictures as it earned little on its release. And Katherine Hepburn was forced to buy herself out of her contract with them. But that comedy was one of the greatest and has been rediscovered in later years.

Incidentally, Baby of the title refers to Hepburn's pet leopard which was sent to her by her brother in South America. And things don't get any zanier than that.

Possibly the first screwball comedy was the 1936 *Mr. Deeds Goes To Town*, directed by Frank Capra, which starred Gary Cooper as Longfellow Deeds, a poet from a rural area who inherits millions of dollars from an estate of a late uncle, decides the money won't do him any good and decides to give it away

to rural communities. A wisecracking reporter played by Jean Arthur starts to squeeze scathing articles about this man she considers a hick, but is eventually converted by his sense of idealism. The film is an anti-materialist and anti-capitalist comedy, a tribute to America's true beliefs!

In 1942 Ernst Lubitsch directed *To Be Or Not To Be* in what could have been a highly controversial film, as it was about an acting troop in Warsaw during the Nazi invasion of Poland, but became a funny and highly regarded satire. Jack Benny played an egotistical actor who indulges in Hamlet's speeches, using the famous Benny slow burn as he watches an American serviceman, played by Robert Stack, leaving the auditorium during one of Hamlet's famous speeches, but what he doesn't realise, as he takes so long over his indulgent speeches, is that the American has an assignation with his wife, played by Carole Lombard, in the theatre dressing room. The Polish acting troop, along with Jack Benny's character, become instrumental in a masquerade to save a Resistance hero from Gestapo headquarters, and so the actors become heroes, and satirize the evil Nazis who have risen from ordinary men. The film was remade by Mel Brooks in a colour version in 1983.

In 1940 Bing Crosby, Dorothy Lamour and Bob Hope starred in *The Road To Singapore* which led to a succession of *Road To* films, which became hugely popular with audiences, and much of their comedy satirised many popular films of the day and other genres. Bob Hope regularly broke the fourth wall, and in *The Road To Bali* (1952) he warns the audience that Crosby '…is gonna sing, folks. Now's the time to go out and get the popcorn.'

They both partnered well and swapped friendly insults and wisecracks, some of which were improvised during the shoot. The musical glamour was provided by Dorothy Lamour who had been a big band singer in the 1930s. *The Road To Bali* was her final appearance as leading lady in the sixth of the *Road To* films, and the chemistry between her and Hope and Crosby was superb.

They made one more film *The Road to Hong Kong* released in 1962, and Joan Collins was Crosby and Hope's leading lady, but on Bob Hope's insistence Dorothy Lamour was written into the script as a cameo appearance playing herself, and sang two songs. It was shot at Shepperton Studios in the UK with a largely British cast including Robert Morley, with Peter Sellers playing an Indian physician.

Although *The Road to Bali* had been their first *Road To* film shot in colour, as were all the others, for some strange reason they shot *The Road to Hong Kong* in black and white.

Probably the biggest comedy act in America during that decade was Dean Martin and Jerry Lewis who made 16 feature films between 1949 and 1956,

with titles such as *Caddy, Sailor Beware* and *Living It Up*, in which the poster boldly declared that they were appearing 'In One Of The Wackiest Films They Ever Made.' Their last film together was *Hollywood or Bust*, but they had fallen out big time by then, and would only speak to each other on camera.

A comedy duo falling out? How unusual that must be.

In the last year of the decade came the comedy icing on the cake. *Some Like It Hot* directed by Billy Wilder and co-written by him and I.A.L. Diamond. Set in 1929, two jazz musicians played by Tony Curtis and Jack Lemmon witness the gangster St Valentine's Day Massacre and become the mob's next hit in order to silence them. They escape by donning drag, masquerading as female musicians Josephine and Daphne, and join an all-girl band heading for Florida, forming a friendship with Sugar, played by Marilyn Monroe. When they arrive in Miami is when the fun really starts as millionaire Osgood, played by Joe E. Brown, falls for Jack Lemmon, and Curtis when out of drag does a parody of Cary Grant. The farcical element grows as gangsters hold a conference at the same Miami hotel. The film has one of the best last lines (if you have never seen it, it doesn't matter) when Joe E. Brown takes Jack Lemmon on a launch, planning to take him out to his boat, and wanting to marry him – or her, as he mistakenly thinks of the dragged-up Lemmon. In desperation, Lemmon says, 'I'm a MAN!' To which Osgood replies, 'Well, nobody's perfect.'

The shooting of the film was not without its problems, which came mainly from Monroe whose tardiness was unbelievably frightful, and she would keep other actors waiting for hours. Curtis, who had some romantic scenes with her, actually went on record as saying, 'Kissing her was like kissing Adolf Hitler!'

But anyone not knowing that would never guess from seeing her wonderful performance, bubbling with innocence and with immaculate timing. Wilder's film is a classic comedy that is as fresh today as when it was first viewed in 1959.

I remember reading a story about Wilder, who when his cinematographer was preparing a shot, apparently Wilder joked, 'Keep it just out of focus. I want to get the Oscar for Best Foreign movie.'

During the sixties and seventies, many successful comedies became more socially realistic. Even Billy Wilder's next film *The Apartment* (1960) made satirical social comment as Jack Lemmon's C.C. Baxter can only get promoted at the insurance company where he works if he loans out his apartment to some of the executives so they can cheat on their wives. And it becomes a dark, but sometimes very funny attack on corruption and the influential types who take advantage of their subordinates. The film, however, does segue into a more romantic comedy as Baxter is redeemed by his love for Fran, played by Shirley MacLaine.

Up until 1963, Peter Sellers had been mainly a supporting actor, playing in British films like *I'm All Right Jack* (1959) produced and directed by the brothers John and Roy Boulting. Sellers played union leader Fred Kite brilliantly, but he was third on the billing after Ian Carmichael and Terry Thomas. Then in 1963 his opportunity for massive stardom came with the jewel thief caper *The Pink Panther* in which he played the inept Inspector Clouseau. It was David Niven who had top billing, but Sellers' character took off as audiences fell-about when they watched his accident prone stupidity and ridiculous pronunciation of English words with a French accent, and he all but stole the film, which would now lead to top billing for Sellers in many more *Pink Panther* films. *The Return of The Pink Panther* established Henry Mancini's 'Pink Panther Theme' with animated opening titles, which would lead to popular cartoons of the pink feline character.

In 1964, during the height of the Cold War, came the nuclear holocaust wake-up call with the brilliant Stanley Kubrick black comedy *Dr. Strangelove, or: How I Learned to Stop Worrying And Love The Bomb*. Based on a serious novel *Red Alert* by Peter George, Stanley Kubrick co-wrote the screenplay with Terry Southern and it starred Peter Sellers in three different roles, as an RAF officer, the American president and the eponymous German who has difficulty controlling his mechanical arm from giving a Nazi salute. The plot kicks off as General Jack D. Ripper (Sterling Hayden) unleashes a B-52 bomber to drop an H-bomb on the 'Russkies'. The plot thickens when the Pentagon learns that Ripper has overridden the fail-safe code and the bomber is heading for Moscow and cannot be recalled, and there are some dark but hilarious scenes in the War Room (an impressive set by designer Ken Adam) with General Buck Turgidson, brilliantly played by George C. Scott, fighting the Russian ambassador (Peter Bull), and Sellers as President Muffley, in his most reasonably controlled voice says, 'Gentlemen, you can't fight in here – this is the War Room.' And Sellers is very funny in a long phone call he has to make to Russian President Dmitri by telephone, when he apologises in his most wheedling tone that one of his commanders 'did a silly thing.' But the dark humour becomes even darker when towards the end -THE end – aboard the B-52 bomber, Major T. 'King' Kong (Slim Pickens), removes his helmet, dons a Stetson, sits astride the H-Bomb, and Yee-haws like a rodeo rider as the bomb is released, followed by doomsday as we then see masses of mushroom clouds, followed by Vera Lynn's song, 'We'll Meet Again'.

This is very much an all-male picture. But that is as it should be, because it is that gender that brought us to the brink of civilization's extinction.

If you have never seen this film, and you are getting on in years, and you may remember that time you joined CND and marched to Aldermaston, then

perhaps you might find it reminiscently scary. On the other hand, comfort yourself by knowing that the use of that song may have given our Vera a few bob.

Mel Brooks took the late-sixties and then the seventies by comedy storm, when he wrote and directed mainly satirical parodies like *Blazing Saddles*, probably influenced by the earlier *Hellzapoppin'*, a zany musical comedy from 1941, with its deliberately ridiculous plot. In Brooks' Western parody, he also lets the action go berserk in the final reel as he literally breaks the fourth wall and the studio sets become plywood. His films were mainly parodies of other genres, such as *High Anxiety* a parody of Hitchcock films, and his parody of horror movies, which he directed, although *Young Frankenstein* was written by Marty Feldman, who played the hunchbacked weirdo Igor, supporting Gene Wilder as a doomed innocent.

But it was the Mel Brooks' *The Producers* (1968) that was the cream of the crop, and was his first feature film as writer/director, for which his screenplay got an Oscar. This was the most audacious of many comedies, inasmuch as it is about Jewish theatre producer Max Bialystock who stages a tasteless musical called *Springtime for Hitler*. Bialystock was beautifully played by Zero Mostel, wearing a terrible comb-over. He was supported by Gene Wilder as Leo Bloom, a timid accountant who innocently realises that if a producer raised a million dollars from investors, for a show costing very little, and it failed at the box office, then investors wouldn't expect a return on their money. And so he finds the worst play ever written by a deranged Nazi (Kenneth Mars) and they begin auditions for the worst performers imaginable, creating the most memorable throwaway line: 'Will the dancing Hitlers please wait in the wings!' When the first night audience see the dance routines by chorus girls goose-stepping as Nazis, they are rightly horrified, but as the actor playing Hitler plays the dictator as a sort of camp bohemian, the audience is convulsed. Waiting in the theatre bar, Max and Leo are surprised by the audience's positive reaction, and Max observes that they picked the worst show with the worse script and the worst actors: 'Where did we go right?'

Mel Brooks wrote his film as a stage musical which opened on Broadway in 2001 and ran for 2,5002 performances, starring Nathan Lane and Matthew Broderick, and was made into a musical film in 2005 with both of them in the lead roles.

Many successful film directors and writers in the seventies and beyond began as stand-up comedians and television sketch writers, a bevy of them appearing and writing for comedian Sid Caesar's live TV show, and Mel Brooks excelled in improvised comedy. Larry Gelbart also wrote for Caesar's shows, and went

on to create and produce the military field hospital comedy *M*A*S*H* for TV which ran between 1972 – 1983. This followed on from the 1970 film, starring Donald Sutherland, Elliot Gould, Tom Skerrit and Sally Kellerman, and was directed by Robert Altman with a screenplay by Ring Lardner Jr. Apparently, Robert Altman hated the TV version. How he must have squirmed for eleven long years!

Another contributor to Caesar's shows was Neil Simon who had many comedy hits on Broadway. In 1968 his stage hit *The Odd Couple* was made into a film, starring Jack Lemmon as Felix and Walther Matthau as Oscar, which became a perfect comedy pairing, with the pernickety Felix obsessed with tidying and cleaning in Oscar's apartment, who is an untidy slob, and pretty soon they get on each other's nerves. Strangely, this very funny film rarely gets a mention in cinema books, but this is perhaps because it was very much a stage play and most of the action takes place in Oscar's apartment. Although, having said that, of all the films ever made, only about a third of them are original screenplays, about two thirds are adaptations, mainly from books.

Another stand-up comedian, and contributor to Caesar's shows was Woody Allen, who having written for many other comedians, used mainly monologues rather than jokes for his own brilliant stand-up act, but whenever a joke appeared in a monologue it was usually a sure-fire winner. One of his gags got him into trouble when he was sued by his first wife, although he never mentioned her by name. She had been sexually violated outside her apartment building and he said in his act, 'Knowing my ex-wife, it couldn't have been a moving violation.'

And he played on insecurities in his stand-up routines, talking about his childhood with lines like, 'I don't think my parents liked me. They put a live teddy bear in my crib.'

What's New Pussycat his first screenplay, in which he also appeared, was so disappointing that he vowed to always direct his own films from then on, although Herbert Ross directed *Play It Again, Sam* (1972) from his Broadway play. He made several film comedies like *Bananas* and *Take The Money And Run* which he co-wrote with Mickey Rose. As his screen character developed he played an insecure version of himself, quite intelligent but slightly neurotic, and always worried about his relationships with women. In the science fiction spoof *Sleepers* (1973). which co-starred Diane Keaton, their characters have been asleep for two hundred years and wake up in a dystopian future. At one point, Allen protests that, 'I haven't had sex for two hundred years. Two hundred and four if you count my marriage!'

His 1977 film, *Annie Hall*, which he co-wrote with Marshall Brickman, and played opposite Diane Keaton again, was an instant success, gaining four

Academy Awards. The film is very much a romantic comedy, and he also plays on his insecure and uncool character, especially as he attempts to be cool when attending a trendy cocaine party, but before anyone has sniffed a line of coke he sneezes hugely, blowing it everywhere.

Allen was very much a New Yorker, and uses his own dislike of the West Coast as a line in the film. While visiting Los Angeles with his friend Rob, played by Tony Roberts, Allen complains about it being so unreal, 'Like living in munchkin land. Where's all the garbage?' To which his friend replies, 'They turn it into TV programmes.'

Annie Hall is a film that is very much in the tradition of the thirties screwball comedies.

A film that was considered one of the best of his most recent features was perhaps *Midnight in Paris* (2011) with Owen Wilson in the lead role of Gil Pender. Sitting forlornly alone in a Paris street, when the clock strikes midnight he travels back in time, attending a 1920s party with Jean Cocteau, Cole Porter, and Zelda and F. Scott Fitzgerald. Pender has written a novel, which he would like Gertrude Stein to read. When Pender meets many artists, including Salvador Dali, Man Ray and Luis Buñuel, and tells them he has travelled back in time from the future, they accept his explanation readily, because they are surrealists. This is a highly inventive and witty film, shot entirely on location in Paris, and was a joint US and Spanish production. Woody Allen must be cinema's most prolific screenwriter and director having made around fifty films.

One of the best parodies of all time was *Airplane!* (1980) which laughed at the typical airline disaster movie. The original screenplay was by Jim Abrahams, and brothers David and Jerry Zucker, and it was directed by all three of them. They bought the rights to the 1957 disaster movie *Zero Alert* so that their often outrageous comedy had a strong plot. The casting of *Airplane!* was superb because the actors played it straight, as if they really believed they were shooting an actual disaster movie, not a comedy. Robert Hays played ex-fighter pilot Ted Striker who has lost his nerve and is trying to win back the love of the air hostess, Elaine Dickenson (Julie Hegarty). The script has dozens of visual gags, such as passengers committing suicide when they hear Ted Striker droning on about his problems. And Striker also has a drink problem: when he goes to knock back a drink he misses his mouth. And there are the verbal gags such as when the Doctor Rumack says, 'We must get her to a hospital.' Striker asks, 'What is it?' And the doctor replies, 'It's a very large building.'

And 'There's been a problem in the cockpit.' 'What is it?' 'It's a room at the front of the plane.'

And there are parodies within this parody, as flashbacks take us back to Striker's military experience, or a disco scene which parodies *Saturday Night Fever* dancing to the Bee Gees soundtrack 'Staying Alive.'

Robert Stack, Leslie Nielsen, Peter Graves and Lloyd Bridges are actors you would recognise from seriously dramatic films, probably even a few disaster movies. And when Lloyd Bridges as an Air Traffic Controller becomes ever more frazzled, and at first says something like 'I picked the wrong day to give up smoking,' it soon becomes a running gag with him becoming ever more desperate and picking the wrong day to give up everything, including glue sniffing!

Surely this film must be in the top ten comedies of all time. Sorry, I didn't mean to call you Shirley!

The film also has some outrageously vulgar scenes, which can only be described as side-splittingly funny. It is not a film for the dedicated prude. But anyone who watches this film and doesn't find it funny should consider joining a holy order on some remote island.

Another spoof from the same team was *Top Secret* (1984) a parody of spy films, and had the recurring lampoon of some bad Elvis Presley musicals when Val Kilmer caricatures the King and sings in the most ridiculous of situations.

1984 also gave us one of the greatest parodies ever filmed with *This Is Spinal Tap*, directed by Rob Reiner, who also co-wrote the screenplay with Christopher Guest, Michael McKean and Harry Shearer, and all four of them appeared in the film as well. The film is a parody of rock/pop documentaries, forging a new genre when it became known as a 'mockumentary', paving the way for many such television comedies.

Spinal Tap is a heavy metal British band, strutting and silly, imbecilic and arrogant, and there are some great and memorable set pieces as and when Derek Smalls (Harry Shearer) sets off an airport metal detector with the pickle wrapped in tinfoil in his underpants. Arguments over an offensive album cover of 'Smell My Glove', and the boast that they are the loudest band performing as their amplifier can go beyond ten to eleven are hilariously memorable. And these prancing rock dinosaurs sing awful numbers like 'Big Bottom' and 'Sex Farm', the latter becoming hugely popular in Japan (not really!).

Another multi-talented artist who began by doing stand-up and writing for sketch shows is Steve Martin whose first film was *The Jerk* (1979), where he plays a buffoon brought up by a poor black family and is ridiculously uncoordinated when he tries to join in with their musical abilities. But Martin's most innovative film was *Dead Men Don't Wear Plaid* (1982) co-written by him, George Gripe and Carl Reiner, who also directed the film. The film was both a parody and

a homage to the noir films of the 1940s. It was shot in black and white and featured Martin as a gumshoe working for Rachel Ward, and he meets James Cagney from *White Heat* and Humphrey Bogart as Philip Marlowe in *The Big Sleep* as their dialogue is cleverly matched with the clips from the 1940s films, and you would swear they appear in the same pictures, as their eyelines match perfectly as they speak, and the clever lighting is the same in *Dead Men* as in the old classic crime films. There were dozens of clips used, everyone from Bette Davis and Veronica Lake to Cary Grant and Lana Turner.

In fact I would hazard a guess that this film inspired some beer commercials from the 1990s where they used similar photographic tricks by using old movie clips set against live action.

The 1980s was the decade when teen movies became popular. John Hughes wrote and directed the popular *The Breakfast Club* in 1985 and followed it up a year later with *Ferris Bueller's Day Off* which he also wrote – apparently in a week. It starred Matthew Broderick as a high school senior playing truant from school and leaving the suburbs to explore Chicago. He is accompanied by his girlfriend, played by Mia Sara, and his friend Cameron (Alan Ruck), who he persuades to borrow his father's Ferrari for the trip, without Cameron's father's knowledge. This very successful comedy led the way for many other teen comedies, including *Can't Buy Me Love* and *Some Kind of Wonderful*, both released in 1987, but it was the Ferris Bueller comedy that most audiences remember. And I often wondered, if when someone recognised Matthew Broderick in a bar or restaurant, might they have asked him, 'Is this your day off?'

How many of us remember great lines from films? I'm thinking of the scene in a deli when Sally, played by Meg Ryan, demonstrates loudly to Harry, Billy Crystal, that she can convincingly fake an orgasm, and demonstrates perfectly. A woman at another table tells the waiter, 'I'll have what she's having.'

The film is of course *When Harry Met Sally* (1989), directed by Rob Reiner, and his mother played the customer with that memorable line. The story kicks off with the twisted judgement of Harry who claims that, 'Men and women can't be friends because the sex part always gets in the way.' The film has an excellent screenplay by Nora Ephron, with great lines running throughout. And a soundtrack with 1930s and '40s songs, including the standard 'It Had to Be You', sung by Harry Connick Jr.

In the 1990s, America produced many funny movies. In 1993 came the classic fantasy comedy *Groundhog Day*, a story that is based on a true event in a town called Punxsutawney, Pennsylvania, where a groundhog called Phil on every 2nd of February either heralds the start of spring or the continuation of

winter. The film had an original screenplay by Danny Rubin, and was rewritten by director Harold Ramis, and starred Bill Murray as the grumpy and rather obnoxious TV weatherman and broadcaster Phil Connors, who is reluctantly sent on an assignment to film the groundhog day with his producer Rita (Andie MacDowell) and his cameraman (Chris Elliott), and when Connors wakes up at six a.m. to Sonny and Cher singing 'I've Got You, Babe', followed by a DJ's inane banter, little does he realise the same thing will happen the very next day, because it is always going to be February 2nd from now on, and as much as he attempts to alter the situation, he wakes up the to the same day and at the same time to the same tune. This very funny film doesn't attempt to explain how this has happened to him, it just has, which makes it all the funnier, and in the story we eventually see his redemption as he becomes a better person and falls in love with Rita.

Although Bill Murray and Harold Ramis were great friends, and having made the hugely successful comedies *Caddyshack* (1980) and *Ghost Busters* (1984) together, following disagreements during the shooting of *Groundhog,* they fell out, and Murray threw tantrums and was often late to the set or location, so that after the film ran over its time, Murray and Ramis never spoke again.

At the end of the decade came the outrageous Austin Powers (Mike Myers) sequel *The Spy Who Shagged Me*, a send-up of the James Bond franchise and swinging London. And in the 21st century, again some very funny films, including two starring Ben Stiller in *Meet the Parents* (2000) and *Zoolander* (2001), but a list of all American comedies during the noughties decades might prove to be an arduous task for any serious film buff, and I'm not convinced that many of them figure in a history of cinema, and so I think it's time to move on across the Atlantic.

> *Comedy is an imitation of the common errors of our life.*
> Philip Sidney 1554-86

Britain

Two prominent comedy performers from the 1930s to the 1950s were Arthur Lucan and Will Hay. Lucan played Old Mother Riley, an Irish washerwoman, and his wife and business partner, Kitty McShane, played his daughter. It may have been the first time a comedy drag act became hugely popular on film, and their act may have inspired the television comedies *Mrs Brown's Boys*, which is very much in the music hall/pantomime tradition, though the language is more modern!

Arthur Lucan's final film was in 1952, but without Kitty McShane, as they had separated in 1951. The film was *Old Mother Riley Meets the Vampire* and it also starred Bela Lugosi. It was shot at Nettlefold Studios in Walton-on-Thames, which later became known as Walton Studios.

The 1950s was when the toothy Lancashire comic George Formby churned out many films, in which he always played his ukelele, singing songs like 'Little Stick of Blackpool Rock' and 'When I'm Cleaning Windows'. His films usually ended with a motorbike or car chase, usually done with obvious back projection. Film critics were not blown over by his films but he was very popular with the general public.

Will Hay played a rather roguish headmaster in *Boys Will Be Boys* in 1935, and one of the set pieces was his taking a class and asking them, 'What is a unit of electricity?' One of the schoolboys answers, 'A watt.' Hays then says, 'That's what I'm asking you.' And so it goes on, spreading more confusion. This music hall routine is similar to Abbott and Costello's vaudeville sketch, 'Who's On First.' (Abbott & Costello's sketch *Who's On First* can be seen on YouTube and it is a perfect example of comedy timing and memory and well worth watching.)

In 1942 Will Hay starred in *The Goose Steps Out*, a spy comedy, which gave Peter Ustinov his first film role, and Charles Hawtry played Max, who as I'm sure we all know went on to become a comedy regular of the *Carry On* films. An uncredited role in the film went to William Hartnell who became TV's first *Doctor Who*.

But the film of Hay's that most people seem to have heard of is *Oh, Mr Porter* (1937), directed by a Frenchman, Marcel Varnel. The film was loosely based on Arnold Ridley's play *The Ghost Train,* and the plot had Will Hay playing a man called Porter who is sent to become stationmaster of a ramshackle old station in Northern Ireland which was supposed to be haunted. Director Varnel said it was probably one of the best films he had directed, and film critic Barry Norman includes it among one of his 100 best films of all time.

The film's railway scenes were mainly filmed near Basingstoke and the interior scenes were shot at Gainsborough Studios. The title of the film came from a music hall song which may explain why some people remember this film when they recall these lyrics:

'Oh! Mr Porter, what shall I do? I want to go to Birmingham,

And they're taking me on to Crewe. Take me Back to London,

As quickly as you can, Oh! Mr Porter, what a silly girl I am.'

In 1944, based on the music hall character, Tommy Trinder played *Champagne Charlie* about the music hall comedian, George Leybourne, who became known as the first performer to make the song famous. The film was set in the

nineteenth century at the height of music hall's popularity, and Leybourne's rival for popularity was Alfred Vance, played by Stanley Holloway. The two female leads were Betty Warren and Jean Kent as a music hall owner and her daughter. In that year *Champagne Charlie* was a quintessential morale raiser and a feelgood film. It was an Ealing Studios production directed by Alberto Cavalcanti, who directed *Went The Day Well,* a propaganda drama in 1942 for Ealing Studios. The cinematographer for *Champagne Charlie* was Wilkie Cooper, who was D.O.P. for *Jason and the Argonauts* (1963), *Seven Waves Away* (1956) and *Please Sir!* (1971).

It was the Ealing Studios that produced arguably UK's best comedies of all time. Films like *Kind Hearts and Coronets* (1949) directed by Robert Hamer for Ealing Studio's producer Sir Michael Balcon. It was a black comedy about eight members of the snobbish, wealthy, aristocratic D'Ascoyne family, who are systematically murdered by a disinherited member of the family who married beneath his station, played by Dennis Price. Alec Guinness brilliantly plays all eight members of the family, including Lady Agatha who is shot down in a hot-air balloon. Incidentally, Valerie Hobson, who played Edith D'Ascoyne, was married to John Profumo, who became involved with Christine Keeler and Stephen Ward resulting in the 1963 scandal that brought down the government, And they were eventually portrayed in the 1989 film *Scandal,* directed by Michael Caton-Jones. A politician involved in a scandal? A bit hard to believe that one!

From the late forties through most of the fifties was Ealing Studios greatest comedy output, *Whisky Galore* (1949) directed by Alexander Mackendrick, then *The Man in the White Suit* (1951) starring Alec Guinness, who also starred in the 1951 film *The Lavender Hill Mob,* with Stanley Holloway, Sid James and Alfie Bass. The first Ealing Comedy to be shot in Technicolor was the 1953 *Titfield Thunderbolt,* about villagers struggling to keep a railway branch line open and run their own service. And then in 1955 came the jewel in the Ealing Studios crown with a black comedy directed by Alexander Mackendrick. *The Ladykillers,* with a screenplay by William Rose, is set in a house in a cul-de-sac near King's Cross station, in which a sweet little old lady lives, Mrs Wilberforce, who is a frequent visitor to the police station to report fanciful suspicions, and they humour her. She is indoors talking to her parrot one day, when we see a shadowy figure through the glass of her front door, causing the parrot to squawk urgently. (This, along with some other shot compositions, is almost as if Mackendrick was inspired by German Expressionist cinema.)

The disturbing shadow turns out to be 'Professor' Marcus (Alec Guinness), who wants to rent a room in her house for his quintet of musicians to

practice. The other musicians (gang of thieves) are the Major (Cecil Parker), a typical gangster (Herbert Lom), a spiv/Teddy boy (Peter Sellers) and a heavy nicknamed One-Round (Danny Green). When they have robbed the mail train at King's Cross, and are preparing their getaway with the money stashed in their instrument cases, One-Round gets his stuck in the door, revealing the money to Mrs Wilberforce. Now they decide to kill her and draw lots on who should do it. But this inept species of ne'er-do-wells end up killing each other instead.

Also in the film is Jack Warner as a police superintendent, and there is a funny cameo from Frankie Howerd as a barrow boy.

But despite the 'black comedy' label, this glorious film has a certain innocence about it, mainly from the wonderful performance by Katie Johnson as the very trusting Mrs Wilberforce, who when she discovers they are thieves, admonishes them as if they are a bunch of naughty children.

No wonder the BFI rates it as the 13th greatest British film of all time.

It was remade in 2004, with Tom Hanks in the leading role, and set in the southern states of America. Unfortunately, it was like a cover version of someone who wants to make it bigger and better, but succeeds in missing the point about its timelessness and innocence.

The most popular film at the British box office in 1954 was *Doctor In The House*, based on the novel by Richard Gordon, and starring Dirk Bogarde as Simon Sparrow, with Muriel Pavlow, Kenneth More, Donald Sinden and James Robertson Justice, which led to six sequels. The second *Doctor* film the following year was *Doctor At Sea,* again starring Dirk Bogarde, with Brigitte Bardot in her first British film. When she was interviewed by a reporter, and asked what she thought of Englishmen, she replied, 'I don't know. I haven't tried one yet!'

The 1953 film *Trouble in Store* became the second most popular film of 1954 at the British box office, starring Norman Wisdom, in his first low-budget film for the Rank Organisation, and earned him a BAFTA Award for the Most Promising Newcomer to Film.

Based on Ronald Searle's cartoon strip, *The Belles of St Trinian's,* directed by Frank Lauder, became Britain's third most popular film of 1954. It starred Alastair Sim, who donned drag to play the school's headmistress, and also played the dual role of her twin brother. The film had a great cast of British actors, including George Cole as the spiv 'Flash' Harry, and Joyce Grenfell and Hermione Baddeley. And Sid James had a cameo role in the picture.

If in a quiz you were asked to name a British comedy film in which Sid James has *not* appeared, you might find it difficult to answer that one. He became a regular in the *Carry On* films, kicking off with *Carry On Constable*. He appeared in 19 out of the 31 *Carry On* films.

These films produced by Peter Rogers and director Gerald Thomas were as British as Christmas pantomimes, and very much in the music hall tradition with a mixture of bawdy seaside postcard humour. Dozens of famous British actors were to appear in various roles over the years, but the most memorable actors for their sheer outrageous eccentricity must be Kenneth Williams and Charles Hawtrey.

Surely the nadir of the British comedy film arrived in the seventies, when comedy was combined with sexploitation, and we had titillation in the form of bare-breasted actresses in films like *Confessions of a Window Cleaner* (1974), starring Robin Askwith, leading to more *Confessions* films, and a plethora of titles that promised to reveal all but failed to deliver, such as *Come Play With Me*, promising to show much in the way of steamy sex but had only a naked Mary Millington sitting on someone's lap in a sauna, and what passed for comedy was provided by actors like Alfie Bass and Irene Handl.

Even the reliable seaside postcard comedies jumped onto the sexploitation wagon when they resorted to *Carry On Emmannuelle* (1978) which was universally slated by the critics who gave it a yellow card. Judging by the reviews, it should have been a red one, but after 14 years in the sin bin it returned for one last outing with its 31st feature *Carry On Columbus* (1992).

The seventies also produced a huge crop of TV spin-off features. But rescue came galloping with King Arthur's knights riding hobby horses when we were blessed with *Monty Python and The Holy Grail* (1975) thanks to Terry Gilliam (co-director), John Cleese, Eric Idle, Graham Chapman, Terry Jones (co-director) and Michael Palin, who made the transition from television's *Monty Python and the Flying Circus* into film and gave us some of the best comedies of that decade. And their 1979 *Monty Python's Life of Brian* has become a comedy classic that can be viewed over and over ('What did the Romans ever do for us?'), with Terry Jones perfect as he delivers the line, 'He's not the Messiah, he's a very naughty boy.'

In 1983 the Python team returned to the sketch format for *The Meaning of Life*, although the sketches were vaguely connected by the film's title. It wasn't as well received as *The Holy Grail* and *Life of Brian* as far as critics were concerned, although many of them loved it. Gene Siskel of the *Chicago Tribune* called it 'fresh and original and delightfully offensive. What more can you ask of comedy?'

I'm sure so many audiences would agree with him. And there were some brilliant highlights in the film, like Mr Creosote offering 'Just one little wafer-thin mint.' And 'Every Sperm Is Sacred,' with Catholics dropping babies everywhere. Outrageous, yes. But gloriously funny.

One of the best coming-of-age comedies was *Gregory's Girl* (1980), written and directed by Bill Forsyth, and this Scottish production brilliantly captured the feeling of what adolescence is like. It starred young actors John Gordon Sinclair and Dee Hepburn, as the teenagers falling in and out of love with angst and confusion in the very modern town of Cumbernauld. There is also a very funny cameo from comedian Chic Murray as the school's headmaster. Forsyth shot the film on a paltry budget of £200,000, but it became hugely popular and took millions at the box office. Which meant that Forsyth's next project got producer David Puttnam on board, and they managed to finance the production by getting Burt Lancaster involved, playing a Texan oil executive in the comedy *Local Hero* (1983), also written and directed by Bill Forsyth about Lancaster's character being tasked with getting an oil refinery built at a beauty spot, and the film was shot mainly at the quaint village of Pennan in North Aberdeenshire.

A hugely enjoyable comedy from 1984 was *A Private Function* directed by Malcolm Mowbray, with a screenplay by him and Alan Bennett. The picture was cast with many great British actors, and Maggie Smith and Denholm Elliott were a delight to watch as awfully snobbish people. The film was about post war food rationing and concerned a stolen pig, wanted for eventual roasting.

Director Charles Crichton directed many successful Ealing comedies, including the great *Lavender Hill Mob*, but his last two films in the late sixties lost money, and from then on he directed mainly for television and also corporate videos. Working as a director for John Cleese's company Video Arts, they both began writing a script in 1983, which became the successful heist comedy *A Fish Called Wanda* (1988), starring John Cleese, Jamie Lee Curtis, Michael Palin and Kevin Kline, who won an Oscar for Best Supporting Actor. Cleese wanted Crichton to direct the film, but as Crichton was in his late seventies, it posed problems with insurance for the film. It was agreed that Cleese would co-direct the film, though he admitted he had no idea how to do this, offering to step in should anything happen to the director. Fortunately, they reached the end unscathed and healthy after a 70 day shoot.

The film was a joint USA and UK production but I decided it should go in the British section as it was an English director from his time directing Ealing comedies who co-wrote the script with John Cleese. And another ex-Python was cast as Ken, played by Michael Palin with a stammer. Apparently Palin's father had a stammer, and a few years after the film was released, a specialist centre and charity for speech and language therapy opened in north London and was called The Michael Palin Centre for Stammering, which unfortunately sounds like the sort of centre you would go to if you wanted to get a stammer!

The *Wanda* film is one of the eighties more hilarious comedies. But be warned: Ole Bentzen, a Danish audiologist, while watching a run of the film, died laughing. John Cleese wanted to use Bentzen's unfortunate demise as publicity, but decided it was too tasteless. Can you imagine what he had in mind? *This film is so funny that a man died laughing!*

The nineties produced many good comedies, like *Four Weddings and a Funeral* (1994), directed by Mike Newell, with a great screenplay by Richard Curtis, starring Hugh Grant as Charles and Andie McDowell as Carrie, with Charles falling for the American who is soon to marry Hamish, played by Corin Redgrave. There are some great cameos in the picture, especially from an inept and bumbling vicar played by Rowan Atkinson officiating at a wedding. A gay couple, Gareth and Matthew, are played by Simon Callow and John Hannah and when Gareth suffers a massive heart attack during Carrie and Hamish's wedding, Matthew is devastated, and at the funeral he reads *Funeral Blues* by W. H. Auden, a truly poignant moment in the picture.

Richard Curtis also wrote *Notting Hill*, with Julia Roberts and Hugh Grant and *Love Actually,* another romantic comedy showing aspects of love, often when love misfires, through a series of ten films.

In 1997 he co-wrote with Robin Driscoll *Bean* which was directed by Mel Smith and starred Rowan Atkinson as Mr Bean. The film was based on the *Mr Bean* TV series written by Atkinson and Curtis. A huge advantage of a feature film like *Bean* meant that the slapstick comedy with almost no dialogue could be enjoyed globally, and was perhaps inspired by the Jacques Tati films.

That same year a great comedy about unemployment in Sheffield, a city that was once the centre of a great steel producing industry, gave us *The Full Monty*, directed by Peter Cattaneo and starring Robert Carlyle and Mark Addy as two blokes desperate to find work, which they eventually do by becoming male strippers rather like The Chippendales. *The Full Monty* of the title refers to the scene at the end of the film when they have to get all their kit off for the raucous female audience.

Possibly the most outrageous comedy of the decade was the 2006 mockumentary *Borat: Cultural Learnings of America for Make Benefit Glorious Nation of Kazakhstan,* directed by Larry Charles, with the fictional journalist from Kazakhstan played by Sacha Baron Cohen. Although there is a plot of sorts, as Borat on learning that his wife is dead, and having seen an episode of *Baywatch* in New York, decides he would like to marry Pamela Anderson (participating and playing herself) and travels across America to the West Coast in a clapped out ice cream van. The many improvised interviews throughout the film as Borat pretends not to understand the real-life Americans he interviews,

teased the interviewees into looking foolish, and these scenes become highly satirical. The film was successful, but many of his interviewees were deeply insulted and many tried to sue the producers of the picture.

Is it possible to get laughs out of suicide bombers? Writer and director Chris Morris managed that with *Four Lions* (2010), when four jihadi men plan suicide bombings at the London marathon. They are so inept and gullible that each incompetent bomber blows himself up, and this film shows that it is far healthier to ridicule and laugh at extremists than to glamorise them.

While Richard Curtis brought us mainly romantic comedies in the 1990s, the noughties gave us a trilogy of parodies. The trilogy was titled *Three Flavours of Cornetto* and the first picture in the trilogy was *Shaun of The Dead* (2004) a zombie comedy, written by Simon Pegg and Edgar Wright, and directed by the latter. It starred Pegg and Nick Frost in the lead roles and it was a United Kingdom, United States and France co-production. Of course, like all zombie movies, the zombies wage war on the general population. Or as a propagandist might call it: a Special Zombie Operation!

Second in the trilogy was the police and murder spoof *Hot Fuzz* (2007), followed by *World's End* (2013) a science fiction parody, in which five friends go on a pub crawl and discover the town is the heart of an alien invasion. Which I can relate to as an allegory for the many pub crawls I took part in.

One of television's greatest comedy characters has to be Alan Partridge, the self-delusional radio broadcaster, superbly played by Steve Coogan. Eventually, the rather ridiculous Partridge made it to the big screen with *Alan Partridge: Alpha Papa* in 2013. It was directed by Declan Lowney and parodied a siege and hostage movie as one of the DJ's, played by Colm Meaney, is sacked from the radio station and seeks revenge.

Do presenters get sacked in real life? They do if they insult a respected actor's daughter. Then they just go over to a rival channel.

France

Jour de Fête (Day of the Fair, but the English title used was *The Big Day)* was writer and director Jacques Tati's first film in 1949, in which he plays Francois, a postman in the small town of Sainte-Sévère, who having seen a film about the efficiency of the American postal service decides to speed things up himself with disastrous consequences. But the film which really brought Tati to the fore was the wonderful 1953 comedy *Les Vacances de Monsieur Hulot (Monsieur Hulot's Holiday),* set in a seaside town on the Atlantic coast, where the accident-

prone Hulot arrives in a clapped out old backfiring car, ruining the peace of the neighbourhood and the other guests at the Hotel de la Plage. This very funny film is full of visual humour and can be enjoyed globally as there is very little dialogue in his films.

And once he had established Hulot as his character he stuck with it for his other films, using his hallmark gangling strut, clutching an umbrella, with a pipe in his mouth. In 1958 he made his first colour film *Mon Oncle* in which his nephew lives in his parents' ultra-modern house where gadgets go wrong, the furniture is uncomfortable and is a nightmare of modern consumerism. Hulot by contrast lives in an old-fashioned house that is comfortable with friendly neighbours.

The film won an Academy Award for Best Foreign Language Film, which is ironic if you consider there is hardly any dialogue in the film. Any dialogue is barely audible, and it is used as background to add atmosphere to scenes. Unusually for a comedy film, it is 120 minutes long.

His other films were *Playtime* (1967) and *Trafic* (*Traffic*) released in 1971. *Playtime* was his most ambitious film, and we see less of Hulot in this film than any of the other films, as his character is swamped by hundreds of characters, but his visual comedy and sound effects have become part of his distinctive trademark. The urban set, showing a highly urbanized and soulless Paris, became known as Tativille, and needed a hundred workers to construct it. Editing the finished film took nine months, and the film's budget had so overrun that Tati had to file for bankruptcy.

The film is highly regarded by film critics, and it is listed as 37th in BFI's Top 100 Greatest Films of All Time and ranked 23rd in the 2022 *Sight and Sound* critics' poll of the greatest films ever made.

Jacques Tati died in 1982, but his Monsieur Hulot character returned for an animated feature based on his own original screenplay *The Illusionist*, (2010) directed by Sylvain Chomet.

One of France's most popular comedy actors was Louis de Funès who made something like 150 feature films including one adapted from Moliere's play *L'Avare (The Miser)* released in 1980.

One of France's biggest box-office hits was *La Cage aux Folles*, (1978) directed by Edouard Molinaro and based on the 1973 stage play by Jean Poiret. Although it was a French language picture, it was a Franco-Italian co-production. It starred Ugo Tognazzi as Renato and Michel Serrault as Albin who are a gay couple who own a drag nightclub in Saint-Tropez, and Renato's son brings his fiancée to meet his father. But she also brings along her ultra-conservative parents.

Many American reviewers criticised it negatively, objecting to the film's portrayal of gay stereotypes, and complained that the plot was predictable. But those reviews didn't hinder the film from becoming the highest-grossing foreign-language film in the United States.

But *La Cage aux Folles* didn't end there as it became a successful stage musical in 1983, using the same French title, with music and lyrics by Jerry Herman. His song 'I Am What I Am' became something of a gay anthem.

There was also an American version of the film which was highly successful. It was called *Birdcage* (1996), adapted by Elaine May and directed by Mike Nichols, and starred Robin Williams, Gene Hackman and Nathan Lane.

In 2001 along came a delightful comedy called *La Fabuleux Destin d'Amélie Poulain (The Fabulous Destiny of Amélie Poulain)* which soon became known by the shorter title of *Amélie*, directed by Jean-Pierre Jeunet with an original screenplay by Jeunet and Guillaume Laurant, starring Audrey Tautou in the title role, with Nino played by Mathieu Kassovitz. Amélie is a young woman who has led a sheltered life until she works as a waitress in a Montmartre café then decides her mission in life is to make others happy. She becomes engrossed in many adventures, even playing practical jokes on unkind people who deserve a lesson in compassion, and sends postcards of her father's garden gnome from famous tourist landmarks across the world. And then there is a mystery of photos from a photo booth when Amélie chases across Paris to solve the mystery. In the end she finds her own true happiness with Nino.

Amélie was nominated for eight Academy Awards and won an Oscar for Best Original Screenplay and won two BAFTAs for Best Film and Best Director.

Italy

Adapted from a novel, *Il Postino (The Postman)* the 1994 film set in 1950, tells the story of Mario, played by Messimo Troisi, as the postman on a small island, where nobody receives any letters until the poet Pablo Neruda (a fictionalised version of the real life Chilean poet), is exiled for political reasons and is Mario's only customer. The postman is in love with Beatrice, much to the disapproval of her aunt, who runs the village café. And when Mario confides to the poet about his love, and how he hasn't made any headway with Beatrice, Neruda, played by French actor Philippe Noiret, teaches him about the metaphorical and poetic language of love, and pretty soon he begins to woo Beatrice, leading to some very funny scenes when her aunt trusts Mario even less when he uses poetic flattery.

The film was directed by Michael Radford, an English director. Sadly, Troisi, who co-wrote the screenplay, suffered a massive heart attack just after the film was completed and never got to see one of his best films and his greatest achievement.

Australia

A comedy about three drag queens, *The Adventures of Priscilla, Queen of The Desert* (1994) starred Terence Stamp, Hugo Weaving and Guy Pearce and was directed by Stephan Elliott. It is very much a road movie as the three drag queens leave Sydney to perform their drag shows in the outback, which is when Bernadette (Stamp) says: 'That's what this country needs, a cock in a frock on a rock!' The film is a hilarious romp with some dazzling costumes and musical numbers, and some very funny one-liners. The film was voted over several years as being one of Australia's five favourite films.

A film about a pig that thinks it's a sheepdog and herds sheep, *Babe* (1995), was sure to be a winner. Based on Dick King-Smith's children's book, with a screenplay by George Miller and directed and co-written by Chris Noonan, *Babe* tells the delightful story as the pig goes from the breeding pen to the barnyard of Farmer Hoggett (James Cromwell) who bonds affectionately with the pig.

The film mixes real livestock with animatronic doubles, and these talking pigs are so cute that if you haven't seen the film, catch up with it soon, and then you may become a vegetarian convert.

Family life in Australia is brilliantly satirised in *Muriel's Wedding* (1994) written and directed by P. J. Hogan, with Toni Colette as Muriel, who dreams of a lavish wedding but lacks so many social graces, and then she meets a potential bridegroom from South Africa, who needs a wedding of convenience to obtain an Australian passport.

Scandinavia

The Devil's Eye (Sweden 1960) is a black comedy by Ingmar Bergman. Because the devil has a stye on his eye, and attributes the cause of this to the daughter of a vicar who is still a virgin at the age of twenty and about to be married, he sends Don Juan from hell to seduce her before her wedding day, but Don Juan falls in love with her.

The film was not based on a true story.

In 1995, two Danish directors, Lars von Trier and Thomas Vinterberg, created a film making movement called Dogme 95, a manifesto created to purify filming along more traditional storytelling, acting and themes without resorting to elaborate special effects, everything shot on location, using props that were available at the location shoot.

The first of the Dogme films was Vinterberg's *Festen* about a family attending the patriarch's sixtieth birthday, and although it was described as a black comedy, and very funny in places, as the film progresses it becomes darker. The second Dogme film was Lars von Trier's *The Idiots* which was highly controversial as it was about a group of people who publicly behave as if they have mental disabilities deliberately to shock people. Film critic Mark Kermode walked out of the Cannes screening after shouting 'Il est merdre!'

Thomas Vinterberg directed and co-wrote with Tobias Lindholm *Another Round* (2020), a co-production between Sweden, The Netherlands and Denmark, starring Mads Mikkelsen, Thomas Bo Larsen and Magnus Milling as three schoolteachers who discuss an influential psychiatrist's theory that humans are born with a blood alcohol deficiency of 0.05%, but should this level be increased by that amount, it would make people more creative and relaxed. They put it to the test and it seems to work. But the experiment goes wrong when the level of alcohol increases and, like *Festen,* this black comedy becomes increasingly darker.

If when you watch this film, might I suggest a glass or two of wine? It might get your creative juices buzzing.

Crime

More than any other genre, this one has genres within a genre and may be in danger of becoming compartmentalised into something which reads like sub sections of a building survey. So I'll try and keep it simple.

Apart from Westerns, crime and gangster movies produced more film clichés than any other genre. The inevitable car chase, for instance: more often than not cars being pursued smash through fruit and veg barrows destroying them or send a wedding party scattering, smashing the wedding cake. And have you noticed how in most British gangster films the villains are either cockney or Glaswegian, never from Wales or the West Country? If gangsters want to meet their rivals, they always meet in a disused warehouse or underground car park and shout at each other from a distance. And psychopathic gangsters like to play music while torturing their victims, while the youngest detective who is about to get married is usually the one who gets gunned down. And detectives can never seem to solve a case until they are suspended by a superior officer, who often turns out to be corrupt. Then there is the hitman who seeks redemption and leaves the business but can always be persuaded to comeback for one more hit. Any female police detective given bad news has to rush to the toilet to vomit. And tough female cops usually have a 99% chance of being murdered in the line of duty and their male partners will solve the crime. And what is the underling's favourite response when given an order by a superior officer? They almost always reply, 'I'm on it.'

But some of those hundreds of film clichés will not be in the classic crime films coming up. But if you happen to spot any, please don't bother to let me know. I've seen enough over the years.

> *If I made Cinderella the audience would immediately*
> *be looking for a body in the coach.*
>
> Alfred Hitchcock

American gangster films in the 1930s owed their existence to the American government's decision to wean the entire population onto soft drinks. The films tended to glamorise violence as the most attractive characters were the smartly dressed, wise-cracking hoodlums who treated their women badly. Humphrey Bogart established himself in this era as a tough guy who had a habit of lisping and tugging his ear lobe. Edward G. Robinson died lamenting his untimely end in *Little Caesar* and James Cagney as a crazed gangster in *White Heat* yelled for his deaf mother, 'Made it, Ma. Top of the World,' before going out in a blaze of glory. In *The Public Enemy*, Cagney the misogynist, treated his moll (Mae Clarke) to half a grapefruit – in the face. Howard Hawks made *Scarface* (1932), a film about opera-loving Italians who also love shooting and killing, starring Paul Muni as the most famous gangster. This was remade in 1983 using the same title by Brian de Palma, with Al Pacino in the lead role, but was updated, and the gangsters are no longer Italian Americans but Cuban immigrants. *The Untouchables* (1987) by Brian de Palma returned to the Prohibition era, but unlike the Paul Muni version, the body count was a great deal higher and Robert de Niro used a baseball bat for an unsporting purpose.

Two small time gangsters became legendary heroes of the Depression era when Arthur Penn directed *Bonnie and Clyde* in the 1960s. From the moment Faye Dunaway fondled Warren Beatty's gun barrel suggestively to the violent slow motion ending when the handsome duo are mown down, the film became an instant hit and resuscitated banjo music.

Marlon Brando, more granddad than gangster, starred in *The Godfather* (1972) with cotton wool in his cheeks and refused to collect an Oscar for political reasons. Directed by Francis Ford Coppola, this epic film from the novel by Mario Puzo, would have been like a public relations exercise for the Mafia, had a horse's head not got in the way. And like comedies that are partial to the use of catchphrases, this gangster film had the recurring 'I'll make them an offer they can't refuse.'

The film begins with Don Vito Corleone (Brando) listening to an Italian American's problems and distributing largesse to the man, followed by his ruthless killing of rival mobsters; his son Michael, played by Al Pacino, when he becomes Don is in a Catholic church renouncing all the devil's works while attending the christening of his child with his wife (Diane Keaton), while his enemies are being swept carelessly into oblivion, could almost be an allegory for every hypocritical dictator, president or monarch that has ever been, and many who still exist.

After Brando dies from a heart attack in the first of *The Godfather* trilogy, and Michael Corleone takes over as Don, the second *Godfather* became both a

prequel and a sequel. The prequel told the story of the early life of Vito Corleone, now played by Robert De Niro as he escapes from Sicily to a life of crime in New York, with no cotton wool in his cheeks!

Organized crime films flourished after the *Godfather* trilogy, and Martin Scorsese directed his gang movies like Jacobean tragedies, full of blood and revenge, where a hapless mobster might painfully kiss the world goodbye just from saying the wrong thing in a bar as in *Goodfellas* (1990). All his films contain gritty dialogue (i.e. gratuitous profanity).

At the end of the *Goodfellas* film, Scorsese uses the same device as Edwin S. Porter did in 1903. Joe Pesci, playing one of the hoodlums who has been shot in the back of the head, is revived for the very last frame to stare at the audience as he raises his gun to shoot at them.

But not all these gangster films were about the Sicilian mafia organizing crime in America. Probably the most epic gangster film was about Jewish mobsters. This was *Once Upon a Time in America* (1984), co-written and directed by Sergio Leone, with music by Ennio Morricone. It starred Robert De Niro, James Woods and Elizabeth McGovern. Filming began in June 1982 and shooting ended in April 1983. This epic was filmed at many different locations in Europe. The Gare du Nord station in Paris doubled for New York's Grand Central; a scene in a lavish New York restaurant was shot at the Hotel Excelsior in Venice, and there were also locations in Canada and France, and the interiors were shot at the Cinecitta Studios in Rome, By the time the film wrapped, Leone had shot ten hours of footage. He edited it down to 3 hours 49 minutes for showing during the Cannes Film Festival, which received a twenty minute standing ovation at the end, and was subsequently shown in European cinemas. Unfortunately, American distributors cut it down drastically and the film flopped in the US.

In *Casablanca* (1942) Claude Rains as the cynical police chief says, 'Round up the usual suspects', which became the title of the 1995 thriller *Usual Suspects* in which Kevin Spacey as Verbal Kint says, 'The greatest trick the devil ever pulled was convincing the world he didn't exist.' Five criminals plan a heist, and they are set up for betrayal and blackmail. This sounds like a movie cliché but there are so many twists and turns in the film that it is like watching a magician's misdirection. It was directed by Bryan Singer with a screenplay by Christopher McQuarrie. Much of the film's mystery is in trying to work out who the evil villain Kyser Soze is, and, like many good mysteries, this revelation is saved for the finale.

Contemporary gangster films have, of course, taken to showing these industrious folk peddling drugs rather than bootleg liquor, a substance which is

no longer financially viable as a motive for crime since many undesirables can drink fairly cheaply in a Wetherspoons pub.

British gangster films were slow in following the American example. For years the British tended to live in the cosier world of Miss Marples and Sherlock Holmes. Then in 1970, along came Michael Caine as a cockney gangster sent up north to upset the natives of Newcastle in the 1971 Mike Hodges thriller *Get Carter*, proving it was too cold and dangerous to go paddling that far north. Bob Hoskins got tangled up with the IRA in *The Long Good Friday* (John Mackenzie 1980) and was driven off to meet Shergar. Twins Martin and Gary Kemp played *The Krays* (1990), showing that even the most ruthless mob can be soft boys deep down when they love their mother. And gangsters showed how funny they can be in *Lock, Stock and Two Smoking Barrels*, directed by Guy Ritchie in 1999, with a similar cliff hanging ending as *The Italian Job*.

<p style="text-align:center">***</p>

Film Noir translates to dark film, and in this genre the films were usually shot in black and white, and were mainly Hollywood movies, but many were directed by European émigrés and showed their German Expressionist influence, with the use of lighting, dark shadows, and sometimes oblique camera angles, also known as Dutch angles. They flourished between the early 1940s and late 1950s, but until the post war period no Hollywood directors knew that what they were shooting was called Film Noir. The phrase came from a French cinema critic after the Second World War and didn't reach common parlance until the sixties.

The plots in these crime films showed the darker side of human nature, when any pre-war optimism seemed to have vanished, leaving a trail of destructive people, hellbent on committing murderous crimes from greed or lust. So many noir films used voice-over narration.

In *Double Indemnity* (1944) director Billy Wilder, used the James M. Cain novel and hired Raymond Chandler to collaborate on the screenplay, but the two men did not get on, although the end result was excellent and both received an Oscar nomination for the screenplay.

In the film, Phyllis (Barbara Stanwyck), as the typical femme fatale, becomes involved with insurance salesman Walter Neff (Fred MacMurray), and they hatch a plot to kill her husband, making it look like an accident because the life insurance will pay double on the policy. But Neff's astute boss, Barton Keyes (Edward G. Robinson) becomes suspicious. There is a great suspenseful scene when Keyes has called on Neff when Phyllis is at his apartment and she has to hide behind the door until he leaves. Most doors open inwards into a room, but Wilder used poetic license and opened it outwards so that she could be concealed

behind it. He also shot it using deep staging so that everything is sharply in focus, from Stanwyck in the foreground, to MacMurray and Robinson further along the hallway, right up to the back wall which is probably about fifteen feet away.

The first cinematographer to use deep staging, more commonly known as deep focus, was Gregg Toland for Orson Welles's (*Citizen Kane*, 1933). Many film makers in the 1930s used deep focus, directors such as Jean Renoir (*The Rules of the Game*, 1939), and many modern directors like Brian de Palma, Steven Spielberg and Quentin Tarantino have made effective use of deep focus.

Director John Huston made his directorial debut with *The Maltese Falcon* (1941) from the novel by Dashiell Hammett, featuring the world weary and cynical gumshoe Sam Spade, played by Humphrey Bogart, with Mary Astor as the femme fatale, and an assortment of greedy, double-crossing villains from the bulky Sidney Greenstreet as Kasper Gutman (appropriately named), Elisha Cook Jr as the rather nervy, psychotic sidekick, Wilmer Cook, and Peter Lorre as the rapacious Cairo, all chasing the statue of the eponymous bird which they believe contains valuable jewels. The film is filled with hard-boiled, tough-guy dialogue, giving Sam Spade an opportunity for repartee.

> **Wilmer Cook:** Keep on riding me. They're gonna be picking iron out of your liver.
> **Sam Spade:** The cheaper the crook, the gaudier the patter, eh?

The femme fatale in a noir film was usually an attractive and sexy woman who was strong and manipulative and knew how to prey erotically on weaker men. But this was not the case with one of the most popular noir films *The Big Sleep* (1946) directed by Howard Hawks, with a screenplay by William Faulkner from the novel by Raymond Chandler. Humphrey Bogart played the incorruptible private eye Philip Marlowe, whose creator (Chandler) said he wanted a hero who 'Down these mean streets a man must go who is not himself mean, who is neither tarnished nor afraid.'

But inevitably the other characters in *The Big Sleep* are a bunch of sleazy scumbags who use blackmail and resort to murder, and there is a complicated mystery our hero must solve. It is such a complex plot that not only is it difficult for Marlowe to untangle, it also leaves the cinema audience in a state of bewilderment. Not that it matters. The dialogue and intrigue is riveting and Bogart, with Lauren Bacall as his love interest, get away with some suggestive innuendo, despite the era's production code when it was forbidden to speak dialogue that was in any way risqué.

Raymond Chandler's only original screenplay, not adapted from one of his novels, was *The Blue Dahlia* (1946), directed by George Marshall, and starring

one of Paramount's most popular stars, Alan Ladd, with Veronica Lake and William Bendix. And as this is a noir film, if a tough guy is offered a drink, naturally he asks for 'Bourbon straight, with a bourbon chaser.'

Chandler had difficulty with the script, and shooting began before he completed it, and he had to get drunk in order to finish it. There was a great deal of tension between him and Veronica Lake and he took to calling her 'Moronica Lake' behind her back.

Many of the Hollywood noir films were strongly influenced by the German Expressionists, especially as directors like Fritz Lang and Robert Siodmak went to America to escape Nazism, and brought with them their experience in creating shadowy films, filled with psychological angst and claustrophobia. In fact, Fritz Lang had already made in Germany a film that would eventually come to be described as noir. This was the 1931 *M*, which is 'M' for Murderer. Peter Lorre, who would soon become the archetypal noir villain, played a child serial killer, whom the society of criminals want to catch. And when someone recognises the murderer, they write a large 'M' on his back and he is put on trial by a kangaroo court of criminals. Pleading for his life, Lorre has a monologue which attempts to invoke sympathy from the cinema audience, as he describes his crimes as an evil compulsion which he cannot help. Hmm. Difficult one to accept that. And certainly not a barrel of laughs.

Film noir came to Britain with Graham Greene's *The Third Man* (1949), directed by Carol Reed, who used many tilted camera angles to unsettle the viewer. The film was shot entirely on location, set in a post-war Vienna with location images of dark shadowy buildings, deep and threatening alleyways – it's a far cry from the opulent city of Strauss waltzes. The music, in fact, is the haunting zither theme by Anton Karas, which became a chart hit on both sides of the Atlantic.

Vienna is run by military groups of four nationalities, Russian, French, British and American. The film begins with the death of Harry Lime, and his old friend Holly Martins, played by Joseph Cotton, is a pulp writer who arrives in the city to discover the death of his old friend. But is Harry Lime really dead? Martins starts to investigate after he meets Anna, Harry's girlfriend, played by Alida Valli. One night, on seeing a kitten in a shadowy doorway, Martins spots the figure of Lime, played by Orson Welles, who runs off and vanishes into the night. Major Calloway (Trevor Howard), reveals to Martins that Lime is a black marketeer trading in watered down penicillin which kills many children, but all this sociopath cares about is in making money. When Lime eventually meets his old friend Martins on that giant Ferris wheel, and looking down at the people below, he compares them to dots and says it would be insignificant

if one of them 'stopped moving forever'. Then on the ground, Welles makes the speech which he wrote for himself, 'You know what the fellow said – in Italy, for 30 years under the Borgias, they had warfare, terror, murder, and blood-shed; but they produced Michelangelo, Leonardo da Vinci, and the Renaissance. In Switzerland, they had brotherly love; they had 500 years of democracy and peace – and what did that produce? The cuckoo clock!'

Lime is nothing more than a very charming rat, one who will have to escape into the sewers towards the end of the film..

The title of the film refers to a third person involved with the faking of Lime's death by a fatal accident. Incidentally, a bit of trivia for you. Carol Reed's first assistant Guy Hamilton went on to become a successful director and directed four Bond films, kicking off with *Goldfinger*.

The BFI lists *The Third Man* as the Best British film ever made. Praise indeed.

More British noir came from another Graham Greene novel *Brighton Rock* (1948), directed by John Boulting and produced by his brother Roy, with a screenplay by Greene and Terence Rattigan. The young thug, Pinkie Brown, was played by Richard Attenborough who pretends he loves the young waitress Rose because she has witnessed something that could incriminate him. She falls in love with him. And towards the finale he makes a recording in a gimmicky little recording booth and gives it to her. On the recording he tells her that she always thought I love you,' and then he gives her the horrific truth that he has always hated her. She plays the record after he dies but it is damaged, and after Pinkie's voice says,

'I love you,' the needle gets stuck as it keeps repeating the phrase, thus deluding her into thinking that he really loved her. This ending was different from the novel in which Rose is in for an agonizing shock when she will hear that Pinkie hated her. Greene was against the film's ending, as the true horror of Pinkie's evil deed could not save him, even beyond his death.

Mods and Rockers make an appearance in a 2010 colour remake of the Brighton film set in the 1960s.

Another classic Billy Wilder film is *Sunset Boulevard* (1950) which he directed and co-wrote with Charles Brackett and D. M. Marshman Jr. Although it could be classed as a black comedy, it is still very much in the noir style, and even begins with William Holden as struggling writer Joe Gillis giving a voice-over narration of how he has ended up dead in a swimming pool, and then the rest is told in flashback as he meets the ageing silent film star Norma Desmond, played by Gloria Swanson, who refuses to accept that there are no longer any starring roles in the offing, and all her fan letters are written by Max (Erich von Stroheim) her butler, who was once a famous film director and her husband.

Cecil B. DeMille plays himself in the film, as does Buster Keaton in a cameo as a card player. After Gillis tells the truth about Norma, that she is all washed up, she shoots him in the back and he ends up in the pool. The flashback ends with the tragedy, and as police and reporters wait to take Norma Desmond away for the murder, she thinks they are there to publicize her latest film project, and as she walks regally down the stairs of her mansion, she says, 'I'm ready for my close-up, Mr DeMille.'

Gloria Swanson's performance is brilliant. Earlier on in the picture, we see the self-delusion bordering on madness when Gillis recognises her, saying that she used to be in silent movies and she used to be big. To which she replies haughtily, 'I am big, it's the pictures that got small.'

There have been so many great films noirs from around 1941 until the end of the 1950s, including Hitchcock's *Shadow of a Doubt* (1943), or Jacques Tourneur's *Out of The Past* (1947) starring Robert Mitchum, Jane Greer and Kirk Douglas, and the 1946 *The Postman Always Rings Twice* from a novel by James M. Cain, starring Lana Turner and John Garfield.

And Orson Welles embraced noir with his 1948 *The Lady from Shanghai*, with an intricate and slightly confusing plot, but with a brilliant showdown as this shattering finale has a shoot-out in a hall of mirrors. And I suppose Welles gets the last word in film noir with his 1958 *Touch of Evil* with its famous three minute tracking shot in which the camera crane sweeps through the Mexican town with myriad occurrences happening as Charlton Heston walks towards the border.

True Crime

In the 1950s a young man by the name of Charles Starkweather and his fifteen-year-old girlfriend Caril Fugate went on a rampage and a killing spree, mindlessly murdering people during their brief odyssey prior to their capture. Starkweather was executed in the electric chair and Fugate received a hefty prison sentence. These crimes inspired the excellent, though fictionalized, *Badlands* (1973), written and directed by Terence Malick, starring Martin Sheen as Kit and Sissy Spacek as Holly, the runaway killers, although it is Kit who does all the killing having first murdered Holly's father (Warren Oates). Kit sees himself as James Dean, and his psychopathic crimes are almost part of a fairytale, and he kills as if he is a wizard in a children's game. As the couple escape across the Badlands of Montana and build a treehouse, their odyssey has become an unreal story of two kids on the run. If this film was a commercial about why American

gun laws need changing, this is perfect. It is beautifully written, charmingly photographed in colour, and with two great performances from the leads. We actually like these killers, and it turns that old excuse on its head: It's not people who kill people, it's guns who kill people!

A biographical drama about a street prostitute turned serial killer is called *Monster* (2003), written and directed by Patty Jenkins. This is the true story of Aileen Wuomos who murdered seven of her clients. She was executed by lethal injection in the state of Florida in 2002. Wuomos is played by Charlize Theron, and her lover Selby Wall is played by Christina Ricci, a character based on Wuomos' s real-life lover. Wuomos was raped and badly beaten by a client whom she kills in self-defence, after which she attempts to give up prostitution. But because of her lack of education, she finds it impossible to get a job and returns to prostitution, but now she kills and robs her clients. To play this difficult role, Theron added 30 pounds to her weight, shaved her eyebrows and wore prosthetic teeth.. Film critic Roger Ebert said that her role was 'one of the greatest in the history of cinema.'

Two schoolgirls living in New Zealand committed a murder in 1952. This was made into the feature film *Heavenly Creatures* (1994), directed by Peter Jackson and co-written by Frances Walsh and Jackson. Pauline Parker and Juliet Hulme conspired to kill Pauline's mother because they didn't want to be separated from one another. Kate Winslet played Hulme in the role that launched her career. Hulme was from Britain and was the more charismatic of the two girls. Pauline (Melanie Lynskey) by contrast was shy and frumpish, yet these two bookish young women bonded and their relationship became intense as they retreated into an almost fictional life, and the murder of Pauline's mother became a *folie a deux*. What is so good about this film is Peter Jackson's casting of the two actresses who are perfect for their roles, and one can actually believe in their intense bonding, which sometimes has moments of humour which Jackson has very cleverly inserted into the script and direction.

When the film was released, the newspapers 'outed' the two women, discovering that after serving five years in prison, they were both released. Hulme moved to England, changed her name to Anne Perry and became a best-selling author of many novels (murder mysteries of course). Pauline Parker after her release took a degree, became a librarian, then moved to England where she ran a riding school. But when the press found her during the film's release, she refused to talk to the media, and went to live on a remote Orkney island and became a devout Catholic.

Had Peter Jackson known of their whereabouts he could have employed them as technical advisors for his film. On the other hand, a lousy idea maybe.

Thrillers and Mysteries

Who is the most filmed fictional detective ever? Arthur Conan Doyle's Sherlock Holmes of course. From 1939 (and there were some earlier Holmes films) there was a series of fourteen Holmes' mysteries starring British actors Basil Rathbone as Holmes, with his sidekick Dr Watson played by Nigel Bruce. The first two films were produced by 20th Century Fox, then they stopped making them and Universal Pictures acquired the rights from the Doyle estate. Unfortunately, these had lower budgets, became B-movies, and were updated from the Victorian era to World War II with Holmes up against the Nazis. They retained the same leading cast, including Mary Gordon as Mrs Hudson. Going from a main feature to a supporting B-movie must have been disheartening for the actors, and it probably became a four pipe problem for Basil Rathbone.

The Hound of the Baskervilles, borders on Gothic horror, especially when it was made by Hammer Horror in 1959, with Peter Cushing as one of the most realistic and interesting screen Holmes, and Watson played by Andre Morrell, with Christopher Lee as Sir Henry Baskerville. The film was made in colour and directed by Terence Fisher, and there is a great eccentric performance from the character actor Miles Mallison as Bishop Frankland. Many changes were made in the film which differed from the novel, to which the Doyle estate took exception. But *Time Out* called this particular Holmes film 'the best Sherlock Holmes film ever made and one of Hammer's finest movies.'

In 2009, Guy Ritchie directed *Sherlock Holmes* starring Robert Downey Jr as Holmes with Jude Law as Dr Watson, and a sequel *Sherlock Holmes: A Game of Shadows* (2011), also directed by Guy Ritchie. These two excellent fast-paced mysteries added to this long-running canon. And I have a sneaking feeling that we haven't seen the last of this super sleuth yet.

Many thrillers in the 1950s were made by Alfred Hitchcock and he used his signature cameo appearance in all of them. In 1951 he directed *Strangers On a Train* from a Patricia Highsmith novel, starring Farley Granger, Ruth Roman and Robert Walker, and eleven minutes into the film Hitchcock put in an appearance as a man boarding a train carrying a double bass.

Apart from *Strangers on a Train*, which was shot in black and white, the rest of Hitchcock's output in the fifties was shot in colour. Two of his films were released in 1954: *Dial M for Murder* and *Rear Window*. The former was based on the stage play of the same name by Frederick Nott, and starred Ray Milland, Grace Kelly and Robert Cummings. Thirteen minutes into the film Hitchcock can be seen in a black and white photograph sitting at a banquet table. In the latter, starring James Stewart with a leg injury, confined to his Greenwich

Village apartment, he sees from his window what he thinks is a murder. The film also starred Grace Kelly, Thelma Ritter and Raymond Burr, and Hitchcock can be seen when he appears at a songwriter's apartment winding a clock.

The Man Who Knew Too Much (1956) starred James Stewart, Doris Day, Bernard Miles and Brenda de Banzie, was set in Morocco and London, and featured Doris Day's popular song 'Que Sera, Sera' that was instrumental as part of the plot as a warning about an attempted assassination at the Royal Albert Hall. Hitchcock makes his appearance at 23 minutes into the film and can be seen at the lower left corner of the screen watching acrobats in a Moroccan market. Bernard Hermann wrote the film score, as he did for many of Hitchcock's films and, just like the director, he made his one and only brief appearance as the orchestra conductor at the Royal Albert Hall. He also wrote the score for Hitchcock's next film *Vertigo* (1958), which starred James Stewart, as a detective with a fear of heights, and Kim Novak, a blonde who is killed in a fall from a bell tower and then from the protagonist's point of view is reincarnated as a brunette shopgirl. Hitchcock's signature appearance has him walking in a street carrying a trumpet case.

Possibly one of Hitchcock's most entertaining films has to be *North by Northwest* (1959), with a screenplay by Ernest Lehman and starring Cary Grant, Eva Marie Saint, James Mason and Martin Landau. Mistaken for a spy, and suspected of murder, Grant's character has to go on the run. There are some brilliant set pieces in this film, as and when Grant gets off a bus in the middle of nowhere and a crop dusting plane is out to kill him. And near the finale on Mount Rushmore in South Dakota, there is the inevitable chase, clambering over the sixty foot high sculptures of the US presidents carved into the granite. And when in the final scene in the film, what might be the otherwise corny kiss and fade out, as Grant kisses Saint in a railway compartment, the next and final shot is of the train going into a tunnel.

The director's cameo appearance is early on in the film when he has bus doors slammed in his face which coincides with his screen credit.

Hitchcock was a master of suspense. He was quoted as saying, 'There is no terror in a bang, only the anticipation of it.' And I once heard a story about him when he was shooting a scene and the actor fluffed several takes. Hitchcock sighed and said, 'I wound it up, I put it down, and it wouldn't go!'

He was also the first to use the word McGuffin to describe a device or object in a film or book which serves as a trigger for the plot.

True Cary Grant story. In the days when we had telegrams, senders were charged by the word, and so they tried to keep them as brief as possible. Grant's agent got a telegram from a journalist reading 'How Old Cary Grant'. The actor

told his agent that he would reply to that one, and his reply said 'Old Cary Grant Fine. How You'.

A creepy French thriller. *Les Diaboliques* (1954) has had audiences on the edge of their seats, and I know it would freak me out if I saw it again. Directed by Henri-George Clouzot, this tale set in a provincial public school where the headmaster's wife and her lover murder him and dump him in a weeded-over swimming pool, and it becomes a nightmare when the pool is drained and there is no body. A schoolboy swears he has seen a ghost and then something terrible rises from a bath. This is one of the most chilling thrillers ever made.

I bet the director was relieved on discovering the name of the clumsy French detective was at least spelt differently.

One of the best French crime thrillers was *Rififi* (1955) a heist film with a wordless 30 minute sequence when crooks attempt a daring safecracking burglary which is hugely suspenseful. The film was directed by Jules Dassin.

'You're only supposed to blow the bloody doors off!' This was Michael Caine's iconic and often imitated line in *The Italian Job* (1969) when he and his team of thieves were practising a heist to grab gold bullion from a security van in Turin. Directed by Peter Collinson and written by Troy Kennedy Martin, the comedy crime caper was quintessential Swinging Sixties, and had the biggest product placement ever seen on the big screen, as the heist in Italy would be using mainly Minis and Mini Coopers. Charlie Croker (Caine) is in charge of the team, but the heist needs financing, which is where the incarcerated Mr Bridger (Noel Coward) comes into it, and the technical expert for the team is Professor Peach (Benny Hill). The great soundtrack for the film is provided by Quincy Jones, and the opening titles song is 'On Days Like These' with lyrics by Don Black and sung by Matt Monro. There is a great car chase after the heist, with Minis disappearing into stores, going down one way streets and up unfinished roads, making patterns in red, white and blue, which is tongue-in-cheek patriotism as Mr Bridger struts through the prison clapping his hands as if England have just won a major football tournament, and all the criminals in all the cells join in as if they too have been converted by the robbery into real patriots. The team of thieves load the gold bullion onto a coach, and are happily singing, 'We Are the Self Preservation Society', when the coach going around a narrow bend in the mountains veers off the cliff edge, and is left balanced precariously in a highly unstable position because the weight of the gold is in the front of the coach, with the rest of the team at the rear. There seems to be no way out of this predicament until Charlie Croker declares, 'Hang on a minute, lads, I've got a great idea!' We never find out what that is, and we are left with a literal cliff-hanging ending.

One of the most successful heist film franchises was the Las Vegas casino robberies in *Ocean's Eleven* which goes back to the original starring Frank Sinatra and the Rat Pack in 1960. The remake of the same title was in 2001, and then *Ocean's Twelve* (2004) and *Ocean's Thirteen* (2007). There was another spin-off: *Ocean's 8* (2018) with an all-female cast. *The Thomas Crown Affair* in 1968 and the remake in 1999 was about an art heist.

Following two Hitchcock thrillers in the sixties, Tippi Hedren in *The Birds* (1963) who also appeared in the 1964 *Marnie* with Sean Connery, along came a very stylish thriller based on a Donald E. Westlake novel, *Point Blank* (1967) directed by John Boorman, starring Lee Marvin and Angie Dickenson. Left for dead, Marvin recovers and it becomes a quest for his stolen money from his double-crossing accomplice. There is great atmosphere in the chosen locations, and the muted colour of the costumes match the mood of the scenes, and there is an appearance of a hit-man, getting ready to kill someone from a distance with a rifle, but first this rather avuncular chap takes out a pipe and lights up.

Stylish, or what?

'They call me *Mister* Tibbs.' Remember that riposte from Sidney Poitier to Rod Steiger when he is called 'boy'? It was of course from the 1967 thriller *In The Heat of The Night* directed by Norman Jewison with a screenplay by Stirling Silliphant from a novel by John Ball. This is a thriller that deals with Deep South racism as Vigil Tibbs (Poitier) passing through a small Mississippi town is arrested simply because he is black. There has been a murder in the town, and much to the displeasure of the gum-chewing police chief (Steiger), Tibbs turns out to be a Philadelphia homicide detective and they are forced to work together.

The film had a great atmospheric score by Quincy Jones and Poitier played Tibbs in two more sequels.

Then in the early seventies along came the ruthless detective *Dirty Harry* (1971) directed by Don Siegel for Malpaso, the production company Eastwood had set-up. Eastwood was not the first choice for Harry Callahan, many actors turned down the role because it was too violent. Steve McQueen claimed he didn't want to do another cop movie after *Bullitt* and Paul Newman said it was too right-wing for him to consider a character like that. And so the role went to Clint Eastwood, who immediately made the character his own. Especially when he aims his powerful Magnum at a bank robber who in all the excitement may not have counted all the bullets Callahan has fired, and the detective dares him to take a punt, saying, 'Ask yourself, do I feel lucky? Well, do you, punk?'

Violent as the Dirty Harry films were, we all enjoyed them when we embraced our inner fascist!

Released the same year, *Play Misty For Me* was Eastwood's directorial debut when he played a radio station disc jockey who is stalked by a female fan who has requested the 'Misty' number on his show, and then pursues him, becoming increasingly possessive, resulting in extreme violence.

Two years later the second 'Dirty' Harry film *Magnum Force* was released, directed by Ted Post, followed by *The Enforcer* in 1976, directed by James Fargo, and *Sudden Impact* (1983), which was produced and directed by Eastwood, and co-starred Sondra Locke. This is the film with the line that everyone remembers as yet another villain stares down the barrel of Callahan's gun, who says, 'Go ahead, make my day.'

The final 'Dirty' Harry film *The Dead Pool* came after a gap of five years. Located again in San Francisco, the car chases bounce over the city's hills, much as they did in *Bullitt*. And Callahan, true to form, has another catchphrase: 'Opinions are like arseholes; everybody has one.'

One of the best filmed car chases took place in the streets of New York in a car driven by Gene Hackman as Detective 'Popeye' Doyle, not chasing another car but a criminal French drug dealer who is travelling on the elevated railway. It is of course *The French Connection* (1971) directed by William Friedkin, and the drug baron from Marseilles was played by Spanish actor Fernando Rey, who manages to evade capture by Doyle and his partner, played by Roy Scheider. Despite its bleak ending, the film received four Oscars, including Best Picture.

Much of the sequel is set in Marseille where Doyle has pursued his quarry in the equally exciting *French Connection II* and there is a long and harrowing scene where Doyle has been captured and injected full of heroin.

In the first of these two thrillers, the car chase beneath the elevated railway is almost a memorial to a part of New York's history; the 'El' as it was known has now been dismantled. It also reminded me of Alfred Hitchcock's *Frenzy* (1972), shot in and around Covent Garden, and we can see how the district was back then, when it was largely a fruit and vegetable market.

At the start of the seventies the movie industry capitalized on making films for a specifically black audience which became known at the time as 'blaxploitation'. First of these was *Shaft* (1971) directed by African American filmmaker Gordon Parks, which starred Richard Roundtree as the hardboiled Harlem private-eye. The film has a convoluted plot and much action, and became hugely popular with both white and black audiences. And the film's score and 'Shaft' theme by Isaac Hayes became almost as popular as the film.

The 1970s produced many good thrillers, including the slightly less violent Agatha Christie whodunnit *Murder on The Orient Express* (1974), directed by Sidney Lumet, and starring Albert Finney as the Belgian detective.

But one of the most intelligent crime films, probably a neo-noir, was *Chinatown* (1974), directed by Roman Polanski, and written by Robert Towne. It starred Jack Nicholson as Jake Gittis, a wise-cracking private eye and ex-cop who belongs in Chandler and Hammett's mean streets of Los Angeles, and the femme fatale of the picture, Evelyn (Faye Dunaway), is the high class daughter of ruthless tycoon Noah Cross (John Huston) who takes corruption to another level. One of the most original ingredients of this movie is in having Polanski playing an undersized thug and slicing Jake's nose with a knife. Nicholson then plays much of his screentime with a nose covered in plaster, which is seriously funny and unusual.

But the most disturbing element in the film is when Jake confronts Evelyn about Katherine (Belinda Palmer), and she finally confesses, 'She's my sister *and* my daughter. My father and I…understand? Or is that too tough for you?'

Not the sort of storyline you would get in *Emmerdale*.

The only Oscar for *Chinatown* went to Robert Towne for the screenplay, because most of the Academy Awards for that year went to *The Godfather II*.

1986 brought us two film titles from well-known songs. *Blue Velvet* directed by David Lynch and the British film *Mona Lisa* directed by Neil Jordan, and co-written by him and David Leland. In the former film, possibly the only non-controversial offering was the title song by Roy Orbison. Most of the film, set in a cute, innocent-looking town, has a medley of crazed violence, kidnapping, psychotic behaviour, rape, and even a severed ear found in a field. This crime film is light years away from a Miss Marples mystery. In the opening titles to *Mona Lisa* we hear that wonderful song by Nat King Cole, a far cry from some of the characters like Bob Hoskins' small time crook, released from prison and given the job of driving a prostitute (Cathy Tyson) around to visit her clients for the superficially charming villain played by Michael Caine, a character who if you shook his hand you would count your fingers afterwards.

Sometimes the beauty of watching films is in spotting the set-up and seeing how it will later be used as a plot device. In *Die Hard* (1988) for instance, when Bruce Willis as John McClane takes his shoes and socks off to rest his weary feet, you can guess there will be a plot reason for this, especially when attending a Christmas staff party in the high rise office block where the staff has been overrun by a group of terrorists, their leader being Hans Gruber (Alan Rickman), and McClane has to creep around and fight a one man battle against these creeps.

So, dear reader, if ever you want to stealthily stalk terrorists in a building, make certain you take your shoes and socks off first, then they won't hear you coming for them.

And in *Collateral* (2004) a taxi driver played by Jamie Foxx picks up a fare, and we can see that they are attracted to each other. His second fare is the villain of the piece, Tom Cruise cast against type. He is a hitman who involves the cab driver in his murderous trade. Possibly three quarters of the way through the film, now that the audience may have forgotten his attractive first fare, Foxx discovers she is next on Cruise's hit list and so the humble taxi driver is metamorphosed into hero, and we realise his first fare was a set-up.

In 1991 along comes Hannibal Lecter, who is both serial killer and cannibal in *The Silence of The Lambs*. Directed by Jonathan Demme, with Anthony Hopkins chilling as Lecter, and Jodie Foster as an FBI recruit sent to interview him in his prison cage, the film won five major Academy Awards and was described as the first time a horror film won Best Picture. The picture was horrific, yes, but I wouldn't have placed it in the conventional horror genre.

On the other hand, when Lecter says, 'A census taker once tried to test me. I ate his liver with some fava beans and a nice Chianti', that is quite horrific. Especially if you don't like fava beans.

There now came a glut of serial killer movies over the next few decades. A sign of the times or Hollywood bandwagon jumping? There was one excellent serial killer film, *Se7en* (1995) directed by David Fincher with a screenplay by Andrew Kevin Walker. It is very much a police procedural as two detectives, played by Brad Pitt and Morgan Freeman, attempt to solve murders based on the seven deadly sins.

Worst of these serial killer films, depending on audiences' attitudes and opinions was *Saw*, which may have started its own genre. Torture Porn.

Some of the best Patricia Highsmith novels have been adapted into films, and there are at least five films featuring her amoral character, the murdering con artist Tom Ripley. The first was the French film *Purple Noon* (1960), starring Alain Delon as Ripley. Although Highsmith said she liked the film and Delon's performance, she was dissatisfied with the ending which looked as if the police were about to catch Ripley. And what is so unusual and different about Ripley is that he never gets caught and gets away with murder. Literally.

Critics and audiences are usually divided over which is the best Ripley film. Many critics go for *The American Friend* (1977), directed by Wim Wenders, which is based on *Ripley's Game* starring Dennis Hopper as the anti-hero, with Bruno Ganz as the terminally ill picture framer whom Ripley hires to murder a gangster. Then, twenty-two years later, the first of Highsmith's Ripley novels stars Matt Damon in *The Talented Mr Ripley* (1999), followed by *Ripley's Game* (2002), with John Malkovich as the very disturbing and believable connoisseur and sociopath. Finally in 2005, along came *Ripley Under Ground* starring Barry

Pepper, and this one seems to have vanished. Perhaps we haven't had the perfect Ripley film yet, although a television series will soon be transmitted with Ripley played by Andrew Scott.

Some of the best thrillers from the 1990s onwards usually came from the brothers Ethan and Joel Coen, although their first thriller was the neo-noir *Blood Simple* in 1984, about a bartender who has an affair with his boss's wife who involves him in murder. Then they gave us a very different crime caper in 1987. *Raising Arizona* was a fast-paced crime comedy about a crook (Nicholas Cage) who marries a cop (Holly Hunter), and because he is infertile they steal a baby. But I wouldn't mind betting that their most talked about film was the 1996 thriller *Fargo*. A black comedy that starts with William H. Macy as a car dealer in a firm owned by his father-in-law (Harve Presnell) hiring two criminals to kidnap his wife, hold her to ransom, and when his father-in-law pays the ransom, he will get a large share of the money. But as these two jailbirds, played by Steve Buscemi and Peter Stormare, are not only vicious but extremely stupid, and they soon commit a triple homicide. Which is when heavily pregnant police chief Marge Gunderson (Frances McDormand) begins to trail the murderers across the snowy landscape of North Dakota. There is a very funny scene where she interviews a prostitute who may have had one of the killers as a client and simply says, 'He was kinda funny lookin.'

Marge asks, 'In what way?'

The woman replies, 'I dunno, just funny lookin.'

Marge probes further. 'Can you be more specific?'

'I couldn't really say,' replies the prostitute. 'He wasn't circumcised.'

'Was he funny lookin' apart from that?' asks the police chief.

The vicious crooks fall out, and one of them dismembers his partner and shreds him in a wood chipper. The police chief manages to arrest the one who has murdered his partner, and as she drives with him locked up in the back of the police car, she says, 'And I guess that was your accomplice in the wood chipper.'

The film is not only violently shocking but occasionally laugh-out-loud funny, with some great dialogue. A classic of the genre.

This decade also gave us Quentin Tarantino's *Reservoir Dogs* (1992), where the criminals use colours as their names, as in Mr Pink, so that if any of them are caught after a diamond heist, they won't be able to rat on their accomplices. Anyone having watched this film, and playing the Steeler's Wheel song 'Stuck in The Middle With You', will have fond memories of the bloodthirsty scene where Mr Blonde (Michael Madsen) cuts off Marvin Nash's ear.

Mr Blonde, who is the psychopath of the bunch says, 'All you can do is pray for a quick death, which you ain't gonna get.'

Two years later Tarantino's *Pulp Fiction* opened, blackly comic with violently crude interlinked stories, cleverly held together with great dialogue and moments of suspense, as for instance John Travolta and Samuel L. Jackson innocently discuss beefburgers and wonder what a McDonald's quarter pounder is called in French, while we wait with baited-breath for the inevitable crunch time.

One of the most awarded films in 2002 came from Hong Kong. *Infernal Affairs,* directed by Wai Keung Lau and Mu Fai Mak and starring Andy Lau and Tony Leung as two undercover 'moles', one working for Triad and one for the police. Two sequels followed in 2003, and the film was also remade by Martin Scorsese as *The Departed* (2006) set in Boston with Matt Damon working undercover for the mob and Leonardo DiCaprio for the police. The characters were mainly Irish Americans, a departure from the director's usual Italian American mobsters in *Mean Streets* (1973) and *Goodfellas,*

The twenty-first century showed that director Clint Eastwood was so much more than just an expert film director when he made *Mystic River* (2003), set in Boston from a book by Dennis Lehane. The film starred Sean Penn, Tim Robbins, Kevin Bacon, Laurence Fishburne and Laura Linney. The music was also by Clint Eastwood. Now that looks like showing off!

Another crime film set in Boston, and also from a Dennis Lehane novel, was *Gone Baby Gone* (2007) starring Casey Affleck and Michelle Monaghan as two private eyes on the trail of an abducted young girl. It was a directorial debut for the leading man's brother Ben Affleck.

In 2005 *Tsotsi* a South African and UK co-production told the grim story of the eponymous teenage thug (Presley Chweneyagae), who having mugged and stabbed dead a man, subsequently steals a wealthy woman's car and discovers her baby is in the back. Now he begins to change as he is forced to look after the child. The film is very realistic, set in the slums and squalor of Johannesburg using many non-professional actors and becomes more positive as Tsotsi is forced to look at his life through the eyes of the infant.

One of the greatest Coen Brothers film was based on a Cormac McCarthy novel. *No Country For Old Men* (2007), with an adapted screenplay by the brothers, is a fascinating film, one minute elegiac and thoughtful with stunning scenery; then at the drop of a hat sudden violence hits the screen. Set in 1980, a Vietnam vet, Moss (Josh Brolin), stumbles on a heroin stash, and Sheriff Bell (Tommy Lee Jones) is soon on his trail. But there are several pursuers, including Chigurh, a psycho, played with a nightmare-giving performance by Javier Bardem, who at one stage goes into a service station and flips a coin, asking the proprietor to call. The man wonders what they are betting on. But when he wins the toss, he little realises that he was gambling on his life. This is very

reminiscent of the controversial *Dice Man* novel by Luke Rhinehart, where the protagonist uses the roll of dice for all his decisions good or bad.

Moss is married to Carla Jean (Kelly Macdonald), and when he ends up dead and Chigurh visits, giving her the choice of life or death from the toss of a coin, she refuses to play, telling him that he can't pass the blame onto luck.

The film is a great study in good and evil, and McCarthy's title came from the W. B. Yeats poem 'Sailing to Byzantium'. Perhaps that was to boast that the story was not mere pulp fiction but a literary piece of work.

If you don't mind sub-titles, probably the most stunning trilogy of crime films came from Scandinavia. Based on Stieg Larsson's *Millennium* novels the trilogy of films were Swedish and Danish co-productions and kicked off with *The Girl With a Dragon Tattoo* (2009), starring Michael Nyqvist as the *Millennium* magazine editor and Noomi Rapace played Lisbeth Salander as the tattooed and pierced, goth-like computer hacker, who had led a terrible life of abuse when she was young, but now she is fighting back and becomes a highly original heroine that we were all rooting for. *The Girl Who Played With Fire* and *The Girl Who Kicked a Hornets' Nest* were both released that same year.

An English language version was made of the first in the trilogy and it was released in 2011, directed by David Fincher. It starred Daniel Craig as the co-owner of the magazine with Rooney Mara as Lisbeth Salander. They didn't get around to making English language versions of the other two in the trilogy. But there was a Lisbeth Salander spin-off film *The Girl in The Spider's Web*.

Stieg Larsson who created this multi-million dollar industry never lived to see its enormous success as he died even before the trilogy was published. His original title for the first novel was going to be *Men Who Hate Women*.

In the ten years between 2008 and 2018, there seemed to be fewer crime subjects in the cinema, whereas on television there seemed to be nothing but police thrillers and murder mysteries. Maybe that was the reason. I have no idea. But I can remember saying to someone that I would love to go to the cinema and see a good thriller, but they seemed to have disappeared. And then in 2019 there came a good-old fashioned murder mystery, as if it had been inspired by Agatha Christie whodunnits. This was the American film *Knives Out*, written and directed by Rian Johnson, which begins with the murder of a wealthy mystery novelist on his 85th birthday in his mansion in Massachusetts. There are greedy relatives hungry for the dead man's wealth, and many suspects with motives for murder. Detective Benoit Blanc (Daniel Craig) has his hands full trying to solve a crime with so many characters, many of whom had murderous intentions.

Daniel Craig plays his detective as though he comes from the Deep South, and I don't mean Brighton, Truro or Portsmouth.

Spy Films

Earlier spy films tended to have innocent people caught up in espionage and having to escape the consequences, such as *The 39 Steps* (1935) directed by Alfred Hitchcock, from the novel by John Buchan, and the aforementioned *North by Northwest*. But as the Cold War loomed ever more threateningly, and the Berlin Wall was built, separating West Berlin from the Eastern sector, spy films lost the vulnerable bystander caught up in mayhem and instead created professional spies and secret agents as their central characters.

Obviously the most enduring spy on film is James Bond, created by Ian Fleming, and the first film was *Dr. No* (1962), directed by Terence Young, starring Sean Connery. The film was so successful that it became a major franchise. Then as more films were developed, so they created more deadly gadgets and the locations became ever more exotic. Roger Moore played Bond more than any of the other actors, and gave the character a lighter, almost comedic, touch. Despite having begun during the cold war, the storylines moved away from Russian villains to international nasties such as SPECTRE and villains like Blofeld. Each film had a different Bond girl, so that audience's interest was kept up by wondering who the next one would be, as was the case with the main song. Although it is the 'Bond Theme' that gets the pulse quickening, one of the greatest leitmotifs in cinema sound.

One of the most realistic Bond films was the second one, *From Russia with Love* (1963), reuniting director Terence Young with Sean Connery. Bond is after a Russian decoding machine and goes to Turkey armed with an attaché case containing tear gas and other Get Out of Jail Free cards. His antagonist Red Grant (Robert Shaw) sets out to kill him. One of the best and most thrilling fight scenes occurs in the confined compartment of the Orient Express. Later villainess Rosa Klebb (Lotte Lenya) tries to dispatch Bond with a poisoned spike on her shoe. (Poison as a weapon? Fairly topical that.)

During the trip on the Orient Express, when Bond is in the dining car with Tatiana (Daniela Bianchi) and Red Grant, because of his snobbery he notices that Grant must be Russian because he is eating fish with red wine, and therefore must be the villain.

I only ever drink red wine, even with fish, and so I had better watch my back!

In the new millennium, Daniel Craig took over as Bond, his first outing being in *Casino Royale* (2006) directed by Martin Campbell. Craig's Bond was more of an echo of the early Bonds starring Connery, but what he brought to the character was always a feeling of vulnerability. His Bond, one felt, really was in danger, and really did fear for his life, but always managed to defeat his adversaries, until he reached the end of the road in *No Time to Die* (2021). More Bond movies means some form of resuscitation of 007. Perhaps when those missiles hit that island in the Sea of Japan, Q might have given him another Get Out of Jail Free card.

Len Deighton created spy Harry Palmer, and Michael Caine played him in the first film *The Ipcress File* (1965), and had the unorthodox idea of having a studious-looking protagonist wearing glasses. His character was a very realistic and believable spy, one who was a bit of a gourmet and proud of his culinary skills. Which didn't mean he couldn't handle himself when the going got tough. There were two more Harry Palmer films, *Funeral in Berlin* (1966) and *Billion Dollar Brain* (1967), directed by Ken Russell.

The other great writer of spy fiction was John Le Carre whose *A Deadly Affair* (1966), his first novel, featured the MI5 spymaster Smiley, but the name had to be changed to Charles Dobbs (James Mason), because it was a Columbia Pictures production, and Paramount had already bought and owned the name Smiley. The film was directed by Sidney Lumet and the D.O.P of the picture, Freddie Francis, created a new technique to soften the colour by exposing the negative to a tiny amount of light, which came to be called pre-fogging. Sidney Lumet called it colourless colour.

But the spymaster, having been a BBC stalwart for many series, starring Alec Guinness, eventually made it to the big screen as *Tinker Tailor Soldier Spy* (2011) with Gary Oldman as Smiley.

One of the best Le Carre novels and films is *The Spy Who Came in From the Cold* (1963), and the protagonist Alec Leamas (Richard Burton) is the complete antithesis of James Bond in his grubby raincoat and his dispirited mood. And director Martin Ritt shot it in black and white so that it has the appearance of a noir thriller. Leamas is given one last job, pretending to defect to East Germany. He almost fools his East German interrogator (Oskar Werner) but the spanner in the works comes when Liz, (Claire Bloom) a Communist Party member he befriended in England, turns up in East Berlin, and his cover is blown. When they both try to escape across the Berlin Wall, they are shot. This is a very dark look at the world of spies, but is also riveting in the cat and mouse game played between interrogator and double agent.

The Deighton and Le Carre fictions were far nearer to what was happening in the real world of espionage with defectors like Guy Burgess, Donald Maclean and Kim Philby. Whereas the world of Bond has perhaps influenced the action-packed spy franchises like *Mission: Impossible*, the Jason Bourne thrillers and many others, including a few spoof spy thrillers such as *Our Man Flint* with James Coburn.

Drama

This will be in two parts, the second part being costume drama for films set before 1900. I acknowledge that a recently made film set in the 1930s would count as a costume drama, but as many classic films were actually shot in that era and beyond, the filmmakers in those decades would not have considered they were making costume dramas but contemporary subjects. And so any men in tights or women in corsets will go into Costume Drama.

Also, drama is a vast subject, and so I will confine it to innovative films or a film that started a new trend in the history of cinema such as the French Nouvelle Vague or the British New Wave or Italian Neo-Realism.

A French critic once pointed out to filmmaker Jean-Luc Goddard that a film should have a beginning, a middle and an end. Goddard agreed with him but said it wasn't necessary to put them in that order.

Greta Garbo started something when she said, 'I want to be alone,' in *Grand Hotel* (1932), which became her most famous utterance and was the beginning of her own solitary predisposition. The film was said to make cinematic history because of its line-up of stars, including not only Garbo but Joan Crawford, John Barrymore, Wallace Beery and Lionel Barrymore performing in what at that time was the largest hotel set ever created, and the film employed more than 100 extras. The film followed the lives of staff and guests at a Berlin hotel. The Hollywood premiere built a copy of the film's foyer and guests attending the showing had to sign in at the reception desk.

Garbo has been written about as one of the greatest Screen Goddesses of all time, but she rarely played comedy, although she managed to get many delightful comic moments into *Ninotchka* (1939) directed by Ernst Lubitsch. It was her last great screen role. No doubt she really did need to be alone.

Another iconic film actress, also given the sobriquet of Screen Goddess, was Marlene Dietrich, who had made her name playing Lola-Lola in *The Blue Angel* (1930) a German film directed by Josef von Sternberg. The film starred Emil Jannings and was filmed in both English and German. Jannings played

a dedicated schoolteacher who becomes obsessed with Lola when he visits The Blue Angel to probe his students' infatuation with the singer, whose song 'Falling in Love Again (Can't Help It)' became Dietrich's hallmark song.

When she and Sternberg moved to Hollywood, they made seven films together including the adventurous *Shanghai Express* (1932) in which Dietrich plays Shanghai Lily. Dietrich was a perfect femme fatale in these films, and Sternberg shot them using lighting and dark shadows that was very German Expressionist in style.

Artist Auguste Renoir's son Jean Renoir became a renowned film director, and many film buffs and critics consider his 1939 *La Règle Du Jeu (The Rules of The Game)* was his masterpiece. But, as so often happens with critically acclaimed works, it was a commercial flop. Renoir was left-wing, and the film, mainly located in and around a wealthy estate, was highly entertaining but heavily critical of the bourgeoisie. After the war began the film was banned as it was considered bad for morale. It was shown again in cinemas in the early 1950s and at the Venice Film Festival in 1959, when it was recognized as a masterpiece.

Sorry to bring up Vincent van Goth and Mozart again, but that's how it goes!

Most American Depression era pictures were escapist, but one from that era that stands out as social realism drama is *The Grapes of Wrath* (1939). Based on the 1935 novel by John Steinbeck, it was well-researched by the author, who told the story of the Joad family. Following the Oklahoma dustbowl, farmer's crops failed and they were forced to abandon their homes and became refugees in their own country.

Despite objections from financiers, Daryl Zanuck of 20th Century-Fox forged ahead with the project. John Ford directed, and Henry Fonda played Tom Joad. It was photographed by Gregg Toland very much in a documentary style, and in one memorable scene early on in the picture Ma Joad, played by Jane Darwell, has to burn most of their possessions before they abandon their farm. She got the Oscar for an actress in a support role, and John Ford got an Oscar for his direction.

Pictures are for entertainment, messages should be delivered by Western Union.

Sam Goldwyn

For which film did Alfred Hitchcock win his only Best Picture Academy Award? It was for *Rebecca* (1940) and was to be his first Hollywood movie when he moved to the US from Britain, contracted to work for David O. Selznick. The film is a psychological drama, based on a Daphne du Maurier novella,

and starred Laurence Olivier as widower Max de Winter, with Joan Fontaine as the timidly shy unnamed character he marries, and they live in the Gothic mansion 'Manderley'. Mrs Danvers, the housekeeper (Judith Anderson), makes the young bride's life a misery, and she obviously had a 'thing' about the late Rebecca, whom we never see. When Rebecca's corpse is discovered in a boat that Max scuttled, he is accused of her murder. But as she was dying of cancer, she committed suicide, making it look as if he murdered her. The film ends with the spectacular burning of Manderley, as the Rebecca obsessed Mrs Danvers sets it on fire.

Opening lines in novels are very important, and Daphne du Maurier's first sentence is: 'Last night I dreamed I went to Manderley again.' It grabs the reader's attention, wanting to hear more, and intrigued to know what Manderley is. And the same goes for the film with Joan Fontaine's voice-over arousing the audience's curiosity and wondering what that flashback from a dream sequence can mean. And Hitchcock's direction, and the black and white photography of George Barnes, made for a far more atmospheric Gothic romance than the 2022 colour remake.

Who or what is Rosebud? This is a mystery in Orson Welles's classic film *Citizen Kane* (1941) which is not revealed until the very end. If you have for some misguided reason avoided this film because it isn't in colour, then you can forget an indulgent spoiler.

Welles's picture broke new ground and it was his directorial film debut when he was only 24-years-old. The screenplay is credited to him and Herman J. Mankiewicz, and he played the leading role of newspaper magnate Charles Foster Kane. The film begins with his death, and his final word as he utters 'Rosebud'. Soon reporters are trying to find the meaning of this powerful man's last word, and the story is then told in flashback. Kane's rise to power, his riches and ruthlessness and his discovery that money doesn't buy happiness.

Because of the similarity between Kane and the real-life newspaper tycoon William Randolph Hearst, the picture nearly didn't get made. Hearst did everything in his power to stop the shooting, and when that failed he attempted to put pressure on the distributors to stop it being shown. Fortunately for the viewing public for years to come, his attempts to block the picture failed.

Gregg Toland, was the cinematographer, and he developed the technique for using deep focus, with the expressionist images in the picture contributing to its brilliance. The picture got an Oscar for the screenplay by Welles and Mankiewicz. To find out more of what went on between Welles, Mankiewicz and Hearst see the 2020 black and white film *Mank* directed by David Fincher, from a screenplay written by his father. Mankiewicz is played by Gary Oldman,

with Charles Dance as Hearst, and Tom Burke plays Welles. The film got a limited cinema release but was later shown on Netflix.

A film that was released in 1942 could be described as a war film, but is also a romance, with dashes of thriller and anti-Nazi propaganda, dozens of memorable lines ('Here's lookin' at you, kid,') and a great cast, including Humphrey Bogart, Ingrid Bergman, Paul Henreid, Claude Rains, Conrad Veidt, Sydney Greenstreet and Peter Lorre, not forgetting the great Dooley Wilson as Sam who plays it again 'As Time Goes By'. Yes, you've guessed it. *Casablanca* (directed by Michael Curtiz), based on a play by Murray Burnett and Joan Alison, but the screenplay was by brothers Julius and Philip G. Epstein and Howard Koch.

Apparently the script was written and re-written from day-to-day so that Bergman never knew until the final scene who she would end up with. The film takes place in 1941 when Casablanca is run by the French Vichy government in collaboration with the German occupiers, and the city is filled with refugees all attempting to get papers that will help them to flee to the United States. Much of the action takes place in Rick's Café Américaine, Rick Blaine being the proprietor played by Bogart in white tuxedo, who moans to Sam after he has seen his old Paris lover Ilsa (Bergman), 'of all the gin joints in all the towns in all the world and she has to walk into mine.' Paul Henreid as Victor Laszlo the Czech Resistance leader is married to Ilsa, complicating Rick's relationship with her, but as she reminds him, 'We will always have Paris'. There is a great scene in which the Germans at Rick's Café start singing, and Laszlo drowns them out by singing 'La Marseilleise'. Everyone joins in, even the ruffians and villains join in with patriotic passion and drown out the Nazis.

Rick, who was reluctant to become involved in what he considers someone else's war, although he is sympathetic to all the refugees attempting to get visas, does eventually do the right thing. After disgustedly slamming a bottle of Vichy water into a bin (Take that, Vichy government!), and when Claude Rains as the world-weary and cynical Louis Renault, police chief of this now Vichy run collaborationist government shoots Major Strasser (Conrad Veidt), he tells his men to 'Round up the usual suspects' then he and Rick go off into the night together to join the Free French at Brazzaville in the Congo. And Bogart has the last line in the picture: 'Louis, I think this is the beginning of a beautiful friendship.' And the film is also known for its famous misquote. Humphrey Bogart never said, 'Play it again, Sam.'

What he actually said was, 'If she can stand it, I can. Play it!'

Which line do you prefer?

When the Marx Brothers made *A Night in Casablanca*, Warner Brothers sent them threatening letters telling them the title was too close to their own and they

had no right to use it. Groucho Marx responded with a very funny reply, telling them they were brothers long before Warner Brothers became a production company, and so what right did they have to use the name 'brothers'. It was ignored and the Marx Brothers continued to use their Casablanca title.

The *Casablanca* film was also an inspiration for Woody Allen's comedy, using the misquote as its title. *Play It Again, Sam.*

For this history of cinema, a tearjerker I feel obliged to mention, although it seems a tad dated now, is David Lean's *Brief Encounter* (1946) starring two beautiful performances from Celia Johnson and Trevor Howard. A chance meeting in a railway station buffet leads to further meetings between them and platonic love. They are both married, and know it would be wrong to consummate their relationship, and their realisation that this bond between them is doomed from the start is told with silent tragedy and dignity in their subdued lives. The film was beautifully shot, with much atmosphere and great sound effects. It was based on *Still Life*, a one-act play by Noel Coward.

Most drunken moments on the screen are often played for laughs, but *The Lost Weekend* (1945) dared to handle alcoholism seriously. Director Billy Wilder may have been attracted to Charles R. Jackson's semi-autobiographical novel about an alcoholic writer because of his previous experience of working with Raymond Chandler on *Double Indemnity*. Chandler was a recovering alcoholic and had to hit the bottle again in order to complete the screenplay. The screenplay for *The Lost Weekend* was by Wilder and Charles Brackett, and starred Ray Milland as alcoholic writer Don Birman and Jane Wyman played Helen, his girlfriend. During a horrendous drunken weekend, in which he attempts to pawn his typewriter to pay for booze, Birman gets very drunk and ends up in an alcoholic ward suffering from amnesia and delirium tremens. Eventually, attempting to overcome his addiction in front of Helen, he deliberately ruins a glass of whiskey, for what we think will be a positive ending. But when the camera reveals his point of view, we see that there is the outline of a bottle hidden in the glass lampshade of the overhead light.

Much of the exteriors were shot on the streets of New York, and Wilder concealed cameras behind boxes and garbage cans, so that pedestrians observing Milland's drunken performance were unaware that they were being filmed.

The picture received four Oscars, and it is only one of three films to get an Academy Award for Best Picture and also the Grand Prix at Cannes Film Festival, their highest award.

Incidentally, Ray Milland was Welsh. He was born Alfred Reginald Jones in Neath, South Wales.

The Bicycle Thief (1948) directed by Vittorio De Sica cemented the Italian Neo-Realism movement in cinema. It told the story of an unemployed worker in Rome who is offered a job putting up posters providing he has a bicycle, He gets the job but is devastated when his bike is stolen. The picture is very much about his relationship with his son and how they scour Rome in search of the stolen bicycle. There is massive drama in this story of everyday life, and a great deal of action as father and son are plunged into this urban odyssey.

There is a film which is the one and only time a father and son received an Oscar for the same picture. This is *The Treasure of The Sierra Madre* (1948). John Huston got the Oscar for directing and writing the screenplay, and his father Walter Huston got the Oscar for an actor in a supporting role. The film starred Humphrey Bogart and was about a failed quest of three prospectors in search of gold in Mexico. In one scene they are attacked by bandits claiming to be the police, and when Bogart asks for proof and to see their badges, the chief bandit replies with a sneer, 'Badges? We ain't got no badges! We don't need no badge. I don't have to show you any stinking badge.' Presumably the Mexican bandit had the same contempt for bureaucracy as many of us do today.

Storytelling told from different perspectives is always fascinating, and the Japanese film *Rashomon* (1950) has three travellers telling stories involving a murdered samurai, which then flashes back to these tales, and we the audience see the same tale told in a different way, each character claiming their version is the truthful story. This masterful film was directed by Akira Kurosawa and received many awards.

'Fasten your seatbelts, it's going to be a bumpy night.' This famous line is uttered by Bette Davis as Margo Channing in *All About Eve* (1950) written and directed by Joseph L. Mankiewicz (brother of Herman J.), adapted from a short story in *Cosmopolitan* magazine. Margo Channing is a famous theatre actress, and she befriends Eve (Anne Baxter) who wheedles her way into her personal and theatrical life, and is a serial liar and manipulator. Margo's dresser Birdie, played by Thelma Ritter, sees through Eve's scheming behaviour and the 'bumpy night' soon takes off. The picture has a very dark outlook on the theatre scene but is also very perceptive. Oscar nominations went to Bette Davis, Anne Baxter, Thelma Ritter and Celeste Holm, a record for most female nominations in a single film.

I feel a certain amount of sympathy for anyone performing as Stanley in a theatre revival of *A Streetcar Named Desire* (1951) as Marlon Brando is a hard act to follow. Many theatre books do not include this Elia Kazan directed film of Tennessee Williams' play as it is a theatre rather than a cinematic experience. Even so, I have included it simply because it is one of the playwright's best plays,

atmospheric and brilliantly performed by Brando, Vivien Leigh, Kim Hunter and Karl Malden. And who can forget Leigh's wonderful performance as the deluded Blanch DuBois when she ends up in a psychotic state and says, 'I have always depended on the kindness of strangers.'

Vivien Leigh, Kim Hunter and Karl Malden all received Oscars, but Marlon Brando, who was also nominated for an Oscar, missed out to Humphrey Bogart for *The African Queen* (1951), a great adventure film directed by John Huston and photographed in Technicolor by cinematographer Jack Cardiff. Set during the First World War, Bogart plays a rickety tramp steamer captain and Katherine Hepburn plays a puritanical missionary who has to escape downriver on his boat, and she can't stand this gin-soaked man. Although it is very much an adventure film, based on a novel by C. S. Forester, some of the most enjoyable scenes are between Bogart and Hepburn and their characters' troublesome relationship, and there is also a great deal of humour in these set pieces.

The film was a British picture and shot mainly on location in Africa, some of it in the Congo. Many of the cast and crew became ill, and in an early scene in which Hepburn plays the organ in church, a bucket was placed nearby but out of shot so that she could vomit into it. Apparently, the only ones who didn't succumb to sickness were John Huston and Bogart as they both drank whisky on location rather than water.

Some of the scenes, when they were both in the water were considered too dangerous to be shot in Africa, and they built tanks in the London Isleworth Studios.

One of the most suspenseful films of all time was a French Italian co-production *The Wages of Fear* (1953), directed by Henri-Georges Clouzot. It's not a murder mystery, whodunnit or horror movie but a drama set in a South American country, starring Yves Montand and Charles Vanel, and concerns a group of four down-and-outs desperate for money, who take on a challenge: driving 200 gallons of highly volatile nitro-glycerine along a treacherous 300 mile road in order to extinguish a blazing oil well by blowing the pipeline. And the fact that the Southern Oil Company sends two lorries suggests that they suspect that perhaps only one will make it with this dangerous cargo. As both teams set off, the tension builds as they encounter many obstacles along their route which could blow them to bits at any time.

There are scenes showing the US-run Southern Oil Company's lack of concern for their employees, and some of these scenes were edited for showing in the US. The film was shot in black and white and in four languages, French, English, Spanish and German, although the picture is not heavy on dialogue.

Social realism came to Hollywood with the classic black and white movie *On The Waterfront* (1954) directed by Elia Kazan. The screenplay was going to be written by Arthur Miller, but when Kazan became a 'friendly witness' for HUAAC, Miller fell out with him. Kazan then got Budd Schulberg, another 'friendly witness', to write the script, and it was thought that the film, mainly about union corruption on New York's docklands, was an apology and justification for their actions.

Be that as it may, there is no denying that *Waterfront* is a superb film, starring Marlon Brando as Terry Malloy, a failed boxer turned stevedore. There is an unforgettable scene in the back of a cab between Terry and his brother Charley (Rod Steiger). 'I really had class,' moans Terry about his boxing. 'I coulda been a contender, instead of a bum, which is what I am, let's face it.'

Terry falls in love with Edie, (Eva Marie Saint), whose brother was murdered by Johnny Friendly (Lee J. Cobb), and she shames the parish priest (Karl Malden), into a campaign against union racketeering. Terry is blacklisted for speaking out, testifying against the union and Johnny Friendly, and is badly beaten up on the harbourside.

The film also has a great score by Leonard (*West Side Story*) Bernstein.

This film, more than many others, really stands the test of time, and is as relevant today as it was when it was made seventy years ago.

Also in that same year, the Japanese film *The Seven Samurai* was released. Directed by Akira Kurosawa, it told the story of humble villagers at the mercy of bandits being helped by the seven warriors. Kurosawa was influenced by John Ford's Westerns and there have been many crossovers between the Japanese films and Westerns, The most obvious one is, of course, *The Magnificent Seven*, but there have been others, such as the spaghetti Western *A Fistful of Dollars* (1964) which Sergio Leone took from *Yojimbo* (1961).

Satyajit Ray's debut film *Pather Panchali* (1955) was very different from the all-singing all-dancing films from India's Bollywood, which he adapted from a classic novel by a Bengali writer. Ray had difficulty raising the money to finance the picture which began shooting in 1952 and wasn't completed until 1955.

The picture tells a very real and moving story of a young boy, Apu, growing up in a remote village in Bengal, whose poor parents have difficulty providing food for him and his sister. The film became a trilogy with *Aparajita* (1957) and *The World of Apu* (1959). Ravi Shankar's great music contributed to the success of *Panther Panchali* and Ray was recognized as a talented director at the 1956 Cannes Film Festival.

When you think of films about disaffected teenagers, you tend to reflect on poorer kids living in inner city slums. But *Rebel Without a Cause* (1955),

directed by Nicholas Ray, was an early Cinemascope film shot in colour, and these angst-ridden youngsters are shown to come from affluent middle-class homes and have their own cars. James Dean played the leading role of Jim Stark, frustrated by his father's inability to stand up to his wife. Jim Backus plays his father Frank, giving a moving and memorable performance. Another troubled teenager, Judy (Natalie Wood) finds it hard to understand why her father, now that she is sixteen, won't let her kiss him, and when she does he protests too much by slapping her. Corey Allen plays Judy's boyfriend Buzz, who is killed driving a stolen car in a 'chicken run' when his leather jacket gets caught up in the door handle. Sal Mineo is Jim's devoted friend who is shot by the police, and following this tragedy Jim becomes reconciled with his father.

Prior to the *Rebel* film, Dean starred as Cal in Steinbeck's *East of Eden*, directed by Elia Kazan and released earlier the same year, which was the only major film that Dean saw in which he appeared. He died in a car accident when he was speeding in his Porsche 550 Spyder and his death occurred on 30 September before his most iconic film was released on 27 October. He also made *Giant* which was released in 1956, directed by George Stevens. Following his death, and the release of his only three major film roles, he became the first actor to be nominated posthumously for two Best Actor Academy Awards for *East of Eden* and *Giant*.

Incidentally, Jim Backus was the voice of the cartoon character *Mr Magoo*.

The late fifties produced a glut of interesting pictures from around the world. Alexander Mackendrick, who had made several Ealing comedies, including *The Ladykillers*, directed the American black and white noirish drama *Sweet Smell of Success* (1957) with Tony Curtis as the sycophantic press agent Sidney Falco sucking up to J. J. Hunsecker (Burt Lancaster), the gossip columnist who can make or break people. The film flashes through the seedy nightclubs and streets of New York accompanied by a great jazz score. This is a dynamically atmospheric film that deserves more recognition.

Another 1957 classic black and white film was the remake of *12 Angry Men*, which was directed by Sidney Lumet, from a 1954 CBS teleplay by Reginald Rose. Almost all of the action takes place in the jury room as they deliberate the fate of a young man accused of killing his mother. Eleven of the jurors are all for a speedy verdict, condemning the accused to the electric chair. But Juror 8, played by Henry Fonda is the only man who wants to discuss in detail any reasonable doubts about the case, and this leads to confrontation and bigotry from some of the other jurors. The film captures the claustrophobia and sweaty atmosphere of the drama as the jurors battle it out, with many twists in the story.

A colour version was remade for TV in 1997, directed by William Friedkin. In this version instead of twelve angry white men, there are now four black men on the jury, which leads to some racist bigotry. My only problem with this version was that if they had brought it up to date in this way, why no women on the jury? They could easily have changed the title to *12 Angry Jurors*. Just a thought.

Hailed as the James Dean of the East, Polish actor Zbigniew Cybulski played a Polish Nationalist in a film that is set immediately after the war. In *Ashes and Diamonds* (1958), directed by Andrzej Wajda, Cybulski's character sets out to kill a Communist leader. Throughout the film the actor wears a pair of dark glasses and along with the character's hothead mood swings he becomes quintessentially hip. Even his laughing dance with death as he is fatefully shot at the end of the picture, adds a gut feeling of essential cool.

Two of the best French films were released in 1959. The first was Francois Truffaut's debut film *Les Quatre Cents Coups (The 400 Blows)*. It was semi-autobiographical about a young teenager (Jean-Pierre Léaud), who on seeing his mother kissing a stranger, goes on the run. He steals a typewriter and is sent to a juvenile detention centre, from which he escapes. But the bleak ending shows that he has no plan and nowhere to go.

Some of Truffaut's other notable films were *Shoot the Piano Player* (1960), *Jules and Jim* (1962) and *Day for Night* (1973). He also appeared as an actor in a supporting role for Steven Spielberg's *Close Encounters of The Third Kind* (1977).

The other French Nouvelle Vague film released later that year was *A bout de souffle (Breathless)*, directed by Jean-Luc Goddard, starring Jean-Paul Belmondo and Jean Seberg. Michel (Belmondo) is a vicious hoodlum who thinks nothing of casually shooting a cop, and is influenced by and emulates American gangster movies. Godard used jump cuts, so that the film moves along at a frantic pace, cutting out any extraneous business. His car stops, and next he is at the door of the apartment building, it hasn't been necessary to show him getting out of the car and walking up the steps to the apartment building. These types of jump cuts may well have influenced directors of commercials who have to tell a story in thirty seconds.

From the French to the British New Wave. Gone was the British stiff-upper-lip and working class lads touching their forelocks. Beginning in the theatre with John Osborne's *Look Back in Anger* (1956), new social realism plays and films were sometimes disparagingly referred to as Kitchen Sink Drama. *Saturday Night and Sunday Morning* (1960), directed by Karel Reisz, with a novel and screenplay by Alan Sillitoe, is located in the author's hometown of Nottingham. It begins with a rebellious and disgruntled Arthur Seaton, played by Albert

Finney, working at his lathe in a factory, and counting out the drill bits he has made, running into hundreds. He then grumbles, 'Don't let the bastards grind you down.' At the time this was Piecework, where a factory workforce was not paid by the hours worked but were paid on productivity, the 'pieces' they produced. And we see that Arthur is doing rather well and will have a healthy wage packet, money to spend at the weekend. Although Arthur is rebelling, he is not dissenting against any political system, as he says later in the film, 'What I'm out for is a good time. All the rest is propaganda.'

And to prove this sentiment, not only does Arthur drink heavily on a Saturday night, he also has an affair with the wife (Rachel Roberts) of one of his mates at the factory. After she becomes pregnant, he is beaten up by her husband's soldier brother and his mates. Arthur's girlfriend is played by Shirley Anne Field, and at the end we see her and Arthur walking hand in hand and suspect that the bastards have at last ground him down, and he will soon be tamed by a new responsibility, ending up like his father, sitting in his armchair staring at the TV.

When the film came out, fourteen years had passed since *Brief Encounter*, when the decent couple resisted temptation, and many audiences found *Saturday Night* positively shocking. But what did audiences expect? Trevor Howard and Celia Johnson were terribly middle-class, whereas Arthur Seaton was clearly a working class oik, so it was no wonder he shagged his mate's wife and refused to touch his forelock!

During an interview in 1982, Finney joked about the way British films showed sex on the screen. He said, 'You had to have one foot on the floor, like in snooker.'

Perhaps one of the most important films in the history of cinema was *Victim* (1961), simply because it was about the criminalisation of homosexuals almost a decade before the law was changed to make it legal between consenting adults. The film was directed by Basil Dearden and scripted by John McCormick and his wife Janet Green, who was a keen supporter of homosexual law reform. The film stars Dirk Bogarde, as Melville Farr, a barrister, and his wife is played by Sylvia Sims. Farr has a romantic friendship with a young man who is being blackmailed, and when he is arrested by the police for being gay, he hangs himself in his cell. Which is when Farr decides to take on the blackmailers. The film was shot in black and white in a noir style. Some of the locations were authentic too. Scenes were shot in The Salisbury pub in St Martin's Lane, Covent Garden, which was a gay pub in the sixties and seventies.

Film critic Mark Kermode notes that Sylvia Sims's reason for readily accepting her role in the film, when so many other actresses had turned it down, was because of her theatre work with John Gielgud, which brought her into contact

with the laws surrounding homosexuality at that time. Also, a family friend of hers had committed suicide after having been accused of being gay. Watching the film today makes it hard to believe what went on before the law was changed in 1967. No wonder they called the law back then 'the blackmailer's charter'.

This Sporting Life (1963) was another ground-breaking British film. It was director Lindsay Anderson's film debut at the age of forty. From a novel by David Storey, it begins with Machin (Richard Harris), who is a professional rugby league player, having his teeth knocked out in a match, and is in a dentist's chair going under from the anaesthetic. Machin lodges with recently widowed Margaret (Rachel Roberts). Because they both lack understanding and are emotionally unbalanced, and despite Machin's success on the rugby field, their relationship eventually reaches a violent climax.

Another notable British New Wave film was *The Loneliness of The Long Distance Runner* (1962) directed by Tony Richardson, and starring Tom Courtenay as the petty thief who ends up in borstal. Many of the British New Wave films were adapted from stage plays, like John Osborne's *The Entertainer* (1960), directed by Tony Richardson (he had also directed the play at the Royal Court Theatre), starring Laurence Olivier on stage and in the film, with his wife to be, Joan Plowright, playing his daughter in the film. A refreshing change came with a female playing the protagonist on screen. Adapted from Shelagh Delaney's play and starring Rita Tushingham, *A Taste of Honey* (1961) was directed by Tony Richardson, and also starred Dora Bryan, Murray Melvin, Robert Stephens and Jimmy Danquah. It was set in Salford, a very different district to how it is now. Dora Bryan plays Rita Tushingham's common-as-muck mother, constantly knocking back the booze, and Melvin plays a gay design student who moves in with her, then looks after her when she becomes pregnant in a mixed-race relationship with a young black sailor. Many of the issues may not be as relevant today as they were in the early sixties, but it's interesting looked at from a historical perspective.

Incidentally, all the British social realism films were shot in black and white, but the American 1961 romantic drama *Breakfast at Tiffany's*, directed by Blake Edwards, was shot in colour. Edwards went on to direct many of Sellers's Inspector Clouseau films. The screenplay of *Tiffany's* was by George Axelrod from a novel by Truman Capote. Because of the Hays Code the darkness of the novel was toned down, so that Audrey Hepburn as Holly Golightly was not a call girl as in the novel but a good time girl. Sharing her same apartment building is struggling writer Paul (George Peppard), who is a kept man, but soon falls in love with his neighbour. But where can you go wrong with a film that includes a song like 'Moon River' and has a cute black cat called Cat?

The stunning chic black dress that Hepburn wore for the film was sold in auction not so long ago and fetched over $400,000.

Another great film from 1961 was *The Hustler*, directed by Robert Rossen, starring Paul Newman as the pool shark 'Fast' Eddie Felsen. Shot in black and white, this is very much a story about winners and losers, with Eddie obsessed with beating the talented pool player 'Minnesota Fats' (Jackie Gleason), while he is managed by Bert Gordon (George C. Scott), who accuses him of being a loser, however much he appears to be winning. When Eddie is reduced to hustling pool for money, he gets his thumbs broken. Eddie's love interest is played by Piper Laurie, who is an alcoholic and her story ends in tragedy when she slits her wrists.

The film is beautifully photographed, with widescreen shots of the densely smoky pool halls, and the Oscars for this picture went to art direction and cinematography.

George C. Scott refused his Oscar nomination for a supporting role, as he didn't believe actors should be in a race against one another, and he had no interest in attending the ceremony.

Twenty-five years later came *The Color of Money* (1986), directed by Martin Scorsese, with Paul Newman again playing 'Fast' Eddie Felsen, who sees the talented pool player Vincent (Tom Cruise) as a potential hustler and convinces Vincent's girlfriend Carmen (Mary Elizabeth Mastrantonio) of the opportunity to make big money. This is beautifully shot, mainly in real pool hall locations in and around Chicago. And Scorsese said that for many of the close-up shots he was influenced by the Ealing Studios drama *Black Narcissus*.

One of the most imaginative Italian films of 1963 was 8½ directed by Frederico Fellini. Already a successful film director, he had made eight feature films. His fourth film *La Strada* (1954) brought him international recognition, and then *La Dolce Vita* (1960) consolidated his reputation as a major director. The film portrays shallow and hedonistic celebrities, starred Marcello Mastroianni and Anita Eckberg, and brought a new word into our language. Paparazzi came from one of the film's characters Paparazzo, who is a photojournalist zapping around on a motor scooter attempting to get a compromising shots of celebrities.

But it was Fellini's *8 ½* that was the most stunningly creative, beautifully shot in black and white, as were his previous films. The film also starred Marcello Mastroianni as a film director searching for his new project. But what makes the picture so original is the surrealistic use of Freudian dream sequences, also with great dashes of humour.

Fellini made his first colour film when he made *Juliet of The Spirits* (1965) starring his wife Giulietta Masina, and then used mainly colour in his future films.

One of the most successful films of 1962 was adapted from Harper Lee's classic novel *To Kill a Mockingbird*. The screenplay was by playwright Robert Foote, and the film was produced by Alan J. Pakula and directed by Robert Mulligan. They would both go on to work together on many other pictures.

The *Mockingbird* story is set in Alabama, where a black man is falsely accused of raping a white woman, and the lynch mob await the outcome of the trial. The events are seen through the eyes of 'Scout' Finch, played by nine-year-old Mary Badham, her adult voice-over telling the story in retrospect. She is the daughter of the idealistic Atticus Finch (Gregory Peck), the Alabama lawyer who defends the accused, played by Brock Peters. Robert Duvall made his feature debut, playing the Finch's reclusive neighbour, a man the children think of as a scary bogyman, but he turns out to be their rescuer when he saves Scout's brother Jem from the false rape victim's father.

Robert Foote and Gregory Peck received Oscars for the movie.

Incidentally, John Badham, Mary Badham's brother, became a film director and made *Saturday Night Fever* (1977) and *War Games* (1983).

As the gritty Northern British New Wave dramas lessened, directors such as Tony Richardson who had been at the forefront of the breakthrough in British social realism now made the colourful period caper *Tom Jones* (1963) before going to Hollywood, and was followed soon after by John Schlesinger, after he made the northern comedy/drama *Billy Liar* (1963) and *Darling* (1965). But these filmmakers of the early sixties had paved the way for serious directors such as Mike Leigh and Ken Loach.

Loach had been successful with television dramas such as *Up The Junction* and his first feature film was *Kes* (1969), with a screenplay by Tony Garnett and Loach, based on the novel by Barry Hines. David Bradley played a young boy who is bullied and having a hard time at school, trains a kestrel and takes a keen interest in falconry, a refreshing change from his dreary existence in the northern working-class town. And there are funny scenes in the picture. Brian Glover, as the school's sports master, becomes over-enthusiastic as he demonstrates football to his class, hogging the ball while he fantasises about being a professional footballer.

The focus of the film, though, (shot in colour) is not on begrimed and grubby industrial town streets but on the relationship of the characters and their hardship and privation.

David Bradley, who wanted to continue acting, had to change his name to Dai Bradley, because there was already a David Bradley as an Equity member, and the union will not accept two actors with the same name.

Political upheaval and disorder are perfectly demonstrated on film in the epic *Doctor Zhivago* (1965). Directed by David Lean, with a screenplay by Robert Bolt, it was based on the lengthy novel by Boris Pasternak. It is a love story between Zhivago (Omar Sharif) and Lara (Julie Christie), although the doctor is already married to his childhood sweetheart Tonya (Geraldine Chaplin). The characters become separated by different factions of the First World War and the Russian Revolution, and there is an alarming scene when an army of sword-wielding Cossacks on horseback attack protesters in the streets. There are some outstanding supporting performances in the film, including Rod Steiger and Tom Courtney. The wonderful expansive photography of the vast Russian plains and snow scenes contrasting with spring is by Freddie Young. The score was by Maurice Jarre and 'Lara's Theme' became a hugely popular instrumental, and lyrics were later added to the theme, and titled 'Somewhere My Love – Lara's Theme' and sung by Andy Williams among others.

An exceptional anti-colonialism film was an Algerian/Italian co-production. *The Battle of Algiers* (1965) directed by Gillo Pontecorvo is about the Algerian struggle for independence, told in a gritty documentary style. This film is not one for the squeamish as there are brutal scenes of torture and atrocities perpetrated by the French paratroopers, but the conflict is handled with objectivity, showing the human cost from both sides of the hostilities, as women from the Algiers casbah plant bombs in restaurants and we see the aftermath of the explosions as innocent diners suffer the wrath of the anti-colonialists.

Shot in black and white the film is extremely suspenseful, and has a great musical score written by Pontecorvo and Ennio Morricone.

One of the very best film adaptations from a stage play was Edward Albee's *Who's Afraid of Virginia Woolf?* (1966) directed by Mike Nichols with a screenplay by Ernest Lehman. It was probably the best performance Richard Burton and his wife Elizabeth Taylor gave when working together. Burton played George, a history professor at the local college, and Taylor was his wife Martha, the daughter of the college president. They have invited a younger faculty member (George Segal) and his wife (Sandy Dennis) for an evening which becomes a living hell as their marriages are laid bare in mental games of humiliation. The film was shot in black and white and received five Academy Awards.

A year later Mike Nichols directed *The Graduate* for which he won an Oscar. When it opened, the film was considered one of the most daring for its time, as Benjamin, Dustin Hoffman's first starring role, is seduced by Mrs Robinson (Anne Bancroft). 'Mrs Robinson, you're trying to seduce me. Aren't you?' Her daughter (Katherine Ross) little realises that her mother is screwing her boyfriend. But this lid off American suburbia is not all serious and soul-

searching, and has some hilariously funny moments, and dashes along with many Simon and Garfunkel tracks as Benjamin zaps along in his little red sports car.

Along with *The Graduate*, 1967 was a good year for films. It brought us *Cool Hand Luke*, Paul Newman as a rebellious ordinary bloke who is incarcerated for cutting the tops off parking meters. And the previously mentioned *Point Blank* and *Bonnie and Clyde*. Then from Czechoslovakia came the brilliant *The Firemen's Ball*, directed by Milos Forman, an episodic black comedy featuring scenes about a volunteer fireman's retirement, a raffle for much coveted food (which is stolen), a beauty contest which goes haywire, and eventually a fire breaking out. Because most of the firemen have been drinking at the ball, most of them are incapable of dealing with the fire when an elderly man's house goes up in flames. But someone very kindly fetches him a chair, so that he can sit and observe the inferno.

In the film there is an obvious subtext about the hardship of living in a Soviet-dominated society. But it's worth bearing in mind that less than a year later in 1968, Soviet tanks invaded Prague. And that was the year that Milos Forman went to live in America, where he made many successful films, including *Amadeus* (1984) from Peter Shaffer's play about the rivalry between Salieri and Mozart.

The only X-rated picture to win a Best Picture Academy Award was *Midnight Cowboy* (1969), directed by John Schlesinger. John Voight as Joe Buck plays a stud, new to NYC, hoping to hustle rich women for sex. His journey to New York is enhanced by Harry Nilsson's memorable song 'Everybody's Talkin''. Soon disillusioned, Joe befriends 'Ratso' Rizzo, played superbly by Dustin Hoffman, and they share destitution together as things go from bad to worse. Much of the picture was shot on the busy streets of New York, and in one scene, while crossing the street, a yellow cab almost hits Hoffman, who remains in character and improvises slapping the cab's bonnet and yelling, 'Hey! I'm walkin' here.'

Searching for a better life, they both manage to buy Greyhound bus tickets for Florida, but during the journey the sickly Rizzo dies in Joe's arms, and this poignant scene is enhanced by the music, John Barry's recurring theme as the bus reaches the Florida sunshine.

Easy Rider (1969) became one of the first counterculture films, reflecting young people's disillusionment with conventional living when two bike riders in this road movie, Wyatt (Peter Fonda) and Billy (Dennis Hopper), make a large amount of money from cocaine smuggled from Mexico and are soured by what they see of the USA on their travels. They spend some time in a hippie commune where free love is practised, and plan to head for the New Orleans

Mardi Gras. Along the way they are arrested, and in jail they meet George, an alcoholic lawyer, played by a scene-stealing Jack Nicholson. George gets them released and joins them on their trip, but they are ambushed in their campsite and George is bludgeoned to death.

Inventive scenes of an LSD trip taken by Wyatt and Billy become an almost nightmare phantasmagoria, but the finale of this film is truly shocking when the two bikers are riding along peacefully and are casually shot by extreme right rednecks in their pick-up truck. The film was produced by Fonda and directed by Hopper, with a screenplay by Hopper and Terry Southern, and some great music by Jimi Hendrix, Steppenwolf and many others. It was made on a shoestring budget and took millions at the box office, which must have made some of the Hollywood moguls sit up and ponder.

Of course *Easy Rider* was not the first biker movie, up until then there had been many, starting in 1953 with *The Wild One*, starring Marlon Brando, where a biking army of Hell's Angels terrorise a town. But it was the Fonda and Hopper picture which was an important mirror to the antithetical way of American life.

In contrast to the drug-fuelled picture, 1969 brought us a British picture from a D. H. Lawrence novel, *Women in Love*, which was directed by Ken Russell, with a screenplay by Larry Kramer, the producer. The film is located in a Midlands town and is about the relationships of two couples. The film stars Alan Bates, Oliver Reed, Glenda Jackson, Jennie Linden and Eleanor Bron, and has the famous nude wrestling scene between Bates and Reed. Ken Russell had doubts about filming the scene but it was 'Olly' Reed who persuaded him to do it. Although, on the day of the shoot, both actors consumed much alcohol to enable them to do it. The only Academy Award went to Glenda Jackson.

One of the most controversial pictures of the 1970s was Stanley Kubrick's *A Clockwork Orange* (1971), based on the novel by Anthony Burgess, and starring Malcolm McDowell as Alex, the bowler-hatted 'Droog' gang leader, whose rampages of rape, violence and murder, led to the film being taken out of circulation for many years.

Music plays an important role in the film's imagery as Alex's violence is coupled with Beethoven's 'glorious' *Fifth Symphony* or 'Singin' in The Rain' as he sings and kicks someone to death. But when he is eventually arrested by the State, the picture reverts to its sci-fi origins as he undergoes shock treatment when his eyes are forced open to watch violent images, and the State manages to curb his violence by a conditioning process.

The logline on the film's poster stated: 'Being the adventures of a young man whose principal interests are rape, ultra-violence and Beethoven'.

It makes me wonder what Ludwig would have made of the film!

That same year Nicholas Roeg directed his second feature *Walkabout*, with a screenplay by playwright Edward Bond from a novel by James Vance Marshall. An office worker, played by John Meillon, drives into the lonely outback with his daughter (Jenny Agutter) and her younger sibling (Luc Roeg), sets fire to the car then shoots himself. At a parched waterhole they meet and are befriended by an Aboriginal youth (David Gulpilil) on a walkabout, and the two young city-dwellers join him on his walkabout.

This is a very different film for Jenny Agutter who had played the rather prim young girl in the family favourite film *The Railway Children* (1970). In *Walkabout* her character is not given a name, and she communicates less with the Aborigine youth than her young brother, who communicates easily by mime. The film is beautifully photographed by Nicholas Roeg himself.

Two films about the acceptance of death were released in the early seventies. *Harold and Maude* (1971), directed by Hal Ashby, which soon became cult viewing and developed an enormous following over the years. Burt Cort played the eponymous Harold, aged 20, who attempts to gain the attention of his cold mother by some hilarious fake suicides. But when he meets the ageing Maude (Ruth Gordon), who is outrageous and steals cars, he is soon smitten and they become lovers, despite their difference in age. A priest in the film says that the thoughts of Harold's young body having intercourse with Maude's ageing flesh makes him want to puke.

But for Maude, and also Harold, who had shared a love of visiting funerals together, it is as if they both undergo therapy and death gives life a meaning.

Sweden in 1972 gave us Ingmar Bergman's *Cries and Whispers*, beautifully shot in colour by Sven Nykvist, starting off by photographing a beautiful early morning on a country estate, and inside the mansion a woman is awakened from sleep by her cancer. Although this is an examination of death, in which the dying woman who is the mansion's owner, and her relationship with her devoted maid and two sisters (Ingrid Thulin and Liv Ullmann), it could well be depressing. But as Bergman, who also wrote the screenplay, shows us intricately the inner life of each character, it becomes a beautiful study of the acceptance of death.

George Roy Hill directed *The Sting* (1973), and teamed Paul Newman and Robert Redford again following their triumphant *Butch Cassidy* film. This was another 'buddy' movie, with two likeable rogues as con artists about to pull an enormous 'sting' on a gangster boss played by Robert Shaw. If the details of the con plot were too complicated to follow, what did it matter? The film was set in the Depression era, with colourful costumes and cars, and introduced us to Scott Joplin's ragtime music with 'The Entertainer' which became a hit record. Most of us had never heard of Joplin prior to this film.

Perhaps one of the most explicit love-making scenes in a film was in *Don't Look Now* (1973) between Donald Sutherland and Julie Christie. The film was based on a short story by Daphne du Maurier and directed by Nicholas Roeg. After their daughter dies in a drowning accident, Baxter (Sutherland) and his wife Laura (Christie) travel to Venice as art restorers, attempting to recover from their loss. In Venice they meet a strange and eccentric elderly couple (Hilary Mason and Clelia Matania), one of whom is a blind psychic who claims she can communicate with their dead child. Baxter is sceptical, but when he sees a child running through narrow streets and crossing canals, wearing the same red coat his daughter wore when she drowned, he races through narrow alleyways at night, attempting to catch her. Then a truly shocking moment when…spoiler alert. Watch the film if you haven't already seen it.

If you like rock 'n' roll from the fifties and sixties then *American Graffiti* (1973) is a highly entertaining film. It was director George Lucas's second feature before he went on to make *Star Wars,* and is set during one night in the sixties with an ensemble cast featuring Ron Howard, Cindy Williams, Richard Dreyfuss, Candy Clark, Paul Le Mat and Charles Martin Smith. It's a great episodic coming-of-age film about a bunch of high school kids, playing pranks, mooning and buying illicit liquor, and the picture clearly inspired the TV series *Happy Days*, which Ron Howard starred in. It was also Harrison Ford's debut feature as a drag racer. The film follows the antics of the teenagers over a hot summer night, with beautiful photography, all shiny chrome and bright colours, visually stunning in an almost science fiction setting occasionally. Also in the film is the legendary DJ Wolfman Jack, sending out messages during his late-night slot on the radio. And if you like Chuck Berry and Buddy Holly, you can't go wrong with this picture.

For which film did Michael Douglas first win an Oscar? It was for the 1975 picture *One Flew Over The Cuckoo's Nest,* which won Best Picture, and he was one of the producers. His father, Kirk Douglas, owned the film rights to Ken Kesey's novel, but by the time it reached the production stage, his father thought he was too old to play the anti-authoritarian McMurphy, and the role went to Jack Nicholson. Set in a state mental institution, one of the inmates, McMurphy, rebels against the unbending and brutal Nurse Rached (Louise Fletcher), and gets the other inmates protesting against her rule of law. The film was directed by Milos Forman and is a modern classic, which became only the second film to win five major Academy Awards, including Forman, Nicholson and Fletcher.

Two reporters working for the *Washington Post,* Bob Woodward and Carl Bernstein, exposed a break-in at Washington's Democratic Watergate building, revealing President Richard Nixon's involvement. Their book became an

exciting screenplay by William Goldman for *All The President's Men* (1976), directed by Alan J. Pakula, and starred Robert Redford and Dustin Hoffman as Woodward and Bernstein. Not only was this film political fact but it became an intoxicating thriller, filled with dirty tricks and conspiracy, leading to the resignation of Nixon in 1974. And interestingly, coming from the name of Watergate, by combining nouns with the word 'gate', it is often used in the English language whenever there is a cover up or scandal as in Irangate or Partygate, the latter being the denial of parties during the lockdown at 10 Downing Street.

'You lookin' at me?' Which is how Vietnam veteran Travis Bickle practises confrontation in front of a mirror. He is played superbly and intensely by Robert De Niro in *Taxi Driver* (1976), directed by Martin Scorsese with a screenplay by Paul Schrader. Outraged by the social decay of the city, as Travis drives his taxi around New York's late-night streets, we hear his voice over: 'Some time a real rain will come and wash away all the scum.' Totally disillusioned with life, and angry and embittered after his date (Cybil Shepherd) rejects him, he becomes a vigilante and sets out to kill senator Palantine, and when this fails he rescues an underage prostitute (Jodie Foster) from her pimp by shooting him and her customer. Not many films come any darker than this one, so don't watch it expecting a few laughs along its journey of decay.

The atmospheric jazz music was Bernard Hermann's final film score, and he died not long after its completion. Perhaps he found the subject matter depressing.

The film was thought to be one of the best of the decade by many critics. And so obsessed with the film was John Hinckley Jr., he claimed it motivated him in his attempt to assassinate Ronald Reagan.

In contrast to *Taxi Driver*, one of the most successful feelgood films of 1976 was *Rocky* written by Sylvester Stallone, who turned down a six figure sum for the rights so that he could play the lead. It was directed by John G. Avildsen about an ordinary working-class man, past his prime as a boxer, but still has his sights on winning the world heavyweight championship from the world champ Apollo Creed (Carl Weathers). It catapulted Stallone to stardom and became the highest grossing film of that year, a sports subject with a love story thrown in, when Rocky falls for the sister of his friend, played by Talia Shire. The film led to a plethora of sequels, up to *Rocky V*. And even beyond number five and then three *Creed* films. Sequels were coming out of Stallone's ears.

Peter Finch at his messianic best plays Howard Beale, a broadcaster on prime time TV urging people to get mad and not to take it anymore in the satirical *Network* (1976). Directed by Sidney Lumet, with a screenplay by Paddy

Chayefsky, the film shows how Beale climbs high in the television ratings, engineered by TV executive Diana Christensen (Faye Dunaway), much to the incredulity of the head of news, played by William Holden, as Beale yells at his TV audience, 'I'm as mad as hell, and I'm not going to take it anymore!'

The film made headlines the year after its release when Peter Finch became the first actor to receive a posthumous Oscar for his manic performance.

The seventies was a milestone in the history of cinema. Now people were buying video recorders so they could watch films on VHS, and it was this system that overtook Betamax which vanished almost overnight. People could now stay at home and record their favourite programmes or films, and many studios now marketed their movies for sale or for hire. Unfortunately, these magnetic tapes created another market for illegal pirating, which Hollywood reckoned to be a loss of more than 300 million dollars from illegal recordings.

Peter Seller's penultimate film was *Being There* (1979), directed by Hal Ashby, with a screenplay by Jerry Kosinski, from his novel. Sellers plays Chance a gardener, an exceedingly simple man whose wealthy employer has died, and Chance is cut adrift. Having spent his entire special needs life in his employer's garden, he has no knowledge of the outside world. Through mistaken identity he is taken in by a powerful senator (Melvyn Douglas) and his wife (Shirley MacLaine), and when he makes the most facile comments, they misinterpret them as profound statements, rocketing him to presidential adviser level. Sellers gives a powerfully restrained performance, full of dignity and subtle humour. The final scene is of him suited and booted, carrying an umbrella, and walking on water across a lake. Which is not so far-fetched. There may be a few actors and sportsmen who think they can walk on water!

The 80s decade began with a drama about a boating accident and problems with an upper middle-class Chicago family. *Ordinary People* (1980), was Robert Redford's directorial debut, with a screenplay by Alvin Sargent, from a novel by Judith Guest, in which 19-year-old Timothy Hutton played Conrad who, devastated by his brother's drowning, attempts suicide and undergoes treatment in a psychiatric hospital. His mother Beth, played by Mary Tyler Moore, known for her sitcom roles in *The Dick Van Dyke Show* and her own *Mary Tyler Moore Show,* was perfect in her serious role as a horrendously cold and distant woman who has difficulty sympathizing with her son. Donald Sutherland as his father was excellent as the floundering figure, unable to cope with his wife's lack of feeling. And Judd Hirsch, who was in the TV sitcom *Taxi*, plays the psychiatrist who helps Conrad to overcome his post traumatic distress.

The picture received four Oscars including Best Picture for producer Ronald L. Schwary, Robert Redford for directing, Alvin Sargent for the screenplay, and

Timothy Hutton for his supporting role, who was at that time the youngest ever Oscar winner.

Many people thought that *Raging Bull*, directed by Martin Scorsese, which was released the same year, should have received Best Picture and Best Director Oscars. But then it was a sports picture, and I guess many people suffer from sport chauvinism.

One of the best ever sports films was released the following year. *Chariots of Fire* was directed by Hugh Hudson, with a screenplay by actor Colin Welland, who researched it vigorously as it told the true story of two runners in the 1924 Paris Olympics. Ian Charleson played Eric Liddell, a Scottish Christian, and Ben Cross was Harold Abrahams, an English Jew, who is affected by anti-Semitism at Cambridge. After much conflict from various sources, both runners are triumphant and win gold medals at the event.

One of the highlights of the film is the wonderful slow-motion running of the athletes, barefoot along the beach to the Vangelis, electronic music score, which received an Oscar.

It took Richard Attenborough a frustrating 20 years until he managed to start shooting his labour of love *Gandhi* (1982). From a screenplay by John Briley, shot in Technicolor, and over three hours in length, this epic film starred Ben Kingsley in the title role as the Indian pacifist who became a world-wide influence for peaceful protest until he was assassinated by a Hindu fanatic. The film starts with his assassination and then flashes back to when as a young lawyer he campaigned in South Africa for the equal rights of Asians, and later in India he worked tirelessly for independence from British imperialism. This is a remarkable film and Ben Kingsley's performance is perfect as the sympathetic non-violent Gandhi, and in one contrasting scene he loses his temper with his wife, and we see his guilty devastation following this outburst. There are so many famous actors playing smallish roles in the film, and all of them are perfectly cast. The film deservedly won many Academy Awards.

In 1986 the most expensive French films ever made at that time were *Jean de Florette* and *Manon des Sources,* shot back to back in colour, directed by Claude Berri, based on novels by Marcel Pagnol. The first film starred Gerard Depardieu, Yves Montand, Daniel Auteuil and Elisabeth Depardieu. Set just after the First World War and located in a village in Provence, Jean of the title (Depardieu) is a city dweller who inherits some land in this rural village, and is treated badly by the locals, especially as he is a hunchback. And most of the trouble is instigated by Le Papet (Montand), the village elder. Some of the locals block a spring with cement, sealing off water that would supply Jean's land, which eventually kills him. But the young Manon (Emmanuele Béart) has seen

what has happened and seeks revenge on the village (which is the subject of the sequel). She falls in love with a local schoolteacher, they marry and she has a daughter. To complicate matters it transpires that Jean turns out to be Le Papet's son, for whose death he is partly responsible. Devastated by the news, on his deathbed he wills his land to Manon's daughter, the granddaughter he has never known.

The films were commercially and critically successful both nationally and internationally, which wouldn't surprise anyone, as they were two of the greatest of French films, stand the test of time and they are worth seeing several times. The music, too, is superb and perfect for the pictures. The only problem with the music is that they used the same theme for several Stella Artois commercials. So if you watch these films, don't be surprised if you are made subliminally thirsty and have to sink a couple of pints of lager afterwards.

In the same decade an unusual British film that won few awards, later became a success through its massive cult following. *Withnail and I* (1987), written and directed by Bruce Robinson, and loosely based on his experiences as an out-of-work actor (the 'I' of the title), played by Richard E. Grant, and his fellow thespian Withnail (Paul McGann), who live in unbelievable squalor, and exist on a diet of booze and drugs. The characters' outspoken and outrageous behaviour generates very funny moments in the picture, and when Withnail's gay Uncle Monty (Richard Griffiths) invites them to spend a week at his cottage in the Lake District, disaster looms, especially when they upset the locals. Eventually, Withnail's agent fixes him up with an acting job, and he has to leave London. His friend is left behind, for whom it seems there is to be no happy ending.

A great tribute to cinema, and an Italian film full of nostalgia for a time in the 1950s before television took over, a time when people enjoyed going to their local picture house, is *Cinema Paradiso* (1988), directed by Giuseppe Tornatore. It tells the story of Salvatore, a film director living in Rome, who learns about the death of Alfredo (Philippe Noiret) from his mother. The film becomes a flashback, and now the young boy Salvatore, whose mother is a widow, befriends the projectionist Alfredo at his local Sicilian cinema, and Alfredo becomes a father figure to the youngster, When Alfredo is blinded by an accident, he is helped and assisted by Salvatore. As well as nostalgia, there is a great deal of humour in the film, especially when Alfredo is forced to splice screen kisses and embraces from the films by the local priest who owns the cinema, causing an uproar in the cinema when the audiences boo from being deprived of the obviously missing scenes. In the present time, the adult Salvatore returns to his hometown in Sicily to attend Alfredo's funeral, and Alfredo's widow gives him a can of film, a gift bequeathed him by the projectionist. Back in Rome, Salvatore

watches the film Alfredo has left him, and it turns out to be every screen kiss and embrace excised from all the films which Alfredo has spliced into one film. Salvatore watches with tears in his eyes.

The film deservedly won the Oscar for the Best Foreign Language Film.

Rain Man (1988), directed by Barry Levinson, starred Tom Cruise as a used-car salesman, determined to get his hands on his autistic brother's inheritance, a brother he has made no effort to get to know. But as the film develops we see Cruise give one of his finest performances as we see this shallow man developing a sense of decency as he sympathises and gets to know his brother, who is also a savant and has an incredulous understanding of mathematics. It was Dustin Hoffman as the autistic brother who got the actor's Oscar, although Cruise gave an equally good performance. It's no wonder George C. Scott was so set against the very idea of this form of competition. But obviously film distributors and producers value them highly because they help to promote their films.

Closely following Hoffman, Daniel Day-Lewis got an Oscar for playing the severely disabled from cerebral palsy Christy Brown in *My Left Foot* (1989). Directed by Jim Sheridan, it was based on Brown's autobiography which he wrote with the eponymous foot, as this was the only part of his body over which he had control. In the film his heavy-drinking father, played by Ray McAnally (who died before the film's release) had little understanding of his son's condition and treated him like an idiot. It was his mother, played by Brenda Fricker (who also received an Oscar for her supporting role) who saw Christy's potential intelligence. Not only is the film almost tragic in places, it is also very funny, as Christy Brown in real life had a great sense of humour and appeared on many television chat shows.

Two films that showed that at last African Americans had a voice of strength in filmmaking were *Do The Right Thing* (1989) and *Boyz 'N The Hood* (1991). In the former, directed by Spike Lee, this social protest film is full of youthful and radical issues, challenging racism, and beautifully photographed in bright colours and slightly tilted camera angles. The film contains a great deal of positivity, despite the scenes of police brutality as anger builds during a very hot day. In the latter, directed by John Singleton, it was a semi- autobiographical coming-of-age story that focuses on three youngsters in single-parent households, attempting to avoid gang violence in the streets outside, and shows them growing up. The boy Tre, when he is 17-years-old, is played by Cuba Gooding Jr., and his father (Laurence Fishburne) instructs him in the hardships of life, and his son manages to avoid violence and makes it into college.

Boyz 'N The Hood was the film debut of rapper Ice Cube.

On 22 November 1963, a murder was witnessed by millions of people on television when President Kennedy was shot in Dallas, and the question of whether assassin Lee Harvey Oswald acted alone or not has never been satisfactorily answered. *JFK* (1991) was directed by Oliver Stone, and focuses mainly on real-life lawyer Jim Garrison (Kevin Costner) as he attempts to sift through evidence and doubts about the Warren Commission report. The film has many great actors, including Gary Oldman as Oswald, and Kevin Bacon, Tommy Lee Jones and Sissy Spacek,

But, although the picture throws up many theories, if you don't buy into the lone assassin story, then there are still no concrete answers about who was really responsible for this 60 year-old murder. And if you think about the endless theories that have been written about the murder of the princes in the Tower of London 500 years ago, and still nothing is resolved about whether it came from Richard the Third's orders or not, might future historians still be discussing the conspiracy theories about the Kennedy assassination in the next millennium?

Tom Hanks got an actor in a leading role Oscar two years running. The first was for *Philadelphia* (1993) in which he plays a gay lawyer with AIDS, directed by Jonathan Demme. In 1994 he got an Oscar for his role in *Forrest Gump*, directed by Robert Zemeckis, with a screenplay by Eric Roth, from a novel by Winston Groom. Hanks plays the eponymous mentally handicapped Forrest, who sails amiably through an American history of the second half of the twentieth century, meeting at least three US presidents. Hanks plays this simple character perfectly.

La Haine (Hate) released in 1995 was written and directed by Mathieu Kassovitz, and actors Vincent Cassel, Hubert Kounde and Saïd Taghmaoui play three young men from poor immigrant families, who learn of their friend Abdel's severe injuries in police custody and become hellbent on revenge. Riots in a Paris suburb are sparked by police brutality, and the film follows the three friends over 24 hours, climaxing in a bloody ending as Cassell as Vinz is captured by a detective who holds a gun to his head. The gun goes off accidentally, killing Vinz. This powerful film received a standing ovation when it was shown at the Cannes Film Festival.

Probably the best British picture of the decade was the 1996 *Trainspotting*, directed by Danny Boyle, with a screenplay by John Hodge, from the controversial novel by Irvine Welsh. Located mainly in Edinburgh, the picture kicks off to a brilliant start as Mark 'Rent Boy' Renton (Ewan McGregor) runs along streets and alleyways escaping from a petty crime, and we hear his voice over of the ironic 'Choose Life'. He and his pals, Sick Boy (Jonny Lee Miller), Spud (Ewen Bremner) and Begbie (Robert Carlyle) are the sickest bunch of drug

addicts and dealers you have ever seen, especially Begbie who has the makings of a serious psychopath. There are some scary moments in the film, enough to put you off developing any habits yourself, as Renton imagines diving into the most disgusting toilet in Scotland to retrieve some drugs, and when he attempts detox he hallucinates about the haunting images of the dead baby on the ceiling.

Towards the end, the story locates to London for the final scenes where Renton double-crosses his pals following a lucrative drug deal, and disappears to forge a new life for himself.

The film was also Kelly Macdonald's debut feature.

Having seen this film several times, and also the sequel *T2 Trainspotting*, I decided I would stick to red wine!

Another great British film was released the same year. *Secrets and Lies* was written and directed by Mike Leigh, and was very different from *Trainspotting*. Hortense (Marianne Jean-Baptiste), who is black, discovers at her adoption agency that her mother is white. Cynthia (Brenda Blethyn) put her up for adoption at birth and emotions become strained when they meet up. There is a terrific scene between mother and daughter in a café, and Mike Leigh encouraged the actors to improvise as he did for many of his films. And there are some ferocious family scenes in the picture. But the mark of a good, well-written drama means that there are also some comic moments in a story, as there are in this picture.

The English Patient (1996), from a novel by Michael Ondaatje, is an epic film, directed by Anthony Minghella, who also wrote the screenplay. During World War Two a biplane is shot down by German gunners while flying over the North African desert, and the badly burned pilot (Ralph Fiennes) is rescued by a group of Bedouin. In 1944 he is cared for by Hana (Juliette Binoche), but he cannot remember who he is or his name. The film becomes mainly a flashback revealing that the English patient is in fact a Hungarian cartographer who spoke with an English accent, and began a love affair with Katherine (Kristin Scott Thomas), who is married to a colleague (Colin Firth).

Rather than a conventional war film, although set during the war, this very romantic tale involves several love stories, and the eloquent and striking narrative brought it into high regard by the BFI who rates it as the 55th greatest British film of the 20th century. Not to mention all the other many awards it received.

Run Lola Run (1998) is a remarkable German film, written and directed by Tom Tykwer. Lola (Franka Potente) has to raise 100,000 Deutschmarks in twenty minutes to save the life of her boyfriend Manni (Moritz Bleibtrue) who has lost money belonging to a gangster. The film explores the difference between free will and determinism as Lola races at breakneck speed to help her

boyfriend, and follows different timelines as her story rewinds and events take different paths with alternative outcomes, and scenes suddenly jump cut to Lola's plight in animation. This is a highly fascinating and original film and zaps along at a cracking pace. Don't worry if you don't like sub-titles. You can follow this story without reading them.

Edward Norton plays an unnamed character, the narrator, in *Fight Club* (1999), directed by David Fincher, from a novel by Chuck Palahniuk, with a screenplay by Jim Uhls. Tortured by day-to-day lack of interest and his work, Norton attends support group meetings where he meets and falls for Maria (Helena Bonham Carter), and later meets the wild Tyler Durden (Brad Pitt), who has strange philosophical and radical views, and then the unnamed narrator persuades Tyler to take up bare knuckle fighting. Their street fighting attracts other men who need to get some action into their consumer dominated lives, and the Fight Clubs soon organize into terrorist cells. Meat Loaf (sans a motorbike) plays a cancer patient with gigantic breasts.

Fight Club, when it opened, became something of a Marmite picture. Many people loathed it, but it was regarded favourably by younger audiences, leading many people to fear that it would lead to copy-cat behaviour, as happened to a certain extent with *A Clockwork Orange.*

However, the film's photography was stunning and the special effects superb. The film was undeniably exciting and strange. The only Oscar nomination the picture received was for special sound effects. But it had a great deal of competition that year as it was up against *American Beauty, Being John Malkovich, The Matrix* and *The Sixth Sense.* But *Fight Club* has to a certain extent become a cult classic and often receives five stars in TV guides whenever it is shown on television.

Lester Burnham (Kevin Spacey) is having a mega mid-life crisis in *American Beauty* (1999), as his suburban, American glossy magazine life seems to be grinding to a halt. Beautifully directed by theatre director Sam Mendes, with a screenplay by Alan Ball (TV series creator of *Six Feet Under*), we hear Lester's voice-over saying, 'I'm 42-years-old, in less than a year I'll be dead. Of course, I don't know that yet. In a way, I am dead already.' This plot device seems to be paying homage to the classic *Sunset Boulevard* when Joe Gillis is found dead in Norma Desmond's swimming pool.

This film, though, is about the souring of the American Dream. Lester is unhappily married to Carolyn (Annette Benning), who is neurotic and materialistic, and their homophobic neighbour Frank Fitts (Chris Cooper), is an ex-US marine who is very much the dominant patriarch of his family. Lester becomes infatuated with his schoolgirl daughter's best friend and imagines

her naked and covered in roses. When distraught Frank Fitts takes his family problems to Lester and attempts to kiss him, Lester rejects him, and he ends up shot in the back of the head. We then see Fitts returning home and taking off his bloodied plastic gloves, and there is a gun missing from his gun rack. Finally, we hear Lester's voice-over, almost accepting his inevitable death, which he knew was coming from his voice-over at the start of the picture.

One of the most successful foreign-language films in American movie history was the martial arts *Crouching Tiger, Hidden Dragon* (2000), directed by Ang Lee. The actors seemed to defy gravity as they fought over treetops and rooftops during the balletic fight scenes. Stunt work was performed by the actors themselves, and computers were used to eliminate the safety wires that held them up high. Problems during the shoot came from the many different dialects and differences in the Chinese language of the actors, some of whom spoke Cantonese, while others spoke Malay Chinese, or standard Chinese with a Taiwanese accent. Apparently only one actor spoke with a native Mandarin accent.

The fight sequences were jaw-droppingly spectacular, however, but the character development and the motivations of the characters did not take a back seat to the martial arts choreography.

Director Ang Lee was already a well-known Hollywood director, having made the Jane Austen classic *Sense and Sensibility* (1995), from a screenplay by Emma Thompson, in which she played Elinor Dashwood, with Kate Winslet as her younger sister Marianne. Ang Lee also went on to make *Brokeback Mountain* (2005), starring Jake Gyllenhaal and Heath Ledger as two gay modern day cowboys. In 2012 he directed the incredible *Life of Pi* from the Man Booker prize-winning novel by Yann Martel.

One of the most terrifying films in the first decade of the new century was the South American, *City of God* (2002), although it was a Brazil/France co-production, directed by Fernando Meirelles and Katia Lund, it was made in the Portuguese language of Brazil. Set in a favela, a ghetto or slum in a suburb of Rio de Janeiro, it features mainly young boys having to deal in drugs in order to survive. The gang warfare is shocking and brutal, and there is one horrendous scene as a very young boy is given a gun and told he must shoot another young boy to avoid his own execution, and he has tears of real fear streaming down his face. One of the leading youngsters acquires a camera, and manages to earn a living by selling photographs of the favela to newspapers. But when one of his photos of a vicious gang leader makes the front page of a newspaper, he fears for his life, but is let off the hook by the psychotic gang leader's ego at seeing his front-page notoriety.

The cast were mainly non-professional actors who were recruited from the real favela and given acting workshops in advance of the principal photography. The film is brilliantly shot, fast-paced, with hand-held camerawork and jump cuts, and is highly regarded as one of Latin America's finest films.

Spanish filmmaker Pedro Almodóvar's fourteenth picture *Talk To Her* (2003) is possibly more restrained than many of his earlier films. Two of the female leads in the film end up in hospital in a coma, one of them being a female matador who has been gored by a bull. The two male protagonists are antisocial and lonely, and their dialogue with the women is limited and blinkered. His 1999 feature *All About My Mother* is far more demented, echoing the liberalisation of Spain following dictator Franco's death in 1975, and the film's bright colours and colourful characters border on surrealism, melodrama and comedy. For instance, crazed with grief at the death of her gay son, single mother Manuela travels to Barcelona and becomes a sort of surrogate mother to a pregnant nun with AIDS (Penelope Cruz).

An Academy Award for the Best Foreign Language Film went to *All About My Mother* and Almodóvar also received an Academy Award for his screenplay *Talk To Her.*

Set in East Germany, prior to the collapse of the Berlin Wall, *Good Bye Lenin!* (2003) is a German film directed by Wolfgang Becker. Alex (Daniel Bruhl) has been arrested at a riot, and his mother (Katrin Sass), who is a committed communist, collapses and goes into a coma. Alex is told that when his mother recovers, a shock could give her a relapse. And so Alex sets about keeping the reunification of Germany a secret and goes to great lengths to show her that the old GDR has survived and he even finds the vilest East German foodstuffs to keep up the masquerade. The story contains a great deal of humour as well as having a more serious side towards the end.

Crash (2004), directed by Paul Haggis, with a screenplay by him and Robert Moresco, was the surprising winner of a Best Picture Oscar. Surprising because it was heavily criticised in so many circles for its plot contrivances. However, the picture has some brilliant surprises, and interconnecting storylines and great dialogue. The film concerns racial tensions in LA is heaped with misunderstandings, a murder and a few twists, and became a highly entertaining picture.

Probably one of the best German films of the decade was *The Lives of Others* (2006), written and directed by Florian Henckel von Donnersmarck. Set in East Germany in the early '80s, Ulrich Mühe plays Gerd Wiesler, a Stasi captain who is ordered to spy on and monitor a playwright and his girlfriend. And when his superior officer fancies the writer's girlfriend, Wiesler is ordered to increase

his efforts to convict the writer. But as Wiesler does his grubby surveillance, he becomes sympathetic towards them and alters his observations. After the collapse of the Berlin Wall and reunification of Germany, Wiesler sees in a bookshop window that the writer has written a bestselling book. He goes into the shop, looks inside the book, and discovers that the dedication is to himself, not by name but by his Stasi codename. And so he buys a copy of the book.

Although this might be described as a thriller, it is a great deal more than that. Political thriller, perhaps. It is such an outstanding film, dark in places, but often with snatches of humour, with a truly uplifting ending. It deserved its very many world-wide awards.

The bestselling 1995 book, *The Diving Bell and the Butterfly* was the true memoir of Jean-Dominique Bauby, editor-in-chief of the magazine *Elle*, who suffered a stroke and became paralyzed with locked-in syndrome. The film of the same name (2007) was made in French at the insistence of American artist and director Julian Schnabel, who learnt French prior to shooting it, with a screenplay by Ronald Harwood (*The Dresser*).

In the film, following his stroke, we the audience can hear Bauby's voice-over, but the characters visiting him in hospital, family and friends, don't hear what he is saying and how he is trying to communicate. Although he is totally paralyzed he is mentally normal. Then it is discovered that he has slight movement in his left eyelid, and with the aid of a speech therapist, he dictates his memoir by laboriously blinking his left eyelid when the therapist gives him options of various letters. In his dictated memoir he reveals some of his past and normal life. There is also one suspenseful scene in which we empathise with Bauby's frustration when he watches one of his favourite football matches from his hospital bed, and a porter comes in and switches it off mid-match. We hear Bauby screaming for it to be left on, but of course no one can hear him.

This very moving film (and book) has a tragic ending as Bauby completes his memoir and dies of pneumonia only a few days after its publication, although there is some solace in the fact that he did at least complete his memoir.

Director Paul Thomas Anderson directed the excellent *Boogie Nights* (1997) about the porn industry, and *Magnolia* (1999), but it was his epic *There Will Be Blood* (2007), for which he wrote the screenplay based on the Upton Sinclair novel *Oil*, that would become his masterpiece, a story of greed, capitalism, religious fanaticism, and American acceptance and a craving for all of them.

At the turn of the 20th century, Daniel Plainview (Daniel Day-Lewis), adopts H.W. the son of a miner who was killed while prospecting and discovers oil on the Sunday family ranch in California. Remarkably, no dialogue is spoken during the first 20 minutes of the film, but the audience is drawn in to the

action as Plainview prospects for the black gold. At first he seems a fair and reasonable man, and uses H.W. as his real son, claiming to be a family man which helps in his negotiations. And so, there is little actual conflict for the first hour. Although there is a fascinating development and change in his character that becomes apparent. His nemesis is Eli (Paul Dano) a fire and brimstone preacher, who demands more money for oil-drilling on his family's land.

Tragedy happens when one of the oil wells explodes and H.W. becomes permanently deaf from the blast and Daniel, as if the boy is now a broken toy, sends him away. Tragic events are now compounded as Daniel commits murder, shooting a man claiming to be his long-lost half-brother (Kevin J. O'Connor) and he hits the bottle, becoming more and more paranoid. H.W. returns, marries one of the Sunday family daughters, but his father insults him, tells him he is adopted and calls him 'Bastard from a basket'. The final scene of the drama takes place in Plainview's mansion, where he drunkenly forces Eli to renounce his religion in favour of money and kills him. His butler then enters as Daniel cries out, 'I am finished'.

Daniel Day-Lewis is brilliant as the paranoid Plainview, as is Paul Dano as the fanatically religious Eli.

But from the very first scene which takes place at the end of the nineteenth century, up until 1929, no women are seen to cavort with or even to share Plainview's life. He appears to have been celibate from the off. No wonder he became frustrated and paranoid!

A French film *The Prophet* (2009), directed by Jacques Audiard, is a powerful prison drama, telling the story of Malik (Tahar Rahim), a young Muslim man, whose disintegration into an immoral abyss when he, in order to become accepted in the prison's hierarchy, kills a man on the orders of a Corsican gang leader. In his cell at night, his conscience is troubled by the ghost of a Muslim, and the Corsican eventually gets his comeuppance from the redemptive Malik whose Muslim brothers kill him.

The Prophet is a hugely compelling film, intelligent and passionate. But here is a health warning: there are no laughs in the picture.

The biggest hit of 2009 was a British film set in India. *Slumdog Millionaire*, directed by Danny Boyle, with a screenplay by Simon Beaufoy, based on the novel *Q & A* by Vikas Swarup, had as its core of the plot a contestant on a Hindi version of *Who Wants To Be A Millionaire*. The production company of the famous quiz show was Celador, who also produced the *Slumdog* film.

The film begins with the arrest of Jamal Malik (Dev Patel), a Muslim from the slums of Mumbai, who is accused of cheating on the quiz show, and then in a series of flashbacks we see his impoverished childhood, and see how

throughout his early life he became able to answer the questions on the show. He is exonerated, wins the top prize, and then we are treated to a Bollywood type of ending with a big production number on a station platform.

The film won eight Academy Awards, and for showing in Indian cinemas the actors were dubbed into Hindi. The main character was not an army major and there was no coughing involved in the quiz show.

The Social Network (2010) a film about the founding of Facebook was directed by David Fincher, with a screenplay by Aaron Sorkin (writer and creator of *West Wing*) and based on the book *The Accidental Billionaires* by Ben Mezrich.

The film details how Mark Zuckerberg, played by Jesse Eisenberg, a 19-year-old second year student at Harvard, created Facebook. A film about internet social media might not sound exciting or even watchable, but this story gallops along at a cracking pace (keep up, can't you!) with issues of greed, jealousy, betrayal, power struggles, disloyalty and treachery, with investment deals being made behind backs and depositions flying around like confetti in a gale. The logline to the film reads: 'You don't get to 500 million friends without making a few enemies.'

The first Iranian film to win the Academy Award for Best Foreign Language Film was *A Separation* (2011), written and directed by Asgar Farhadi, it tells the story of a secular middle-class family in Tehran, a husband and wife who have marital problems, their eleven-year-old daughter, and her grandfather who lives with them and suffers from Alzheimer's. When they employ a working class woman and her pregnant daughter to look after the old man is when the fireworks start, as at one stage they lose him in a busy street. Not only is the film filled with great observation and humour, it has great tenderness and humanity. It finishes when the husband and wife go to court and are granted a divorce, while their daughter waits outside prior to telling the judge which parent she would prefer to live with.

Steven Spielberg said that the film was by far the best of that year.

In 2016 Farhadi wrote and directed *The Salesman*, also set in Tehran, about a husband and wife and their fellow actors producing a translation of *Death of a Salesman* by Arthur Miller for the theatre. This excellent picture also won Best Foreign Language Film at the Academy Awards but Farhadi did not travel to Los Angeles this time to attend the ceremony as a protest because of Donald Trump's signing the declaration banning Muslims in certain countries from travelling to the US.

Ken Loach in a much lighter vein than usual directed the Scotland-based *The Angels' Share* (2012) in which a bunch of scallywags find a way of stealing extremely expensive malt whisky which they plan to sell. The title refers to the portion of whisky that evaporates during the ageing process.

And like the Proclaimers' musical *Sunshine on Leith* (2013), Loach's film ends with their song 'I'm Gonna Be (500 Miles)'.

Two outstanding films were released in 2013, both about making money, but both very different inasmuch as the American one was about greed and power, whereas the British film was about poverty and making money in order to survive.

The Wolf of Wall Street, directed by Martin Scorsese was based on a memoir by Jordan Belfort, played by Leonardo DiCaprio in the film, the fifth film the actor had made with Scorsese. 'Greed, for lack of a better word, is good,' is a quote which shows how corrupt Belfort is as he swindles his way in financial deals, which leads to excessive sex and drug-taking. It was banned in many countries and also heavily edited in others, mainly because of its excessive use of profanities. It is in *The Guinness Book of Records* as having used more profanities than any other film, using the word 'fuck' 506 times, narrowly beating the British picture *Nil by Mouth* (1997).

To know how many profanities there are in a picture, someone must have sat with pen and paper as they watched the film and counted each swear word. Was it a paid employment, I wonder?

The British film *The Selfish Giant* was written and directed by Clio Barnard, set on the outskirts of Bradford, about two young teenage lads collecting scrap metal in order to survive. When they discover an easier way to find metal by stealing copper from telecoms and railway installations, the scrap metal dealers don't question where they are getting the metal from. One of the boys has a talent and a great affection for horses, which scrap dealers use. The film ends tragically as one of the boys cuts through high voltage wire on a pylon to extract the metal and is electrocuted.

One of the boys is named Arbor, which was the title of Clio Barnard's 2010 film about playwright Andrea Dunbar (*The Arbor* and *Rita, Sue and Bob Too*), the Buttershaw Estate in Bradford, and Dunbar's tragic death at the age of twenty-nine.

If you like bizarre tales then check out the Spanish language *Wild Tales* (2014), an anthology of highly original stories in six segments, shot in Argentina. The first one takes place on an airline where mysteriously all the passengers discover they have something in common resulting in their death. The second film has a chef at a roadside restaurant offering to put rat poison in a customer's meal whom the waitress has recognized as a criminal.

Be warned: the third tale is what happens to people during a road rage incident. Number four is what happens to a man after his car has been towed away and he tries to reclaim it, and this tale seems to be about the helplessness

of someone trying to fight against an unfair system. The fifth segment is about a teenage boy driving his wealthy father's car and is guilty of a hit and run when he kills a pregnant woman. And the final spectacular film takes place during an enormous wedding reception where the bride discovers her groom has had sex with one of the guests. The reception becomes a squawking and screaming nightmare as guests and new in-laws are plunged into fights and arguments. What begins as a fairly normal wedding reception, is suddenly warped into horrendous and unbearable abominations, and becomes highly entertaining.

One of the most important biographies to be made into a film was *The Imitation Game* (2014) about Alan Turing (Benedict Cumberbatch), and was written by Graham Moore, based on a biography on Turing by Andrew Hodge, and directed by Morten Tyldum, the Norwegian director who directed *The Headhunter* from a novel by Jo Nesbo.

The largest section of the film dealt with Turing's work at Bletchley Park, along with his co-worker and later his wife Joan Clarke, played by Keira Knightly, as he attempts to break the code of the Enigma machine used by the Germans to send messages and secrets during World War Two, Although Turing has problems with his superior officer regarding some of his failed attempts to break the code, he does eventually succeed in breaking it, thus saving many British and allied lives, and paving the way for the advent of information technology. But Turing was gay, and when the authorities found out and hounded him, he was offered either a prison sentence or chemical castration. He chose the latter, and in 1954, he became depressed and committed suicide.

Turing should have been showered with accolades and tributes instead of being persecuted. The film does reveal at the end that he received a posthumous pardon from the Queen. Was that an intended irony of the filmmakers?

A suspenseful film with a harrowing subject is the Danish *Land of Mine* (2015), directed by Martin Zandvliet. It is based on true events immediately after World War Two when German soldiers, many of them still in their teens, were forced to clear thousands of land mines from the beaches in Denmark. Many of the soldiers are blown up and killed, while others suffer severe injuries. Because of the German occupation during the war, they are shown little sympathy, and become malnourished from lack of food. However, despite this horrifying though gripping narrative, it does have a positive ending when one of the main characters, a kindlier Danish officer, takes pity on four of the boys, drives them to within 500 metres of the German border and tells them to run for it.

An exceptional and sensational film in 2016 was *I, Daniel Blake,* written by Paul Lavery and directed by Ken Loach. Set in Newcastle, Dave Johns plays the

title role as a joiner who has a heart attack and is told not to work by his doctor, but is unable to claim any benefits as the authorities think he is perfectly fit to get a job. He meets Katie (Hayley Squires) a single mother, who cannot afford to feed her daughter and becomes a prostitute. Things go from bad to worse in this socially realistic film, and Blake near the end paints graffiti on a wall near the employment office claiming that he is not a blip on a computer screen but is a human being.

The film won the Palme d'Or at Cannes and a BAFTA for an Outstanding British Film.

Based on a true story, *Green Book* (2018) co-written and directed by Peter Farrelly, starred Vigo Mortenson and Mahershala Ali as Frank 'Tony Lip' Vallalonga, an Italian American club bouncer, and Ali as Don Shirley, an African American classical concert pianist. Set in 1962, Tony is employed as Don's bodyguard and driver, taking him to attend classical concerts in the Deep South. At first there is friction between the two very different men, but eventually they become friends when Tony witnesses hostility and prejudice towards Don. And when a police officer insults Don, Tony lashes out and ends up in jail, but is released when the influential pianist makes a call to Robert Kennedy, then the Attorney General. Following the concert tour, and stuck in a blizzard, they eventually make it home in time for Christmas, and Don spends Christmas Day with Tony and his extended family. During the end titles we see actual photographs of the real Don and Tony, who remained friends until their deaths only months apart from each other in 2013.

The screenplay was co-written by Tony's son Nick. And the film's title comes from a book that was published in the sixties called *The Negro Motorist Green Book*, which gave details about which hotels, restaurants and filling stations that were available to black motorists in the segregated South.

The first South Korean film to win the Palme d'Or at Cannes was *Parasite* (2019). It was directed by Bong Joon-ho, which he co-wrote with Han Jin-won. The film follows a poor family and their schemes to take over an extremely rich household, which they do by guile, cunning and subterfuge, with an almost shocking and very bloody climax. There is also a great deal of humour in the film as family members take over the house in dribs and drabs, eventually becoming the controllers, until it all goes horribly wrong.

The wealthy family's house was not real but was a stunning architectural feat of set design, as was the poor household. And the film seems to be a metaphor for social inequality and the extreme chasm that divides the poor from the rich.

More violence in Gotham City as the DC Comics villain is given his own story in *Joker* (2019) which was directed by Todd Phillips, which he co-wrote

with Scott Silver. Here the joker, Arthur Flecks (Joaquin Phoenix) becomes a clown, often laughing himself silly, and when he does a stand-up routine, no one finds him funny. His love interest is a single mother played by Zazie Beetz, and Robert De Niro is a talk show host, his character almost a reverential tribute to his classic film *King of Comedy* (1982) which was directed by Martin Scorsese, and also starred Jerry Lewis and Sandra Bernhard.

But this Joker's Gotham City is possibly the darkest ever on film. There is no help for the citizens of this sombre urban hell. It looks and feels like a super hero picture, but there are no super heroes in this Gotham, only violence and despair. But there are some very funny moments in the film, which ends with Arthur Flecks in a lunatic asylum, laughing hysterically as he runs down a corridor, leaving behind him a trail of bloody footprints.

The most fascinating and interesting film of 2020 was the Irish *The Banshees of Inisherin*, written and directed by Martin McDonagh. Set just after the Irish Civil War in 1923 on an island off the west coast of Ireland, it begins one day as Padraic (Colin Farrell) visits his friend Colm (Brendan Gleeson) who no longer wants to know him. And this is where the wonderful story takes off, a one-sided relationship with Padraic failing to understand why his friend no longer wishes to even speak with him, leading eventually to misguided violence. Padraic's wife (Kerry Condon) can stand it no longer and leaves for a job on the mainland, and Dominic, a friend of the couple (Barry Keoghan), is abused by his Garda father. This is a wonderful supporting performance from Barry Keoghan, ending in tragedy when Dominic's body is found drowned in the sea. In fact, everyone gives a perfect performance in this moving and intelligent picture, with atmospheric locations and great music. And it reunited Farrell and Gleeson with Martin McDonagh, who wrote and directed *In Bruges* (2008), a black comedy crime thriller in which the two actors played hitmen.

Another film set in Ireland is the coming-of-age and family drama *Belfast* (2021). It was written and directed by Kenneth Branagh, influenced by his own Protestant upbringing in that city during the start of the troubles in 1969. Predominantly shot in black and white it tells the story of a difficult family life as seen through the eyes of young Buddy (Jude Hill). His father 'Pa' (Jamie Dornan) often has to visit England to find work, and his supportive wife is beautifully played by Catriona Balfe, with Ciaran Hinds as Buddy's granddad and Judi Dench as his grandmother. Following grandad's death, and finding the escalating violence ever more dangerous, 'Pa' decides he will accept a job in England and move there with his family. Buddy throws a tantrum as he doesn't want to leave his home, and leave behind his Catholic school friend, but he eventually gives in. Judi Dench as grandma wants them to have a new

beginning and a better life, but sadly she is left behind and watches as they catch the bus to take them to the airport.

There is a scene in the film when the family are in church listening to the fire and brimstone sermon of the Protestant preacher, Buddy watches with curious interest, and at the end of the vicar's religious rant, he congratulates him on having performed a good sermon. Was this, like the family's visits to the local cinema, early influences on Branagh becoming an actor?

The music for the film is by Belfast musician Van Morrison.

Costume Drama

One of MGM's most powerful stars in the 1930s was Greta Garbo whose contract with them had expired in 1932. They wanted her to play the title role in *Queen Christina* (1933), and she was lured back to Hollywood from Sweden to play the 17th century Swedish queen because it was a part she had helped to instigate. The director was Rouben Mamoulian, who summoned Laurence Olivier to meet her and play the part of her lover, the Spanish envoy Antonio. But when Olivier met with Garbo she treated him frostily and the renowned British actor was forced to withdraw. Such was Garbo's power at the time that she was able to choose her own leading man, and she insisted the role went to John Gilbert, one of her silent movie co-stars and a former lover. It was the fourth and last time they would work together. Garbo was probably the first star to wield so much power over the Hollywood moguls.

Hollywood was successful in choosing the story of a French writer for one of their greatest costume dramas. *The Life of Emile Zola* (1937), directed by William Dieterle, told the sensational story of the principled 19th century writer who risked everything when he stood up for Dreyfus, a military officer falsely accused of selling military secrets to Germany and sent to Devil's Island in Guiana. Émile Zola wrote the famous letter which took up the entire front page of a Parisian newspaper titled *J'accuse*.

The Zola story was the second French subject for William Dieterle. In 1935 he made *The Story of Louis Pasteur* and actor Paul Muni starred in both as Pasteur and Zola.

David O. Selznick was one of Hollywood's most powerful producers and bought the rights to Margaret Mitchell's epic American civil war drama *Gone With The Wind*. But it was several years before shooting began as he wanted Clark Gable to play Rhett Butler who was under contract to MGM, Eventually he managed to negotiate a deal but then had difficulty in finding his ideal Scarlett O'Hara, and hundreds of well-known actresses vied for the coveted role and were screen tested. But the part eventually went to British actress Vivien Leigh. George Cukor began directing it but Selznick sacked him and got in Victor Fleming instead. Vivien Leigh and Olivia de Havilland (who played

Melanie) then visited Cukor who secretly gave them the direction they weren't getting from Fleming.

The film had many memorable lines, ending with Scarlett's plaintive but optimistic 'Tomorrow is another day,' before the end credits role. The film was enormously successful and if you make allowances for monetary inflation, it's the highest grossing film in cinema history. It premiered at Loew's Grand Theatre in Atlanta on 15 December 1939. As the stars were driven in a motorcade to the premiere, it was estimated that at least 300,000 Atlanta residents lined the streets. But it also had an enormous downside: none of the African American performers were allowed to attend the event. Hattie McDaniel (the first African American to receive an Oscar for her supporting role), could not attend because it would have meant her sitting in the auditorium next to a white person. When Clark Gable heard that she had been barred from the premiere, he threatened to boycott the event, but it was McDaniel who persuaded him to attend.

Over the years many people have criticized the film, accusing it of historical negationism, for the way it glorified slavery, and filmmakers and audiences alike were in denial about the way the slaves were actually treated. Unlike the excellent *12 Years a Slave* (2013), directed by artist Steve McQueen, which is based on the memoir of an African American free man, who was kidnapped in Washington D.C., taken down south and sold into slavery.

Hattie McDaniel was also criticized for taking on such a role in Margaret Mitchell's epic. She responded by replying that she would sooner earn 700 dollars a week playing a maid rather than seven dollars for being one.

The books of the Brontë sisters have been filmed many times, both for cinema and TV. In 1939 Emily Brontë's *Wuthering Heights*, directed by William Wyler, starred Laurence Olivier as Heathcliff and Merle Oberon as Cathy. Although many of their scenes are memorable, their relationship was sometimes fraught, and there were many tears before bedtime. And Wyler didn't let up on Olivier's performance, demanding take after take. When Olivier asked him after 39 takes what he wanted him to do, Wyler just told him to do it better.

But the film has a great deal of atmosphere, framed against the background of the forbidding moors (studio-based) and aided by Gregg Toland's brilliant black and white cinematography.

20th Century Fox made Charlotte Brontë's *Jane Eyre* (1943), directed by Robert Stevenson, and Aldous Huxley contributed to the screenplay. Rochester was played by Orson Welles with Joan Fontaine in the title role, Welles received a salary of $100,000, but he accepted this decent sum of money for his performance so that it enabled him to finance one of his own projects, and this would happen on many occasions in the future.

Laurence Olivier had thought of Shakespeare's *King Henry V* as too jingoistic for his consideration. But during the Second World War he reconsidered making it as a film, especially as the government thought of it as a patriotic morale booster, and it was released in 1944 in colour. The film begins by showing Elizabethan actors performing at the Globe Playhouse, and in this part of the film the performances are distinctly hammy, up until the location shoots and the battles in France, where the actors give a more realistic portrayal of the events.

The battle scenes were shot in Ireland, and during one of the scenes a horse passed too close to Olivier, who was observing the scene through a viewfinder, and his upper lip was cut to the bone, leaving him with a permanent scar, which probably explains why he played many film roles after that with a moustache; except for *Marathon Man* (1976), in which he played a nasty Nazi, and those evil thugs often have scars.

Following the success of Olivier's *Henry V* it was decided that *Julius Caesar* (1953) would be a good subject with some British and some American actors. It was adapted for the screen and directed by Joseph L. Mankiewicz, although he retained most of Shakespeare's dialogue. And because this was thought of as a story about politics and power, it was decided that they would not make it as an epic movie, and it was shot in black and white. Marlon Brando starred as Mark Antony, with James Mason as Brutus and John Gielgud as Cassius, with Greer Garson and Deborah Kerr as Calpurnia and Portia. Brando asked Gielgud's advice about declaiming Shakespeare, and so impressed was Gielgud with Brando's performance that he offered to direct him as *Hamlet* on stage. Brando seriously considered the offer but eventually nothing came of it.

William Shakespeare is one of the most filmed authors with over 400 adaptations of his works in one shape or form. In 1967 Franco Zeffirelli made *The Taming of The Shrew* with Richard Burton and Elizabeth Taylor, and he followed this up in 1968 with his *Romeo and Juliet* starring teenage actors Leonard Whiting and Olivia Hussey. Zeffirelli also made *Hamlet* (1990) with Mel Gibson as the Prince of Denmark and Glenn Close as his mother. An excellent film of *Macbeth* came out in 2015, directed by Justin Kuzel, starring Michael Fassbender in the title role with Marion Cotillard as Lady Macbeth. Olivier's very thoughtful *Hamlet* was in 1948 and in 1955 he brought a very distinctive *Richard the Third,* to the screen, a Technicolor adaptation featuring many well-known Shakespearian actors. Olivier's performance was so distinctive that Peter Sellers parodied it when he did a perfect impression of Olivier as King Richard when he recited Lennon and McCartney's 'A Hard Day's Night'.

One of the most stunning black and white Shakespeare films is *Falstaff: Chimes at Midnight* (1967), directed by and starring Orson Welles, a compilation

of *Henry IV Part One*, *Henry IV Part Two*, *Henry V*, *Richard II* and *The Merry Wives of Windsor*, bringing the outrageous comic shape of Falstaff (Welles) to the centre stage of the action as he bedevils Prince Hal (Keith Baxter), and is brought to a sad end as the newly crowned Henry rejects his old friend now that he's King.

Japanese director Akira Kurosawa filmed *Throne of Blood* (1957) an adaptation of *Macbeth* and *Ran* a reworking of *King Lear*. In fact, filmmakers from many countries have made filmed adaptations of Shakespeare's plays.

So many films have given Shakespeare a modern interpretation, such as *Richard III* (1995) set in a 1930s Britain, with Richard (Ian McKellen) as a fascist plotting to usurp the throne. One of the best modern versions was Baz Luhrmann's *Romeo + Juliet*, set on the coast of California with guns, gangsters and pool halls, with the star-crossed lovers divided by their opposing Mafia families, with Leonardo DiCaprio and Clare Danes in the title roles.

Many films are based on Shakespeare's plots – although that is I suppose debatable, as he borrowed many of his plots from other writers. But life's too complicated, so let's just stick to a few examples of films loosely based on Shakespeare plays. Apart from the Sharks and Jets musical, there is Cole Porter's musical *Kiss Me Kate* based on *The Taming of The Shrew* and the lesser known musical *The Boys from Syracuse* (1940), written by Richard Rodgers and Lorenz Hart and based on *A Comedy of Errors*. The fascinating sci-fi picture *Forbidden Planet* (1956) is loosely based on *The Tempest* and the children's animated film *The Lion King* is based on *Hamlet*. And I think that's enough to be going on with.

Wait a minute! How could I forget one of Shakespeare's most popular plays which is performed all over the world? I mean of course *A Midsummer Night's Dream*. There have been many versions on film, the first being a silent version in 1909. But the first black and white sound version was in 1935 with popular actor and song and dance man Dick Powell as Lysander. He would go on to play private eye Philip Marlowe in *Murder My Sweet*, but critics said he was totally miscast as Lysander and he wholeheartedly agreed with them. Most of the critics liked Olivia de Havilland as Hermia, which was her debut film performance, four years prior to her role in *Gone With The Wind*. James Cagney played Bottom, with Mickey Rooney as Puck, and Joe E. Brown was Flute, although most people would in future remember him for his memorable tag line in *Some Like It Hot*. The *Dream* was directed by Max Reinhardt, an Austrian-born director who didn't speak English and he gave direction to cast and crew in German, which was then translated by his co-director William Dieterle. The film was banned in Germany by those goose-stepping idiots simply because

Reinhardt was Jewish, and so was Mendelssohn, whose music was used in the film.

When it comes to great costume dramas on film, we have Charles Dickens to thank. Although *David Copperfield* had been made in the silent days, the first sound production was in 1935, directed by George Cukor, with Freddie Bartholomew in the title role, and a wonderfully eccentric performance from W. C. Fields as Wilkins Micawber. The film is worth seeing for his performance alone.

More than a decade later came *Great Expectations* (1946) directed by David Lean. John Mills played Pip, with Martita Hunt as Miss Havisham and Valerie Hobson as Estella. This is one of the most atmospheric of all the adaptations, especially in the opening scenes when the boy Pip meets the escaped convict Magwitch (Finlay Currie) and in scenes with Miss Havisham in her bridal dress. This was a worthy and beautiful adaptation by Anthony Havelock-Allan, Cecil McGiven, Kay Walsh, Ronald Neame and David Lean. Obviously not a case of too many cooks!

David Lean was clearly drawn to Charles Dickens as his next film came only two years after *Great Expectations*. This was *Oliver Twist* (1948), and his then wife Kay Walsh also co-wrote the screenplay and played Nancy. Robert Newton was Bill Sikes, with Anthony Newley as the Artful Dodger. Alec Guinness was Fagin, his performance and make-up causing a great deal of controversy as it was considered anti-Semitic. A US release was indefinitely postponed. It wasn't until 1951 that it was released in the States, and then with ten minutes having been edited out. The film was banned in Israel, as it was in certain areas of Germany, as it was thought to be too problematic with regard to Fagin following the holocaust.

The title role was played by John Howard Davies, a child actor, who as an adult went on to become Head of Comedy for BBC Television and also directed many episodes of *Fawlty Towers*.

A favourite Charles Dickens story was, and probably still is, *A Christmas Carol*, retitled as *Scrooge* (1951) in Britain but given its proper title in the US. It was directed by Brian Desmond Hurst and adapted by Noel Langley, starring Alastair Sim as Ebenezer Scrooge, with a stellar British cast, including Kathleen Harrison, George Cole, Hermione Baddeley, Mervyn Johns, Jack Warner and Michael Hordern.

The Rank Organisation made *A Tale of Two Cities* (1958), directed by Ralph Thomas, with a screenplay by T. E. B. Clarke, who wrote many comedies for Ealing Studios, including *Passport to Pimlico*, *The Lavender Hill Mob* and *Titfield Thunderbolt*. The film starred Dirk Bogarde, Dorothy Tutin and Cecil Parker

and, like the other previously mentioned Dickens adaptations, was shot in black and white, which Ralph Thomas said he later regretted.

Exteriors were shot in France, mainly in the Loire Valley, because it was the only area without telegraph poles. Which makes you wonder if the natives of the Loire Valley communicated by carrier pigeon?

Faithful to Dickens, up to a point, and in colour of course, came *The Muppet Christmas Carol* (1999), directed by Brian Henson from a screenplay by Jerry Juhl, starring Michael Caine as Ebenezer Scrooge. This was the fourth Muppet feature and the first to be produced after the death of Muppet creator Jim Henson. In the film Mrs Cratchit is played by Miss Piggy and Kermit the Frog is Bob Cratchit. Brilliant casting!

Nicholas Nickleby (2002) was written and directed by Douglas McGrath. Charlie Hunnam played the title role, with Nathan Lane as the actor/manager Mr Crummles, and Jim Broadbent as the abusive headteacher Wackford Squeers of Dotheboys Hall. And because they thought that Mrs Crummles was very similar to Dame Edna Everage, they cast Barry Humphries in the part. Jamie Bell plays the injured Smike who escapes the clutches of Squeers with Nicholas and, apparently, when Bell auditioned for the role in front of McGrath and several producers, he reduced them to tears. They immediately offered him the part.

Aguirre, The Wrath of God (1972), written and directed by Werner Herzog, starred Klaus Kinski as Aguirre, a Spanish soldier, under the leadership of the legendary Pizarro, whose conquistadores crushed the Inca empire, and Aguirre is sent on an expedition to search for the legendary city of gold, El Dorado. The film was a Mexican/German co-production, was shot in the German language, and Herzog shot it in chronological order.

Ten years later, Herzog, just to make things even harder for himself wrote and directed *Fitzcarraldo* with Klaus Kinski again in the title role about an opera lover hauling a steamboat up over mountains in the Peruvian rainforest. Rather than cheat or fake it, the director took up the challenge of really manoeuvring a steamboat through the jungle.

The 1950s was teeming with biblical sword and sandal movies such as *Quo Vadis* (1951), *The Robe* (1953), *The Ten Commandments* (1956), and then in 1959 came the most spectacular of all, a sound and Technicolor remake of the silent versions of *Ben-Hur*, directed by William Wyler and starring Charlton Heston as the eponymous charioteer and Stephen Boyd as his perfidious friend. This was one of the most successful epic films and thousands flocked to cinemas to see it in glorious widescreen. It was favourably reviewed, although one smart-arse critic wrote, 'Loved Ben…hated Hur.'

Spartacus (1960) a non-biblical epic about the slaves revolt in Ancient Rome starred Kirk Douglas in the title role. He was also the film's producer and sacked director Anthony Mann early on in the shoot and brought in Stanley Kubrick instead, who handled not only some of the battle scenes brilliantly, but also the more emotional moments in the film when the slaves are crucified and Varinia (Jean Simmons) holds up Spartacus's child for him to see before he dies. Tony Curtis was also in the film and had previously starred opposite Douglas in another historical epic *The Vikings* (1958), along with his then wife Janet Leigh.

There have been many Roman sword and sandal movies, but possibly one of the most stunningly memorable is *Gladiator* (2000), directed by Ridley Scott. It starred Russell Crowe and much of it was shot on the island of Malta where vast sets such as the Colosseum were built. This was Oliver Reed's final picture as he had a heart attack, believed to have happened when he was arm wrestling with some sailors in a bar. As he hadn't completed his role in the picture, the CGI boffins had to work hard to make a physical digital replica of him. The film was so successful that sword and sandal films had a new lease of life, like *Troy* (2004), *Kingdom of Heaven* (2005), *Robin Hood* (2010) and *Exodus: Gods and Kings* (2014).

Sometimes films with massive battle scenes, such as Mel Gibson's *Braveheart* (1995), which he produced, directed and starred in, can be quite exhausting and one sometimes longs for the gentler costume dramas, or the ones filled with intrigue and conspiracy. For those look to the Tudors, and often centuries earlier.

Based on a play by Jean Anouilh, *Becket* (1964) starred Richard Burton as Thomas Becket and Peter O'Toole as Henry II. Becket and Henry were friends but when Becket was made Archbishop and opposed the king, he was slaughtered on the steps of Canterbury Cathedral. The first performance of the play had been in Paris in 1959, and opened on Broadway with Laurence Olivier as Becket and Anthony Quinn as Henry II, It was directed by Peter Glenville who went on to direct the film.

Peter O'Toole played Henry II again in *The Lion in Winter* (1968), with Katherine Hepburn as Queen Eleanor and Anthony Hopkins had his first major film role as their son Richard (eventually the Lionheart), and Timothy Dalton made his film debut as Philip II, King of France. Katherine Hepburn received her third Academy Award for her role. Her first was for *Morning Glory* in 1934, and *Guess Who's Coming to Dinner* in 1968, and she received her fourth Award in 1982 for *On Golden Pond*. She was also nominated for 12 Academy Awards, all in all making her the highest Academy Award winner and nominee as a performer.

Now fast forward historically, or backwards to when the film was released, when Charles Laughton played the title role in *The Private Lives of Henry VIII* (1933), directed and produced by Alexander Korda. The title role was played by Charles Laughton, and his then wife Elsa Lanchester played Anne of Cleves. The picture was not historically accurate, focusing mainly on Henry's relationship with five of his six wives. But there were some fun scenes in the film when Laughton as the gluttonous Henry crams his face with chicken and discards the bones by hurling them backwards over his shoulder (not something that would go down well in a KFC). The film ends after he has married wife number six, Catherine Parr, and the fourth wall is broken when the king declares to camera, 'Six wives, and the best of them's the worst.'

The Tudor monarchs gave us some entertaining and intriguing films. Another Henry VIII film was really about his rift with the film's protagonist Thomas More, played by Paul Scofield in *A Man For All Seasons* (1966). And then in 1969 came *Anne of The Thousand Days* and years later Cate Blanchett played *Elizabeth* (1998) with Geoffrey Rush as her bodyguard and advisor Francis Walsingham, a film set in her earlier years. Years later they reprised their roles in *Elizabeth: The Golden Age.*

One of the most entertaining of the Elizabethan dramas was more of a comedy. *Shakespeare in Love* (1998), directed by John Madden was written by Marc Norman and Tom Stoppard. It opens with Shakespeare (Joseph Fiennes) scribbling with a quill pen on paper, and on his desk we can see a tacky souvenir from Stratford-upon-Avon. Now we know the scene is set for laughter. Gwyneth Paltrow plays Viola, his love interest, who disguises herself as a boy in order to appear in one of his plays. When Shakespeare falls for her, and follows her to the river where she climbs aboard her skiff, he quickly hires a boat, telling the boatman to 'Follow that boat!' There is great deal of humour in the film, such as Shakespeare having trouble writing *Romeo and Juliet* which he first calls *Romeo and Ethel, the Pirate's Daughter.* There is a great cast in the picture, including Geoffrey Rush as impresario Philip Henslowe, with Tom Wilkinson, Simon Callow and Imelda Staunton. And Judi Dench got an Academy Award for what must have been her smallest role on film as Queen Elizabeth the First. The film received seven Academy Awards including Best Picture.

One of the most romantic tales was based on a classic tale of doomed love. *Cyrano de Bergerac* (1990), directed by Jean-Paul Rappeneau, co-written by him and Jean-Claude Carrière, based on the 1897 verse play by Edmond Rostand, starring Gérard Depardieu as the long nosed Cyrano who writes wonderful love letters to Roxane (Anne Brochet) on behalf of the handsome hero Christian (Vincent Perez), but both Cyrano and Christian are fated to die, and Roxane

ends up mourning in a nunnery. The film was an international success, which was helped by Anthony Burgess writing the sub-titles.

This classic tale has also been made in a very funny modern version, *Roxanne* (1987) starring Steve Martin.

We shouldn't neglect the Georgians on film, who have inspired some fine pictures, like the aforementioned *Tom Jones* (1963) directed by Tony Richardson, from the novel by Henry Fielding, featuring the rampant sexual adventures of the eponymous protagonist (Albert Finney), with Susannah York as his true love. Edith Evans has a great line when her coach is waylaid by a highwayman, saying 'Stand and Deliver!', to which she replies haughtily 'What do you think I am? A travelling midwife!'

Alan Bennett wrote the film, based on his own play, *The Madness of King George* (1994), directed by Nicholas Hytner, with Nigel Hawthorne as King George III, Helen Mirren as Queen Charlotte and Rupert Everett as the Prince of Wales.

Is what I am about to write an urban myth? I heard that Bennett's play's original title *The Madness of George III* had to be changed for the American market as potential audiences may have thought this was the third film in a trilogy!

Seafaring films seem to have begun in the silent days with an Australian film in 1916 about the Mutiny on the Bounty, but this is one of many 'lost' films. Another follow-up of this biographical story was a sound movie *In The Wake of The Bounty* (1933), an Australian picture which was Errol Flynn's debut film as Fletcher Christian. This seems to be a popular subject, perhaps because it shows ordinary working men rebelling against tyranny. The second black and white sound picture of *Mutiny on the Bounty* (1935) had a snarling Charles Laughton as Captain Bligh and Clark Gable as Fletcher Christian, and then the first colour film was in 1962 with Marlon Brando, as a rather foppish, well-spoken and non-mumbling Fletcher Christian, and Trevor Howard as Bligh. And then twenty-two years later the Bounty sails with Mel Gibson and Anthony Hopkins in 1984.

Over the years there have been dozens of swashbuckling pirate films, from *Captain Blood* (1935) and *The Sea Hawk* (1940), both directed by Michael Curtiz up until the more recent *Pirates of the Caribbean, the Curse of the Black Pearl* directed by Gore Verbruski, starring Johnny Depp, Orlando Bloom and Keira Knightly, and this hugely popular fantasy and supernatural costume drama led to another three Caribbean pirate films.

There have also been many films of Robert Louis Stevenson's *Treasure Island*, featuring one of the screens most popular characters, Long John Silver. The

1950 version starred Robert Newton as Silver, which he played with pieces-of-eight relish. Unfortunately, as excellent as many of his performances were he became possessed by the demon drink and reached an unemployable stage when word about his alcoholism got around. His pal David Niven had been offered the leading role of Phileas Fogg in Mike Todd's *Around the World in 80 Days* (1956), and suggested Newton for the part of Detective Fix, promising that his pal wouldn't touch a drop during the duration of the film. When Newton went to meet with Todd, the producer said, 'David Niven tells me you were a big drinker.' And Newton replied, 'My friend David Niven is a master of the understatement.'

Aside from pirate pictures, there have also been some excellent sea battle films. One of the most successful of these was *Master and Commander: The Far Side of the World* (2003), set during the Napoleonic wars, starring Russell Crowe as Captain Jack Aubrey and Paul Bettany as the ship's surgeon, based on the novels by Patrick O'Brian. The film was directed by Peter Weir and was the only non-documentary film to be partly shot at the Galapagos Islands.

Queen Victoria, too, has contributed to much cinema entertainment. *Mrs Brown* (1997), directed by John Madden with a screenplay by Jeremy Brook, starred Judi Dench as the recently widowed Queen Victoria, in a story concerning Prince Albert's manservant Mr Brown (Billy Connolly), his relationship with the queen, and the rumours that spread from that friendship. The film was intended for showing on television, but Miramax acquired the rights and gave it a very successful theatrical release. And *The Young Victoria* (2009), directed by Jean-Marc Vallée with a screenplay by Julian Fellowes, starred Emily Blunt as Victoria with Rupert Friend as Prince Albert. Then, eight years later, Judi Dench again played the recently widowed Victoria in *Victoria and Abdul* (2017) about her friendship with Abdul (Ali Fazal) and the objections by the Royal household who disapproved of the devout Muslim. The film was directed by Stephen Frears, based on a book of the same name by Shrabani Basu, adapted for the screen by Lee Hall.

In both films Judi Dench is the recently widowed Queen Victoria, who had a relationship with Brown and Abdul, yet Brown makes no appearance when Abdul is on the scene and vice versa. Curiouser and curiouser as Alice might have said.

Victorian imperialism brought the British Army to South Africa where a battle was waged at Rorke's Drift, and they fought bravely against a vast army of Zulu warriors. This was made into a classic costume drama called *Zulu* (1964), produced by Cy Endfield and directed by Stanley Baker, who also starred as the highest ranking Royal Engineers officer at the location. The film was also

Michael Caine's first starring role, but as an upper-class officer named Gonville Bromhead. Following the battle, more Victoria Cross medals were won at Rorke's Drift than at any other battle in history, even winning a medal for the disobedient Private Hook, brilliantly played by James Booth. The picture had some great British actors, and some humorous roles, including one from Richard Davies as Private 593 Jones, who has to grudgingly admit that there are many Joneses in the regiment.

Merchant Ivory productions made many costume dramas. Ismail Merchant, produced and James Ivory directed, and the screen adaptations were written by Ruth Prawer-Jhabvala. It was a team that gave us so many excellent costume dramas. They made several E.M Forster novel adaptations, including *Howard's End* and *A Room with a View* which won many awards.

Films about less fortunate people in Victorian times, apart from the previously mentioned Dickens adaptations, didn't seem as prevalent as pictures about royalty or the middle-classes. But there was one brilliant exception and that was the black and white *The Elephant Man* (1980), directed by David Lynch, which told the true and tragic story of David Merrick whose facial features were so distorted as to cause people to shy away from him in revulsion. He was mistreated, and what made his moving story worse was that he was such a gentle person. John Hurt played Merrick, unrecognizable through the enormous prosthetic make-up, but he still managed to give a very moving performance. Anthony Hopkins played the surgeon who rescues him from a freak sideshow and takes pity on him. The film captures the underbelly of Victorian London, dirty, foggy and greasy, tarnished by the industrial revolution with almost no clean air.

The film was a triumph for everyone connected with it.

Horror & Ghost Stories

Victorians loved gothic horror and ghost stories. The American 19th century horror and ghost story writer Edgar Allan Poe has inspired many horror movies, like Roger Corman's *The Masque of the Red Death* (1964) starring Vincent Price. And Mary Shelley created one of the most lasting monsters in *Frankenstein, or the Modern Prometheus* (1818), which led to literally dozens of *Frankenstein* films. A little later, at the turn of the century, Bram Stoker, who after 27 years working as secretary and touring manager for Sir Henry Irving, wrote the vampire story *Dracula* for which he will always be remembered, and which has led to a plethora of vampire films. And Victorian writers such as M. R. James, Sheridan Le Fanu and Chares Dickens were drawn to ghost stories, and many of their stories have inspired dozens of films and television series.

Although there were silent horror films, especially from the German Expressionist genres, the first sound *Frankenstein* (1931) was a US version from Universal. It was directed by James Whale and the monster was played by Boris Karloff. His make-up would be the way every Dr Frankenstein monster would look with a flattop head, bolts in the neck, and dressed in a shabby oversize suit and workmen's boots. After the scene where the monster is created, with electric lightning flashes from Frankenstein's contraption, he escapes and meets a little girl by a lake. This scene evokes sympathy, as the girl doesn't see him as a monster and invites him to play a game of pulling petals from a flower, and throwing them into the lake where they float. But when the monster has no more petals to pluck, the scene becomes unintentionally hilarious as the frustrated creature now hurls the little girl into the lake, where she doesn't float. Now the angry townspeople set out to destroy the monster.

James Whale also directed the sequel *The Bride of Frankenstein* (1935), and more than six decades later *Gods and Monsters* (1998) a semi-biographical film about Whale, played by Ian McKellen, was released.

1931 was also the year of the first sound *Dracula*, directed by Tod Browning (who made the disturbing *Freaks* a year later). It starred Bela Lugosi as Count Dracula, dripping blood from his fangs as he struts menacingly through the cobwebbed crypt in his Transylvanian castle.

Although *Frankenstein* and *Dracula* are horror movies, they are vastly different. The monster in the former is created by a scientist, and in recent years scientists created Dolly the Sheep by cloning, injecting a DNA cell into an egg rather than creating a creature from dead body parts as in Mary Shelley's novel. *Dracula*, on the other hand, is strictly supernatural.

One of the best *Dracula* films was the 1958 Hammer House of Horror picture, starring Peter Cushing as Count Dracula and Christopher Lee as Van Helsing, shot in colour. Most people know that Van Helsing chased after Count Dracula, landing at Whitby in North Yorkshire, and this fictional horror story is celebrated in the town each year when it is descended upon by hundreds of Goths. But cinema history can be celebrated by the non-fictional Count Dracula, Peter Cushing, who lived by the sea in Whitstable, Kent, famous for its oysters. Wetherspoons converted the local cinema into a pub which is called The Peter Cushing, and the walls proudly display posters and photographs from his films. But Whitstable has another piece of cinema history: in the Old Neptune pub on the beach, scenes from *Venus* (2006) were filmed there with Peter O'Toole and Jodie Whittaker, and there are some signed and framed pictures on the pub's walls of the actors and crew.

Most people would probably agree that *Psycho* (1960) is one of the greatest horror movies of all time. Directed by Alfred Hitchcock, proving he was the master of suspense, with a screenplay by Joseph Stefano from a novel by Robert Bloch, and a terrifying Bernard Hermann score of high-pitched terror, this horror film has no zombies, vampires, ghosts or supernatural beings, but the horror is dished out by what appears to be a normal person. Marion Crane (Janet Leigh) steals a large sum of money and hits the road, spending the night at the Norman Bates Motel. Norman is a pleasant enough chap, played with just the right degree of quirkiness by Anthony Perkins. Then less than halfway through the film Marion is savagely murdered while taking a shower, a scene which Hitchcock composed meticulously of 90 separate cuts, the camera mostly static, except for four shots. It was brilliant cinematography. The film was shot in black and white and. when the film opened, audiences were asked not to reveal the ending.

George A. Romero could have started the zombie craze with his *Night of the Living Dead* (1968), but his film may have been overshadowed by *Rosemary's Baby* which was released in the same year and shot in colour. Directed by Roman Polanski, who adapted the screenplay from the novel by Ira Levin, this Faustian drama was located in a contemporary New York City and starred Mia Farrow whose pregnancy was quite disturbing as she may well have been impregnated by the devil and is carrying his child. And John Cassavetes plays an actor who has

sold his soul to the devil for some show-biz fame, And there are other disturbing tenants in her apartment building, like the ageing maiden aunt type of character (Ruth Gordon) who is turning into something far more sinister as we discover Rosemary is surrounded by Satanists. There are no cobwebs or dank cellars in the film, but Polanski does a brilliant job of building the feeling of dread in this modern apartment block.

If you want a good harvest then a human sacrifice is required, and the victim ought to be a virgin. In *The Wicker Man* (1973), directed by Robin Hardy, with a screenplay by Anthony Shaffer, Edward Woodward is a very upright Christian police sergeant, most probably a virgin, and on the Scottish Island where paganism is taking over, the lord and master of the island (Christopher Lee) has banished Christianity in favour of paganism, leading to the shocking ending of the sacrificial victim (Woodward) being burned alive in a giant wicker man. And so upright and uptight was the police sergeant, and the paganists seemed to be having such a good time, it perhaps leaves audiences siding with those practising paganism. It also leaves one wondering what the harvest was like the following year!

And that same year another sacrifice in a film, but this one was done in order to save someone. *The Exorcist* was directed by William Friedkin, with a screenplay by William Peter Blatty from his novel, and was about the demonic possession of a young girl (Linda Blair) who, after harsh experiments in trying to figure out what was wrong with her obscene behaviour, her mother (Ellen Burstyn) accepts the diagnosis – an exorcism is required.

And so a Jesuit Priest (Jason Miller) performs the exorcism, and it becomes an intense battle as the girl is strapped to a bed which levitates as the demon fights back. Another priest (Max Von Sydow), with more experiences in exorcism is brought in, but ends up dead. Finally, the Jesuit priest sacrifices himself to save the girl by accepting the demon into his own body and throwing himself out of a window.

'Tubular Bells' by Mike Oldfield is a dominant sound leitmotif in the picture, and the film led to many devil possession movies. But it was *The Exorcist* that remains the number one demonic possession film with the possessed girl's head doing a 190 degree turn, then vomiting ectoplasm. The ectoplasm was perhaps played by Heinz pea soup.

Youngsters and children demonically possessed or just plain evil make horrific and creepy stories. Maybe kicking off with *The Bad Seed* (1956), and then *The Village of the Damned* (1960) in which scores of menacing children have telepathic powers. Sixteen years later *The Omen* (1976) in which a switch of babies at birth means that Damien is really the antichrist. His father is the

American ambassador in the UK (Gregory Peck) so perhaps one day Damien will become the US president, and the antichrist will reside in the White House. But fact can be stranger than fiction. We have already had an antichrist in the White House and in the Kremlin.

A film about the disappearance of three schoolgirls and a teacher became a supernatural mystery without a solution. *Picnic at Hanging Rock* (1975), directed by Peter Weir, the film was adapted by Cliff Green from the novel by Joan Lindsay. This rather beautifully disturbing film has no evil monsters, ghosts, zombies, phantoms or other-worldly creatures one might associate with more conventional horror stories. And yet there is something menacing that hangs over this geological landmark when on Valentine's Day in 1900 the corseted young students in Mrs Appleyard's School for Young Ladies are taken on an excursion and three of them decide to climb the rock. Three of them and one of the teachers vanish without a trace and when a search party is sent to look for them, one of the girls is found but her memory of what has happened has been wiped. The film indicates stifling sexual repression, although no actual sex surfaces in the story, and the heat of the Australian summer gives the film an ominous and sinister anticipation of an impending tragedy. The film was stunningly photographed in Eastmancolor by Russell Boyd.

When the film was shown to a film distributor at a private screening in the US, he threw his coffee cup at the screen when it ended, disgusted that he had spent two hours watching a mystery without a solution. But despite his reaction, the film became hugely successful both critically and commercially, and brought Australian cinema to a wider global audience, and became known as Australian New Wave.

In 2014 a very spooky and chilling Australian psychological horror film *The Babadook* (2014) was released. A young boy is possessed by an evil toy in a book. This one is truly disturbing as are many horror films featuring demonically possessed children.

Stephen King is undoubtedly the king of horror fiction. His major success as a horror novelist came with *Carrie*, which became a 1976 film directed by Brian de Palma about a bullied girl with kinetic powers. Following the success of *Carrie* many of King's novels have been adapted into films. Perhaps one of the most exciting of his psychological horrors was *Misery* (1990) with a novelist played by James Caan being stranded in a snowdrift and rescued by a fan of his fiction (Kathy Bates) who keeps him prisoner by breaking his legs. But his biggest success is by far *The Shining* (1980), directed by Stanley Kubrick, where Jack Torrance (Jack Nicholson) is a struggling writer who takes a job as caretaker of the Overlook Hotel out of season, along with his family, whom he terrorises

as he descends into madness. 'Heeeere's Johnny' he yells as he attempts to break down the door with an axe as his wife (Shelly Duvall) cowers on the other side.

Stephen King's reaction to the film: he hated it, and still does. He said it lacked warmth and humanity. Perhaps he feels it would have been better had Stephen Sondheim written it as a musical.

One of the best Vincent Price horror films is *Theatre of Blood* (1973) in which he plays Shakespearean actor Edward Lionheart seeking revenge on all the critics who gave him terrible reviews, killing each one like a scene from a Shakespeare play, and before or after each gruesome death he recites passages of Shakespeare. The film was directed by Douglas Hickox in colour, with a screenplay by Anthony Greville-Bell, and the film boasts a marvellous cast with Diana Rigg as Edwina Lionheart the murderer's daughter, who assists him, and some of his victims include Ian Hendry, Dennis Price, Harry Andrews, Robert Morley, Michael Hordern and Jack Hawkins. Diano Dors and Joan Hickson play two of the critic's bereaved wives. The film also features Coral Browne, the film in which she met Vincent Price and later married him. Jack Hawkins, like many of his later films was dubbed by Charles Gray following his operation for throat cancer.

John Carpenter, who made the exciting action thriller *Assault on Precinct 13* (1976), made two horror films, both released in 1978. The first was *Eyes of Laura Mars* a supernatural horror, but the second was very much a slasher movie. *Halloween*, has an almost Hitchcock feel about it, especially as the tension builds when the victims are being observed by the mysterious killer, before terrorising the small sedate town. The voyeuristic killer is the masked Michael Myers and Donald Pleasance is a psychiatrist with Jamie Lee Curtis doing her best to save some of the young trick or treat victims. This is a truly terrifying film and led to a franchise of *Halloween* films. Carpenter also made *The Thing* (1982) in which a group of scientists, led by Kurt Russell, working in an isolated Antarctica base encounter a slavering alien 'thing' which takes over their bodies. A gruesome, macabre horror and not one for the squeamish.

The same could be said for *Nightmare on Elm Street* (1984), directed and written by Wes Craven, where Freddy Krueger (Robert Englund) who was burnt by the townspeople for murdering children, has returned in an after-life to seek revenge by killing teenagers with his deadly long knives which are talons on his leather gloves. But teenagers are too terrified to go to sleep because that is when Freddy will enter their heads and slash them to death. A nightmare scenario which led to many more Freddy Krueger slasher films. A young Johnny Depp made his screen debut in the first film.

In 1996 Wes Craven made the college teen slasher movie *Scream*, which was fringed with humorous moments and some of the characters referenced other famous horror movies such as *Friday the 13ᵗʰ* (1980) . Other black comedy horror films have become minor classics, such as *An American Werewolf in London* (1981) directed by John Landis, about two American backpackers on the Yorkshire moors entering the Slaughtered Lamb pub and encountering unhospitable regulars. The warnings about the moors go unheeded when one of them is killed by a werewolf and the other American is transformed into one in London. The transformation from man to beast is visually brilliant, while the sound track plays 'Bad Moon Rising' by Creedence Clearwater Revival. So impressive was this scene that Rick Baker who did the make-up and special effect was hired with John Landis by Michael Jackson to work on his *Thriller* video.

David Cronenberg directed *The Fly* (1986), a sci-fi horror starring Jeff Goldblum as a scientist who builds a teleportation contraption, and when he puts it to the test, a fly has got inside and their molecules have become mixed. This was a better remake of a 1958 version.

Another great sci-fi horror takes place in space where 'no one can hear you scream.' *Alien* (1979), directed by Ridley Scott, starring Sigourney Weaver, Tom Skerrit, John Hurt, Ian Holm and Jones the Cat. This is a sort of Agatha Christie *And Then There Were None* scenario as the crew of the Nostromo are being picked off one by one by these repulsive aliens. First to go is John Hurt when one revoltingly bursts out of his stomach, almost as if he has eaten a dodgy doner kebab. The only ones to escape are Sigourney Weaver and Jones the Cat, thus ensuring many more appearances in sequels, although the cat doesn't appear again.

Martin Scorsese recommends *Night of the Demon* (1957) as one of the scariest of supernatural films. It was based on the M. R. James story *Casting of the Runes*. This British black and white film was directed by Jacques Tourneur, and starred Dana Andrews, Peggy Cummins and Niall MacGinnis. There were many problems between writers, producers and director; some wanted the audience to see the demon while others preferred a more subtle approach. There are some truly scary moments in the film when someone sees the demon in the trees: 'It's in the trees!' And walking through the woods we just see and hear footsteps rustling through the grass. The film is about satanists and Dana Andrews plays an American psychologist tasked with exorcizing a curse. In the US the film was called *The Curse of the Demon*. The film's poster states 'Chosen…singled out to die…victim of his imagination or victim of a demon'. Who knows who won the argument about showing the demon, but the film is least frightening when we

clap eyes on the devilish monster, which is as over-the-top as 1970's platform soles.

Not all horror is generated by alien monsters, supernatural fiends or psychotic humans. One of the most horrific and terrifying monsters was a marine animal. The great white shark was the scariest of sea creatures and was used to frightening effect in Steven Spielberg's *Jaws* (1975). It was based on Peter Benchley's novel, and the screenplay was written and rewritten by many others. Contributing to the fear was John Williams's memorable score, pounding away like a frenzied heartbeat. Roy Scheider played Police Chief Brody, Richard Dreyfuss was Matt Hooper, a marine biologist, Robert Shaw was Quint, a shark hunter, and Lorraine Gary played Brody's wife. Following the remains of a bather found on the Amity Island beach, and suspecting a shark attack, Chief Brody wants to shut the beach down. But the beach is a good source of income for the town, and the mayor (Murray Hamilton) objects and keeps it open. This storyline was inspired by playwright Henrik Ibsen's play *Enemy of the People* in which a doctor discovers a medicinal hot spring is contaminated, which is the town's major tourist attraction, and wants it shut down. He is then sacked and ostracized.

After the mayor of Amity Island reopens the beach is when the fun starts, and eventually Brody, Hooper and Quint set out to kill the great white shark. And it is at this point in the film that we hear what has become one of the most iconic quotes in cinema history: 'You're gonna need a bigger boat'.

Jaws was mainly shot in Martha's Vineyard, Massachusetts. Perhaps following the release of the film they should have rechristened the town Martha's Graveyard.

The Turn of the Screw was a Henry James novella published in the late 19th century, and it became an excellent British film retitled *The Innocents* (1961), directed by Jack Clayton. It was, according to the poster, 'A Strange New Experience in Shock'. Most supernatural Gothic horror films mostly had demons and monsters as the supernatural beings, but the ghosts in *The Innocents* were like real people, as a governess (Deborah Kerr) is employed to look after two children in a large estate, and discovers some real people or the living dead in the garden. The screenplay was by William Archibald and Truman Capote, with additional scenes and dialogue by John Mortimer.

One of the most frightening of paranormal stories is *The Haunting* (1963), made in black and white and directed by Robert Wise, with a screenplay by Nelson Gidding from a novel by Shirley Jackson. Julie Harris plays Eleanor, a lonely woman who jumps at the chance to conduct a psychic experiment in this 'things that go bump in the night' house. After arriving at Hill House she meets Dr Markway (Richard Johnson) an anthropologist looking for scientific evidence of paranormal occurrences. Russ Tamblyn (the well-known hoofer)

plays the sceptical nephew of the landlord of the house. The film uses oblique angles, mirror distortions and weird sound, bringing the house frighteningly to life.

One of the best paranormal stories was *The Sixth Sense* (1999), written and directed by M. Night Shyamalan, the film is a ghost story on so many levels as Malcolm Crowe (Bruce Willis) tries to understand a boy (Haley Joel Osment) who sees dead people. Toni Collette plays his understanding and supportive mother. The film is chilling and has a great twist in the tale.

Two paranormal films came from Spain. *The Others* (2001) was written, directed and scored by Alejandro Amenábar and was shot in the English language. It starred Nicole Kidman and this truly unnerving film, which was creepy enough without any special effects, has audiences wondering just who the immortals are. The film's cast also includes the late, great Eric Sykes.

The other Spanish ghost story (in the Spanish language) is *The Orphanage* (2007) in which a mother returns with her husband and child to the orphanage where she was brought up, and things become horrifically menacing, especially as the horror involves her young son.

And now the time has come to leave ghost and horror fiction, because I have just heard a weird noise in the cellar. Which is doubly weird because I don't have a cellar.

Fantasy

Perhaps one of the greatest fantasy films of all time is *It's a Wonderful Life* (1946), which tells a very realistic story of ordinary small town banker George Bailey (James Stewart) who, becomes overburdened by debt because of a greedy plutocrat (Lionel Barrymore) and is about to commit suicide by hurling himself off a bridge when he is saved by a miracle. He is visited by Clarence, an angel (Henry Travers), who shows George what the town would be like had he never existed. Clarence is a second class angel without wings, and if he can deliver George from his suicide and make him see sense, he will get his wings. Clarence succeeds and George is reunited with his wife Mary (Donna Reed) and family at Christmas, and a bell rings out to signal that Clarence got his wings. The film was produced, directed and co-written by Frank Capra, and it has become essential television viewing every Christmas.

One of the most dreamlike and poetic black and white French films was Jean Cocteau's fairytale *Beauty and the Beast* (1946). I am sure we all know the story off by heart, but what made this film so different were the illusionary effects.

Beauty glides through the castle halls where candles affixed to the walls are grasped by human hands, and mirrors become liquid portals, and flames with a mind of their own are suddenly extinguished. And the Beast is magnificent, he is still hideous but we see that his kindness and humanity shines through. This is a truly remarkable film.

Michael Powell and Emeric Pressburger wrote and directed *A Matter of Life and Death* (1946) starring David Niven who, as a World War II pilot about to jump from a burning plane, falls in love when he hears the voice of an American radio operator (Kim Hunter). Thinking he's in heaven when he wakes up on a beach, and finding that he is still alive, he attempts to fall in love with the American girl. But a mistake has been made and Heavenly Conductor 71 (Marius Goring) has come to take him to heaven where he belongs. The Earth sequences are shot in Technicolor and the step into the great beyond is shot in black and white, photographed by the talented Jack Cardiff. The set designs of the ethereal world are remarkable and the film seems to be closely related to surrealism.

Another remarkable film was the medieval tale written and directed by Ingmar Bergman *The Seventh Seal* (1957) where Antonius Block (Max von Sydow) is a disillusioned knight returning from a crusade who makes a living by robbing corpses. The most famous scene people remember in the film is where the knight meets the Grim Reaper and plays him at chess. The chess duel between Death and the Knight is not so much for his life as for his feelings about religion and humanity. Although the film is regarded as a heavily symbolic, arthouse picture, it still has moments of humour and is imbued with a great deal of atmosphere.

A Master of Special effects for fantasy films was Ray Harryhausen whose film *Jason and the Argonauts* (1963) has become a classic of the genre. Long before computer animation and CGI came along, he used stop motion model animation which he called 'Dynamation', and in his *Jason* Greek mythology film an iconic scene was the memorable seven skeleton warriors fighting. Bernard Hermann wrote the score and it was directed by Don Chaffey. Ray Harryhausen has influenced many other filmmakers, including Steven Spielberg, George Lucas, James Cameron, Peter Jackson, and Nick Park, whose Wallace and Gromit films are made using stop motion animation techniques.

The most popular film from 1990 was *Ghost*, starring Patrick Swayze as Sam Wheat, Demi Moore as his girlfriend Molly and Tony Goldwyn as his friend Carl. On their way home one night, Sam is mugged and killed by a burglar, and his ghost attempts to protect Molly from further harm when he discovers the burglar intends to return to their apartment to collect something he has overlooked. Sam visits a fraudulent psychic Oda Mae (Whoopi Goldberg),

and she discovers she does have psychic powers after all when she hears Sam talking to her. Sam learns poltergeist tricks from another ghost he meets on the subway and also discovers the villain is Carl. Both the burglar and Carl get their comeuppance after they are killed and dragged by demons to hell and when all is resolved Sam leaves for Heaven.

The film manages successfully to segue from romance to drama to horror and comedy instantaneously. And the fact that Oda Mae talks to Sam's ghost, and other people don't know who she is talking to is similar to Noel Coward's *Blithe Spirit*, although writer Bruce Joel Rubin said that his idea sprang from seeing *Hamlet* whose father's ghost tells him to seek revenge on his killers. *Ghost* was directed by Jerry Zucker, famous for his spoof films like *Airplane*, and the score was by French composer Maurice Jarre. The song that is prominent in the romantic scenes is 'Unchained Melody'.

Director and writer Tim Burton produced many successful fantasy films, including the Gothic comedy horror, *Beetlejuice* (1988), and the romantic fantasy *Edward Scissorhands* (1990); also two excellent stop motion animated fantasies *The Nightmare Before Christmas* (1993) and *Corpse Bride* (2005). One of the Tim Burton favourites, even though there are many to choose from, is *Edward Scissorhands* starring Johnny Depp in the eponymous role in this Gothic romance. It is very much a fairytale, and begins with a woman telling Edward's story to her grandchildren. And then the actual story of Edward begins with him living in his isolated Gothic castle. He is a humanoid, created by an old inventor (Vincent Price in his final film). The inventor dies before finishing off his creation with proper hands. But Edward is a kindly soul and is taken in by a suburban family. The neighbours are initially kind to him and he repays them by trimming their hedges into topiaries. But the conflict comes in the film when he falls for Kim (Winona Ryder), and she with him, resulting in extreme jealousy in Jim (Anthony Michael Hall), and the climax happens in a battle between Edward and Jim, who is stabbed by Edward after he sees Jim slapping Kim. The film was financially and critically successful, with a brilliant score by Danny Elfman, and the film includes some Tom Jones' tracks, including his first hit 'It's Not Unusual'.

One of the most stunningly visual films is *The Shape of Water* (2017), directed by Guillermo del Toro, with a screenplay by him and Vanessa Taylor. It is set in the early sixties and stars Sally Hawkins as the mute Elisa, a custodian at a high-security government laboratory. A humanoid amphibian has been captured in a South American river and is now a prisoner in a tank while it is being studied. The villain of the story is the military colonel (Michael Shannon), and when Elisa falls in love with the monster and rescues him, the colonel sets out to

destroy them. But the monster has unbelievable healing powers, healing both himself and Elisa. The trouble is by making him totally invulnerable in this way, the writers become gods and can rescue their creations by a few taps on their computer keyboards, although this might be said of all writers' creations. But apart from that, it is the humanity of the film that is important, exploring the love and empathetic feelings between Elisa and her amphibian lover. The film was enormously successful, as was the director's earlier fantasy film *Pan's Labyrinth* (2006).

A trilogy of fantasy books that held the reading public enthralled from the sixties onwards were JRR Tolkien's *The Lord of the Rings*, but they didn't make it to the big screen until the new millennium when Peter Jackson directed *The Fellowship of the Ring* (2001), *The Two Towers* (2002) and *The Return of the Ring* (2003). The films were shot in his native New Zealand, and although there was much computer generated images, some of the picturesque vistas of the country's landscape was captivating and beautiful. Most fans of the books enjoyed the films as well, and marvelled at the creation of the beasts, and enjoyed the hobbits, elves and wizards all of whom drew audiences into the fine attention to detail and were convincing in their believable portrayals. The trilogy runs at a total of nine hours and the end credits for *The Return of the Ring* takes nine minutes of screen time. The film was so successful that the three films were nominated for thirty Academy Awards, won seventeen of them and eleven awards were for the last in the trilogy.

Top that, as they say. Well, yes. In 2001, the same year that the first *Lord of the Rings* film was released, along came *Harry Potter and the Philosopher's Stone* which was adapted from a J. K. Rowling's children's novel published in 1997, a book that many adults read. A fantasy story that delivered young Harry Potter (Daniel Radcliffe) from a humdrum life to the Hogwarts School of Witchcraft and Wizardry, where he met his friends Hermione Granger (Emma Watson) and Ron Weasley (Rupert Grint). But of course you knew that, didn't you? You didn't? In which high security prison were you incarcerated for the last twenty-three years? But prisons have libraries and TV, don't they? Enough already! I am only making the point that I wouldn't dare to presume to enlighten millions of Harry Potter fans about what they could tell me in minute detail.

And so suffice it to say that not only did the eight films in the franchise bring employment to so many people, including a host of British actors too numerous to mention, it took a total of $7.7 billion at the box office from a total budget for all eight films of $1.2 billion. It was made by MGM at their Leavesden Studios in Hertfordshire, a film studio that has been converted from an old

World War II aerodrome by EON Films to make the James Bond *Goldeneye* because Pinewood studios were already booked for other projects.

But it is Harry Potter that is a massive business empire, and the Warner Bros. Studio Tour London – The Making of Harry Potter has become a vital tourist attraction for the Hogwarts fans, and during peak time the attraction receives something like 6,000 visitors a day.

And that's quite an achievement for someone who once, during a time of hardship, sat scribbling notes for her book in a coffee bar in Edinburgh!

Science Fiction

This type of fiction began in the 19th century, when French writer Jules Verne (1828-1905) wrote novels like *From the Earth to the Moon, 20,000 Leagues Under the Sea* and *Journey to the Centre of the Earth.* He was considered to be the father of science fiction, as was H. G. Wells whose works have translated well into many films. Another important figure in the early days of science fiction writing was Hugo Gernsback (1884-1967) who began the first magazine, *Amazing Stories*, devoted to sci-fi short stories.

Walt Disney was attracted to the genre and his company produced *20,000 Leagues Under the Sea* (1954) in Technicolor, starring Kirk Douglas and James Mason as Captain Nemo, battling a giant squid deep in the ocean.

Sci-fi films come in so many different flavours. Many of them are warnings about dystopian futures, and this probably began when George Orwell wrote *Nineteen Eighty-Four*, which has been made into two feature films. The first was in 1956, directed by Michael Anderson, starring Edmond O'Brien as Winston Smith in a totalitarian controlling world, where 'Big Brother' is always watching you. The next feature version was released in the year in which it is set, 1984, directed by Michael Radford, with John Hurt as Smith and Richard Burton as O'Brien. This was Burton's final film.

One of the most prophetic films of a dystopian future was *Soylent Green* (1973), directed by Richard Fleischer and shot in colour. It was set in 2022 and was about the effects of overpopulation, pollution, the greenhouse global warming issues and assisted suicide. Back in 1973 it was science fiction…but now?

One of science fiction writer Ray Bradbury's most well-known novels was filmed by Francois Truffaut. *Fahrenheit 451* (1966) was set in a totalitarian future where books are banned, and anyone caught with a book has them confiscated and burned by the fire brigade. The final poignant scene shows the rebel book people, wandering in a snowy landscape, attempting to commit a book to memory for it to be saved. The title refers to the temperature at which paper burns.

Jean Luc Goddard also turned to science fiction with *Alphaville* (1965), starring American Eddie Constantine as secret agent Lemmy Caution. In his

trench coat, and with the atmospheric black and white photography, this looked very much like film noir, although it is set in a very dystopian future on another planet.

Perhaps one of the best of futuristic dystopian thrillers is *Blade Runner* (1982) directed by Ridley Scott, with Harrison Ford as a detective pursuing 'replicants' – androids disguised as humans. This is a visually impressive picture as taxi-like spacecraft hurtle through the overpopulated foggy city. The film is based on Philip K. Dick's novel *Do Androids Dream of Electric Sheep?* Silly question that. Of course they do. How else would an android get to sleep?

Obviously space travel is another strand of sci-fi, and zooming on from the black and white *Forbidden Planet* (1956), the epic of space travel has to be *2001: A Space Odyssey* (1968), co-written by Arthur C. Clarke and directed and co-written by Stanley Kubrick, with some colourful special effects, stunning production values and what looks like outstanding machinery and equipment for massive sets. The film begins with human evolution as the ape-like hominids discover cognition, and the use of Richard Strauss's music 'Also Sprach Zarathustra' heralds the dawn of humankind. There is also a mysterious black monolith, which may well be a signal to extraterrestrials. When one of the apes hurls a bone into the sky it transforms into a spaceship. Aboard the spacecraft, astronaut Bowman (Keir Dullea) battles with the intelligent ship's computer HAL (named HAL as each letter precedes IBM). As the film was made in the sixties, it shows the voyage becoming a hallucinatory, psychedelic mission into infinity. In fact, many people in that decade watched the film and its 'trip' into surrealism during a marijuana high.

Another surrealistic space trip was the Russian *Solaris* (1973), directed by Andrei Tarkovsky from a novel by Polish writer Stanislaw Lem. As the spacecraft circles the planet Solaris, the astronauts are visited by real people from their past on Earth, some of them dead, and these very ambiguous visits become more and more disturbing. The film was remade by Steven Soderbergh in 2002, starring George Clooney. It was not a box office success.

Perhaps because of Neil Armstrong and Buzz Aldrin's walk on the Moon in July 1969, and many other space missions since Yuri Gagarin's first journey into space in 1961, filmmakers had to turn to more realistic depictions of space travel.

Marooned (1969), for instance, about a space station mission that goes haywire, until help comes from a Soviet spacecraft, is very realistic. As is *Gravity* (2013) where a space shuttle is damaged by space debris and only one astronaut makes it back to earth. Another marooned scenario has Matt Damon all alone on planet Mars in *The Martian* (2015) trying to improvise a way to return home

with the help of his colleagues at NASA. Director Danny Boyle made *Sunshine* (2007), with a screenplay by Alex Garland, and additional consultation from Brian Cox. When it is discovered that the sun is cooling down, an expedition is sent to save it by firing a rocket into its core containing a huge nuclear warhead. (Elton John's 'Don't Let the Sun go Down on Me' was not used in the film!)

Space fantasy adventure films are very different, and nearer to comic fantasy fiction than science inspired films, although many of their production values seem to be based on realistic technology. The very first *Star Wars* (1977), written and directed by George Lucas became an instant hit. Although it had stupendous aerial combat in space ('Man the ships, and may the force be with you.'), there wasn't a vast difference between these space pilots zapping out death rays as World War Two pilots battling it out on film. The significant difference with the space opera was that the audience knows it is only pretend and may never happen. Mark Hamill played Luke Skywalker and Harrison Ford was Hans Solo, with Carrie Fisher as Princess Leia with a strange hairdo, and Lucas's creation of sweet robots like R2-D2 and C3-PO added humour to scenes and appealed to younger audience members. The antagonist of the film was Darth Vader, played by Dave Prowse. But his rather high-pitched West Country accent got him nicknamed 'Darth Farmer' and his character was dubbed by James Earl Jones. Alec Guinness as Obi-Wan Kenobi accepted a percentage of the profits of the film and made a small fortune (actually not so small). But there are millions of *Star Wars* fans all over the world who know all there is to know about the franchise, and so I won't go into any more detail, other than to say that these films led to some of the biggest merchandising sales ever. And conventions took off, held in exhibition centres, where fans meet actors from the franchise to collect autographs. And these fans like to dress up, mainly as Stormtroopers. True story: I once attended one of these conventions and needed the loo. I found myself standing at a urinal next to an Ewok!

Another big space opera franchise is *Star Trek*. Its humbler origin was the TV series which began in 1966, which often had risible storylines and dialogue such as, 'Is he dead, Bones?' The reply was, 'Worse than dead, Captain.' But as TV then was saturated with Westerns which appealed to a more mature audience, the space operas became hugely popular with younger viewers, then budgets increased, as did production values, eventually leading to all the major movies.

Time travel is another branch of the sci-fi genre. One of the earliest was H. G. Wells' *The Time Machine* (1960), directed by George Pal, with Rod Taylor and Yvette Mimieux. Going forward in time, the hero (Taylor) discovers there are now two branches of society, peace loving vegetarians and flesh-eating human monsters. Terry Gilliam (*Monty Python*) directed *12 Monkeys* (1995) set in the

future and Bruce Willis is sent back in time to the nineties to put a stop to a virulent disease to protect people in the future. And using time travel with a lighter, comedic touch we get the highly entertaining *Back to the Future* (1985), directed by Robert Zemeckis, where Marty McFly (Michael J. Fox) goes back to the sixties and inadvertently stops his parents from getting together, which would mean he might never exist. This film led to two more sequels. Forward in time for Charlton Heston in *Planet of the Apes* (1968) where he discovers apes now rule the planet he has landed on and humans have been enslaved by them. The twist at the end has him finding he was on Earth all along when he discovers the remains of the Statue of Liberty washed up on the shore, indicating that there has been an apocalyptic disaster in the world. Of course, the film was made only six years after the Cuban missile crisis and the threat of nuclear war was still a dark cloud hanging over so many people.

But as apocalyptic films became ever more popular, perhaps people stopped thinking of them as threats and viewed them purely for their entertainment value. Films such as the Australian *Mad Max* and John Carpenter's *Escape from New York* were regarded as escapist sci-fi, despite being a cross between a dystopian future following an apocalypse and a thriller. One of the most popular of these was James Cameron's *The Terminator* ((1984), where the inscrutable, terrifying and invincible brute with an Austrian accent (Arnold Schwarzenegger) is a cyborg tasked with travelling back in time from the post-apocalyptic future and behaves in a rather unneighbourly fashion towards Sarah Connor (Linda Hamilton), whom he attempts to assassinate to prevent her from giving birth to the son who will become a rebel in the future. The cyborg gives us a memorable quote from one of his handful of lines delivered in a monotone, 'I'll be back.'

One of the most popular sub-genres in sci-fi are the alien visitors, whether war-mongering or friendly. The friendliest and cutest alien was *ET: Extra-Terrestrial* (1982), directed by Steven Spielberg, with a screenplay by Melissa Mathison. ET wanted to go home to a distant planet but became stuck on Earth, and was treated to his first taste of beer and also dressed up in children's clothes. Visually he looked like a cross between a tortoise and a vacuum cleaner but a group of children loved and defended him. The film appealed to children of all ages. John Williams composed another memorable theme tune for the picture.

Returning to an old black and white film: *The Day the Earth Stood Still* (1951) was about an attack in which alien invaders start off aggressively but warn earthlings that unless they mend the error of their ways and become peaceful, then the aliens will destroy them. The film obviously carried fears of nuclear war and global self-destruction. Directed by Robert Wise the film starred Michael

Rennie, Patricia Neal and Hugh Marlowe. The picture's poster stressed: 'From Outer Space…A Warning and an Ultimatum!'

When viewed in a cinema on a large screen, the most stunning visual effect is of an alien ship coming over a mountain. A breathtaking moment and a fantastic acclamation of Steven Spielberg's wonderful filmmaking. It is a fantastic climax coming as it does towards the end of the film in *Close Encounters of the Third Kind* (1977). These aliens are not on earth to destroy, and the picture is a moving story of ordinary people confronting and daring to believe in the extraordinary. Especially Roy Neary (Richard Dreyfuss) who dares to search and believe in a UFO visitation. And another breathtaking moment in the film is when he is driving at night and looks in his rear view mirror and sees a UFO gliding down behind him.

The score for this great film was by John Williams, and there is a wonderful five note motif used to communicate with the aliens. And once you hear those five notes, you never forget them.

However, these sorts of alien visitation films does leave one wondering why these extraterrestrial visitors always visit the USA, and rarely Malta or the Republic of Ireland?

More aggressive alien invaders were written about in H. G. Wells' *The War of the Worlds,* and the 1953 film, directed by George Pal, began with commentary and newsreel style film in black and white before changing to colour. The picture starred Gene Barry, Ann Robinson, and was set in contemporary southern California, and was spectacular as armies battled unsuccessfully with the alien machines until they died through bacteria for which they had no immunity. Roughly the same story, with different sub plots, was made into a film of the same title in 2005 by Steven Spielberg, with Tom Cruise and Dakota Fanning. Ann Robinson, who had played Sylvia van Buren in the 1953 version, played the grandmother in this version. But I am sure there are many people who might have preferred a version set way in the past, similar to Jeff Wayne's musical version.

But not all alien attacks can be seen. An excellent and suspenseful film, from a Michael Chrichton novel, is *The Andromeda Strain* (1971), directed by Robert Wise, and is located mainly in a research laboratory in the Arizona desert where a group of scientists are fighting for the earth's survival from an extraterrestrial attack by microorganisms.

Robots figure greatly in sci-fi films, especially those that develop minds of their own and begin to take over. Artificial intelligence is topical and a worrying phenomenon in the 21st century, but it has been used to entertain audiences for many years. Going back to 1973, Michael Chrichton wrote and directed

Westworld, starring Yul Brynner who, like his character in *The Magnificent Seven*, is a robot in a theme park where visitors can indulge in a Wild West experience and can become gunslingers and kill robot cowboys. Then the real violence begins when the robots start to think for themselves.

So where did the idea of robots in our culture begin? They mainly began with Czech writer Karel Capek's play *R. U. R* (1920) which is an acronym for Rossum's Universal Robots. It was Capek's play that introduced the word robot into the English language, and comes from the Czech word *robota*, meaning forced labour. In his play, however, the robots are not mechanical devices but artificial biological organisms that could be mistaken for humans, like the replicants in *Blade Runner*.

And this type of artificial intelligence is in *Ex Machina* (2014), written and directed by Alex Garland, where Eva is played by Alicia Vikander, a very attractive android who has passed the Turing Test, which measures an AI machine's ability to exhibit intelligent behaviour equivalent to that of a human. Also starring Domhnall Gleeson and Oscar Isaac, this is a riveting psychological thriller and horror film.

One of the most stunning pictures on this subject is *A.I.: Artificial Intelligence* (2004), directed by Steven Spielberg, from a short story by Brian Aldiss, in which David (Haley Joel Osment) is an android capable of love. But his adoptive mother (Frances O'Connor) has a human son and that is when things start to go wrong. A little green-eyed monster surfaces, which, unlike love, is a highly dangerous emotion. And jealousy has been the staple of so many dramas from Greek tragedies to Shakespeare and beyond.

Virtual reality has been explored many times in the sci-fi genre, certainly in novels, and then in a few films and television dramas. But the definitive virtual reality drama is *The Matrix* (1999). Directed and written by Andy and Larry Wachowski, it starred Keanu Reeves as computer hacker Neo, who is approached by leather-clad Trinity (Carrie-Ann Moss) who introduces him to Morpheus (Laurence Fishburne), and soon they are in mind-blowing action within a computer generated world, and escaping from a sinister group of agents in dark glasses and suits. There are mind-blowing CGI effects, and aerial kung-fu sequences, as Neo fights to make sense of it all as he tries to survive and keep humankind in a perpetual hallucinatory state. Any viewers could be forgiven for thinking that *The Matrix* is allied to Alice's journey down the rabbit hole or Dorothy's trip to meet the Munchkins.

A sci-fi film that doesn't fit easily into any sub-genre (except perhaps from the atomic radiation contamination category) is *The Incredible Shrinking Man* (1957), directed by Jack Arnold from a novel by Richard Matheson. The main

character Scott (Grant Williams) is enveloped by a strange mist while on his boat and later discovers he is shrinking. There are some great special effects as his wife Louise (Randy Stuart) talks to him when he is the size of a desk lamp, and when he is only six inches tall he has to escape the pet cat by taking shelter in the doll's house. The props and scenery have been built to dwarf the actor. He ends up in the cellar, about the size of an insect, where he finds a cotton reel and needle which helps him to kill a spider that attacks him. The film ends when he is so small he can squeeze through a gap in a window pane and knows he will eventually become the size of an atom, but his final voice over regards his predicament philosophically, and says no matter how small he becomes he will still matter in the universe because God will know he exists.

When they showed screenings to test audiences, the overall comments said that the ending would have been better had he returned to his proper size. But despite that reaction, audiences weren't given a happy ending because the producers stuck to the original conclusion.

Superheroes

*Nowadays, everything's evolved into superheroes and it's boring. If
I see one more superhero movie I'm going to shoot myself.*

Ridley Scott

Like *Star Wars* and *Star Trek*, there are legions of fans for superheroes' comics
and films, and there are entire books devoted to these blockbuster action and
adventure films, and so one section in this book can't really do them justice in
the same way that a complete volume can. So this section will be confined to a
brief background of this phenomenal genre.

One of the earliest superheroes on film was in the silent era. The French
director Louis Feuillade, who made *Les Vampires*, directed the cinema serial
Judex (1916), a character seeking justice, who wears a black cloak and hat, and
could possibly be a precursor for the Dark Knight.

DC Comics go back to 1937, and over the years they have given us
Superman, Batman and Wonder Woman, to name but a few. And from 1939
Marvel Comics brought us Spider-Man, Iron-Man, Hulk, Captain America and
many more.

Years before feature films were made, superheroes appeared in cinema serials,
usually each episode ending on a cliffhanger where audiences thought this must
surely be the end of the superhero. But then the following episode showed the
comic book hero had somehow managed to survive, and there was usually a bit
of cheating when the new episode commenced.

George Reeves played Superman in cinema serials and made the first of the
comic book hero's feature films as *Superman vs the Mole Men* (1951) and in
1943 Columbia Pictures had made the *Batman* serial for theatrical showing,
starring Lewis Wilson with his sidekick Robin played by Douglas Croft. As this
was after the attack on Pearl Harbor, the villain was Dr Daka (J. Carrol Naish),
a secret agent for the Japanese Imperial Government.

There were many other comic book serials such as *Mandrake the Magician*
(1939) made in 12 episodes, and *The Adventures of Captain Marvel* (1941),

148

many of which were shown in cinemas on a Saturday, and these serials became so popular that they boosted cinema audience attendances.

From the early *Superman* serials, it took almost thirty years for the first major feature film *Superman: The Movie* (1978) to reach our screens. Directed by Richard Donner, the poster proudly stated, 'You'll Believe a Man can Fly'. The actor doing the so-called flying was Christopher Reeve, with Gene Hackman as the villainous Lex Luther and Marlon Brando as Jor-El, for which he was paid over $3 million and read his lines from cue cards. Up to that point this was the most expensive film ever made, costing $55 million. We all know that Superman is disguised as reporter Clark Kent, and his love interest is co-worker Lois Lane (Margot Kidder). The film almost ends with her tragic accident. So what does Superman do? He flies so fast he is able to spin the world backwards to before the accident happened and save her. If you think that is far-fetched, or indeed that all of the superhero antics are over the top, bear in mind that superheroes are not a recent cultural phenomenon but were a literary feast of mortals and Gods thousands of years ago. Just think of Heracles, Zeus, Aphrodite, Prometheus, Poseidon and all the many weird and wonderful monsters in Greek mythology, and in other world literary cultures. It's possible they may have influenced a few comic book writers and artists.

Batman had been a television serial for many years, starring Adam West with Burt Ward as Robin, with the on-screen graphics giving audiences a taste of comics as they showed the 'Ker Pow!' and 'Splat!' signs during their fights, turning the series from dark Gotham into high camp. It was time for the much darker version of Gotham city and *Batman* finally made it as a feature in 1989, directed by Tim Burton with Michael Keaton in the title role and Jack Nicholson as The Joker. There were many Batman films, but one of the most interesting was *Batman Begins* (2005), directed by Christopher Nolan, taking us back to the hero's early days when his parents are murdered, and the young Bruce Wayne (Christian Bale) travels the world to learn how to fight injustice. His bat cave and bat mobile are kept secret by his loyal butler Alfred (Michael Caine). This was followed up by *The Dark Knight* (2008) with Christian Bale and Heath Ledger as The Joker for which he received a posthumous Oscar for Best Supporting role as he sadly died at the age of 28. But this film was not without a certain amount of controversy as many people complained that it was much too violent for younger audiences.

The noughties brought many comic book films to cinemas. In 2000 *X-Men* took off, starring Patrick Stewart and Ian McKellen, and we had many *Spider-Man* movies with Tobey Maguire as the pretend arachnid, then came the massive green *Hulk* (2003) who was not dissimilar to *Shrek*. Robert Downey Jr was the

industrialist transformed into a superhero when he became *Iron Man* in 2008, showing audiences how even capitalists can contribute to society.

Although she had been around for a long time, Wonder Woman's first big screen appearance was in *Batman v Superman: Dawn of Justice*. But it wasn't until 2017 that *Wonder Woman* made it to the big screen as the protagonist. She was played by Israeli actress Gal Gadot and the film was directed by Patty Jenkins.

Because *Captain America: The First Avenger* (2011) was set in World War II, *Wonder Woman* helps the allies fight the Germans in the First World War. Her adversary though is Ares, the son of Zeus and the God of War. And Wonder Woman is really Diana, a princess in charge of Amazon warriors. So the influence of this story take us back thousands of years to where it all began.

And as they used to say when cinema programmes were shown continuously without a break: 'This is where we came in, folks!'

War Films

What is perhaps the first thing that comes into your mind when you think of a war film? Surely not bows and arrows and swords but tanks, machine guns, explosions galore. And when we think of a war film, there are not many made in the silent film era, because – not only would we miss the noise of the mayhem – but war as we think of it on film only began with the advent of the terrible First World War, beginning in 1914 and ending in 1918.

The trouble with war films, though, was how many clichés they spawned, especially the ones that tended to glorify war. You knew, as soon as the young recruit proudly exhibited a photograph of his fiancée or wife and children that he was next on the grim reaper's list. Those actors usually played small supporting roles and they were as expendable as cannon fodder. Then we had the young soldier who confided to the sergeant that he was scared, to which the very butch but sympathetic 'Sarge' assures him that 'We're all scared, son.' And any British soldier disguised as a German officer, doesn't need to speak German when they are stopped at a checkpoint. All they need to do is speak English with a cod German accent. The same applies at a Russian checkpoint. But hopefully these clichés only apply to the pot-boilers and will have little bearing on the forthcoming choice of classic war films.

<p style="text-align:center">***</p>

One of the earliest war films was the Oscar winning *All Quiet On The Western Front* (1930), told from the perspective of the Germans, and very much an anti-war film. It was from a novel by German writer Erich Maria Remarque, and this US production was directed by Lewis Milestone. After a speech to young German students about the glory of the army and saving the 'fatherland', the young men join up, including Paul (Lew Ayres). The young men soon become disillusioned when they witness the sheer carnage in the trenches and the film contains some epic battle scenes. The final bitter moment in the film comes when Paul sees a butterfly, and smiling he reaches out for it, only to be killed by a sniper.

Lew Ayres became a conscientious objector during World War II, but despite his heroism as a medic, his career suffered. Another World War II conscientious

objector's role as a medic was made into an autobiographical film directed by Mel Gibson. *Hacksaw Ridge* (2016) was the true story of a religious pacifist who saved the lives of so many men in a battle against the Japanese that he became a highly decorated hero.

A German version of *All Quiet in the Western Front* was remade and released in 2002. Many changes have been added to the original story, showing the killing continuing after the armistice had been signed in 1918. Unlike the 1930 version, this one was shot in colour.

The French *La Grande Illusion* (1937), directed by Jean Renoir, was set mainly in a German POW camp during World War I, where two French officers, the Lieutenant (Jean Gabin) and the Captain (Pierre Fresnay) and their relationship with the camp commandant (Erich von Stroheim), is amicable as they are from the same aristocratic class. But this illusion is dispelled by the bullets and carnage which don't respond to privilege.

This very compassionate and profound film was banned by the Germans during the occupation of France during World War II.

Australia made many First World War ANZAC films including *Breaker Morant*, *The Lighthorsemen* and the excellent *Gallipoli* (1981) directed by Peter Weir and starring a young Mel Gibson.

Ernest Hemingway's semi-autobiographical novel *A Farewell to Arms*, was filmed in 1932, starring Helen Hayes and Gary Cooper, and was remade in 1957 with Rock Hudson and Jennifer Jones.

Although there are not so many naval battle films from the 1914-18 war, there were many air combat films. In 1930 Richard Barthelmess and Douglas Fairbanks Jr starred in *The Dawn Patrol*, directed by Howard Hawks, which was remade in 1938 starring Errol Flynn, and Howard Hughes directed *Hell's Angels* in 1930.

The futility of the First Great War is depicted brilliantly in the star-studded musical that was based on Joan Littlewood's stage production *Oh! What a Lovely War*. The film was directed by Richard Attenborough and was released in 1969. The incongruity of so much death was depicted by showing the casualties on a cricket board score, displaying how many were killed against how much ground was gained. And in many cases it was very little ground gained compared to the fatalities. But at least this musical gives us so many jolly songs to cheer us up, although many of them also reveal the sheer hypocrisy of religious beliefs against massive slaughter, especially in a song like 'When This Lousy War is Over' sung to the tune of 'What a Friend We Have in Jesus'.

A more recent war film is *1917* (2019), produced and directed by Sam Mendes, who co-wrote it with Krysty Wilson-Cairns. It was inspired by stories

his grandfather, who had served in the First World War, told him. The film is set during a German withdrawal, which is a ploy to lure a British company into a trap. Two British soldiers, Will (George MacKay) and Tom (Dean-Charles Chapman) are tasked with journeying across no man's land towards the front line with a message warning the British company that they are faced with annihilation. This section of the film becomes more of an adventure, an escapade rather than showing the horrors of war as both soldiers struggle to survive the many obstacles they encounter, until Tom is killed, and Will must continue alone.

The cinematography of Roger Deakin is stunning, with innovative long takes, so that the film appears to be shot completely in just two takes. And there are some effective scenes where Will is struggling to survive bullets and blasts in a ruined town, with pitch black night suddenly bursting into flame with explosions and bright lights, as if he is hallucinating in a nightmare world. One almost breathes a deep sigh of relief when he falls into a cleansing river and is swept along in a torrent and reaches his destination. No wonder this film was so popular.

The prolific film director Stanley Kubrick directed *Paths of Glory* (1957) a black and white film about a deplorable true event that happened in the French army in World War I. Inept generals ordered impossibly ridiculous attacks on the enemy, and when the survivors make it back, they are accused of cowardice, and three soldiers are picked on to stand trial for desertion. Colonel Dax (Kirk Douglas) mounts a defence, but loses the case and the soldiers are executed. This is one of the most powerful and brilliantly acted war films showing that political decisions often betray humanitarian considerations.

Another effective scene in a film showing a deserter being executed by firing squad, again based on truth, happens in *The Victors* (1963), directed by Carl Foreman. An American regiment, a snowy scene in front of a French chateau, and a soldier is marched to the execution post while we hear Frank Sinatra singing, 'Have Yourself a Merry Little Christmas'. This is what is called Sound Dissonance, the juxtaposition of a sentimental song or piece of music during a harrowing scene. This device was also used during the aforementioned *Dr. Strangelove* when we hear Vera Lynn singing 'We'll Meet Again' during the nuclear holocaust.

At the start of and during World War II, many films were propaganda and morale boosters. America was reluctant to participate in the war, and Hitchcock's *Foreign Correspondent* (1940), while not outwardly propagandist, 'The Star Spangled Banner' was added to the soundtrack, playing over the end credits. *In Which We Serve* (1942), directed by David Lean and Noel Coward,

told the story of sailors shipwrecked during a sea battle and their struggle to survive. Ealing Studios' *Went the Day Well* (1942), from a story by Graham Greene, was about Germans infiltrating a cosy English village and the way the ordinary folk rise up to defeat them, although the upper class squire of the village is a quisling and in cahoots with the Germans. (Who did Graham Greene have in mind when he wrote that?) After the fall of Pearl Harbor many American propaganda films followed including *Thirty Seconds Over Tokyo* (1944) with Spencer Tracey and *Hangmen Also Die* (1943) about the assassination of Heydrich in Czechoslovakia. This film was directed by Fritz Lang and Bertolt Brecht contributed to the screenplay, who as a German refugee moved to the USA in 1941.

One of the most highly acclaimed submarine war films is the German *Das Boot* (1981), directed by Wolfgang Petersen. What is remarkable about this film is the way in which it captures the claustrophobia and the filth of the sweaty life of the sailors below as they pray to avoid depth charges. After a tense underwater escape from allied warships, the ending is ironic as the U-boat makes it back to Bremen only for most of the sailors, now on dry land, to be killed by an attack from allied fighter planes.

Controversial, but recognised as perhaps one of the best of British films, is *The Life and Death of Colonel Blimp* (1943) directed and produced by Michael Powell and Emeric Pressburger. It starred Roger Livesey, Deborah Kerr and Anton Walbrook. Livesey is excellent as a military officer in a flashback from his command of the Home Guard to when he won a Victoria Cross in the Boer War and follows his exploits in the First World War. Deborah Kerr plays three different roles and Austrian actor Walbrook plays a German, showing him to be very human and sympathetic. Although Winston Churchill didn't see the film, from what he was told about it being slightly satirical, he wanted it stopped. The film still went ahead and was a success when it was released. It was distributed both in black and white and a Technicolor version.

Italian neo-realism took off with *Rome, Open City* (1945), directed by Roberto Rossellini with a screenplay by Sergio Amidei and Frederico Fellini, and shot in the newly liberated city. Rossellini drew on some of his own experiences of hiding from Nazis searching for young Italians who opposed them. The film is shot in a documentary style and when a young housewife (Anna Magnani) is gunned down it looks as if it might have been taken from newsreel footage. There is also a chilling scene where a priest sits helplessly as he hears the screams of a Resistance fighter being tortured. And the kindly priest is shot by the Nazis, looked on by a crowd of terrified young boys. After her role in this film, Anna Magnani became one of the Italy's most renowned actresses.

Heavy on irony, David Lean's *The Bridge on the River Kwai* (1957) starred Alec Guinness as the army colonel who is in charge of getting the POWs to build a railway bridge for their Japanese captors in the suffocating heat of the Burmese jungle, But a team of Americans, led by an escaped POW (William Holden), succeed in blowing up the bridge, a tragic conclusion for the British colonel who had taken a certain amount of pride in the engineering feat. The film was based on the French novel by Pierre Boulle and the screenplay was by Carl Foreman and Michael Wilson, who as blacklisted Hollywood writers received posthumous Oscars for their screenplay in 1984.

One of David Lean's epic war films was *Lawrence of Arabia* (1962) with stunning desert photography by Freddie Young. The script was by playwright Robert Bolt, based on T. E. Lawrence's autobiographical *The Seven Pillars of Wisdom* and starred Peter O'Toole as the eponymous colonel, siding with the Arabs and waging war on the Turks during the First World War. There are some stunning images in the film, like the effect of seeing a mirage materialising in the distance, and as it becomes more focused, we see that it is Omar Sharif. In another set piece we see a ship gliding through sand, then discover the scene takes place near the edge of the Suez Canal. The film also delves into the hypocrisy of some of the elite military officials and the dangers of colonialism. But it is O'Toole's remarkable performance, his journey from sympathy and understanding to a more bloodthirsty arrogance that captures the character of Lawrence. After this film, O'Toole was elevated to starring roles, even playing the lead in the campy *What's New Pussycat* (1965), remembered mainly for the Burt Bacharach and Hal David song, sung by Tom Jones.

One of the classic POW films is *The Great Escape* (1963), directed by John Sturges, with an all-star cast of American and British actors. Richard Attenborough and Gordon Jackson are in charge of the British contingent, with Charles Bronson digging tunnels despite his claustrophobic fears, and Donald Pleasance as a forger whose eyesight is on the wane, with James Garner as a charmer who scrounges bits and pieces from the guards. But the man who is known as the 'King of the Cooler', the escaper who has been caught many times and has to suffer solitary confinement in 'the cooler' is Virgil Hilts (Steve McQueen) who has the most spectacular escape of all, with McQueen doing his own stunt on a motorbike. Although the film was based on a book's true account, it was heavily fictionalised. Virgil Hilts was based on true life writer Bill Ash's war experiences, and it was he who was known as the 'King of the Cooler'. He settled in Britain after the war and was a member of the Writers' Guild of Great Britain for many years, and died in 2014. I'm also a member of the Writers' Guild and during an AGM years ago, I asked Bill about his prison

camp escapes, and if he managed to grab a motorbike like Steve McQueen. Bill just laughed and said, 'There was never a convenient bike around when you needed one!' That's Hollywood for you.

Over the fifties and sixties there were dozens of war films, many of which were based on books written by ex-servicemen who had served in the war. But when the filmmakers stuck slavishly to the facts, they tended to show too many action-packed scenes and little else. But there were some excellent war films like *Above Us the Waves* (1955), *The Cruel Sea* (1953), *Cockleshell Heroes* (1956) and *Dunkirk* (1958), about the evacuation from the French beaches when the British soldiers were in danger of being overrun and destroyed by the Germans until small pleasure boats came to the rescue. This black and white film was shot mainly on Camber Sands, in Rye, East Sussex, was directed by Leslie Norman and starred John Mills, Richard Attenborough and Bernard Lee.

The 2017 film *Dunkirk*, shot in colour, was written and directed by Christopher Nolan and produced by him and Emma Thomas. It will be remembered as one of the great war films that becomes something of a thriller as many young soldiers suffering from shell shock try any subterfuge to get away on a ship or boat as German fighter planes attack. Although the film is not heavy on dialogue, we still get to know many of the characters who are portrayed economically and realistically. Michael Caine has a small cameo role in the film as a gesture to his role in *Battle of Britain* (1969).

Possibly one of the best, and perhaps the most expensive black and white film ever made, was *The Longest Day* (1962) about the D-Day landings. Produced by Daryl F. Zanuck for 20th Century Fox and directed by Ken Annakin, it featured so many stars, some in cameo roles, most of them accepting fees well below what their agents normally demanded for a major film. Three American pop singers appeared in the film: Paul Anka, Fabian and Tommy Sands. At the time of filming this war epic, Richard Burton and Roddy McDowell were in Rome filming *Cleopatra* and had not been used for several weeks. They were bored and phoned Zanuck to ask if they could play small unpaid cameos in the film, and both flew to the location and filmed their cameos in a day for free. The film was Sean Connery's last film appearance before he played James Bond.

Incidentally, Paul Anka, Fabian and Tommy Sands didn't sing in the film.

The other great D-Day film is *Saving Private Ryan,* (1998) directed by Stephen Spielberg with a screenplay by Robert Rodat. Tom Hanks plays Captain John Miller tasked with the US War Department's directive to save Private Ryan whose three brothers have been killed, and saving Ryan from the war will save his family from the loss of all their sons. But the film begins with the Omaha beach landing on 6 June 1944, which was shot over four weeks with a budget

for this harrowing opening scene of $12 million. As we see the landing crafts arrive on the beach and hear the terrifying explosions and gunfire, with shots of seawater red with blood, and visions of soldiers bodies being torn apart as they become targets of machine gun and mortar fire, the images and sound captured in these opening scenes is a truly terrifying start to the picture.

Following the Omaha beach battles, Captain Miller takes his men behind enemy lines to rescue Private Ryan, and the film then reverts to the typical good guys versus bad guys like many war films, but at the same time it does show how war brutalizes men and dehumanizes them.

The Ryan family was based on the four Nilan brothers, written about by historian Stephen E. Ambrose in his book about D-Day. And the film ends with a documentary style interview with the aged Ryan in the present day (played by another actor of course).

Made in black and white and released in 1993, Steven Spielberg's holocaust picture *Schindler's List*, adapted from Thomas Keneally's non-fiction novel *Schindler's Ark* is set mainly in a Polish labour camp near Krakow where Jews are slaughtered at the whim of the camp commandant (Ralph Fiennes) who thinks nothing of using them for target practice. Schindler, a German industrialist (Liam Neeson), rescued as many as 1,100 Polish Jews by using subterfuge to employ them in his factory. A stunning, moving film which sometimes leaves the viewer devastated by the sheer horror of the cruelty that some men are capable of.

Equally brutal and severely shocking was the film of the Warsaw occupation *The Pianist* (2002), directed by Roman Polanski. It starred Adrien Brody as concert pianist Wladyslaw Szpilman, the film based on Szpilman's autobiography and adapted by Ronald Harwood. Szpilman, having witnessed Jews herded into the ghetto, and then dragged and driven away to concentration camps, is concealed in a flat by some friends where there is a piano. Unable to play the piano, lest he give away his hiding place, he places his hands silently over the keys and imagines the notes in his head. Almost dead from starvation he drags himself into a bombed and derelict building in a search of food and is discovered by a German officer. And then, in the most moving scene in the film, the Wermacht officer finds him a piano to play, and also brings him a coat to wear and some food.

Polanski handled this film superbly, giving great attention to detail, and shot it beautifully in colour, but in certain scenes it was muted to almost sepia tones. But would the director have had nightmares from his own memory as he was shooting it? Polanski was in Warsaw during the Nazi occupation as a youngster and saw his father being taken away to a concentration camp. His father survived

but his mother died in the gas chambers at Auschwitz. Polanski survived as he was helped by some Catholics and was saved by them by pretending he was from the same background.

The war in Europe ended during the first week in May 1945, just one week after Hitler's suicide in a bunker in Berlin. His final days are brilliantly captured in the German film *Downfall* (2004), directed by Oliver Hirschbiegel with a screenplay by its producer Bernd Eichinger. Adolf Hitler was played by Swiss actor Bruno Ganz, an extremely convincing performance with the dictator ranting on his final days on earth, and screaming ridiculous instructions and blaming others for their treachery as the Russians enter Berlin from the east and the allied forces move closer from the west. He and Eva Braun are shown to commit suicide and then their bodies are doused in petrol and burned. The most chilling scene in the film is when Joseph Goebbels and his wife Magda poison their six children with cyanide prior to their own suicide.

Hitler's death, recorded by his secretary (some of this film was partly based on her diaries), happened on 30 April 1945. That same day in Wales, my parents would have been celebrating my second birthday. I don't know what relevance that has, but I thought I would mention it as another more minor but peaceful event on the day of Hitler's downfall..

Although it was peace in Europe, the war in the East continued and didn't end until the Japanese surrendered after the Americans dropped an atomic bomb on Hiroshima then Nagasaki in August 1945, even though the Japanese had almost lost the war by then. Apart from the previously mentioned Kwai Bridge film, there were many films made about the war with Japan, from the bombing of Pearl Harbour to the naval battles in the Pacific. Films like *Tora! Tora! Tora!*, *A Town Like Alice*, *From Here to Eternity* and *Empire of the Sun* were reasonably good films, but three outstanding films were made in more recent years. *The Thin Red Line* (1998), directed by Terence Malick, from a novel by James Jones, with a cast including Sean Penn, Nick Nolte, George Clooney, John Cusack and Woody Harrelson. The soldiers portrayed in the film are fighting a vicious battle on a tropical island against an almost unseen Japanese enemy, where each soldier's feelings and their aspirations, their human failings and bravery, are revealed during lulls in the fighting. One of the soldiers has gone AWOL (James Caviezel) and lives a simple life among a Pacific tribe. But for the rest of his unit, the horror of war continues, and it is fought against a backdrop of tropical beauty, with occasional shots of beautiful flowers, showing that the savagery of war is an affront against nature and sanity.

One of the most famous battles in the Pacific was on the island of Iwo Jima, from which there came the iconic photograph and later a statue of the five

marines and Navy corpsman who raised the flag when the island was taken. *The Flags of Our Fathers* (2006) was directed, co-produced and scored by Clint Eastwood and told the story of this battle, but it is more about the aftermath of the battle and how it affected those involved after the war ended. Eastwood shot this back-to-back with *Letters From Iwo Jima* (2006), in the Japanese language with a Japanese cast, and the story was told from the perspective of the Japanese soldiers who, realising they had no chance of survival, wrote letters home and buried them in the tunnels which the soldiers had dug and occupied on the island. The letters were discovered by Japanese archaeologists in 2005. The film became very popular in Japan and most critics gave it favourable reviews acknowledging that perhaps for the first time the Japanese people were not portrayed as stereotypes.

Not all films written about in a cinema history should necessarily be good enough to merit the label 'classic' or even outstanding. Mention should be made of a turkey if it is significant and adds to the history when compared to other movies and what was happening in the world at the time. Most of the films about the Vietnam war were made years after the fiasco had ended in 1973. But there was one film that was released at the height of the war in 1968. This was *The Green Berets*, starring and co-directed by John Wayne. The actor was very much a flag-waving American patriot who was anti-Communist, although he had never ever served in any military conflict other than on celluloid. His film when it opened in cinemas was laughed at by film critics, many of whom said it was the most laughable picture in years and churned out terrible clichés. When it opened in London it was booed by audiences, although worldwide it still made a healthy profit at the box office.

The Deer Hunter (1978), directed by Michael Cimino, was probably the first major Hollywood film set in the Vietnam war. Shot in Technicolor and three hours long, the opening scenes are during a wedding located in a Pennsylvanian steel town, which is also a farewell celebration for three conscripted recruits: Michael (Robert De Niro), Steven (John Savage) and Nick (Christopher Walken). All three become prisoners of war by Vietcong soldiers, their characters portrayed as stereotypical Asian 'spooks'. After the escape of the three American soldiers, Steven ends up a paraplegic, Nick flounders somewhere in Southeast Asia and Michael makes it back home carrying a heavy burden of guilt, but still manages to fall in love with Linda (Meryl Streep), Steven's fiancée.

The horrors of the Vietnam war are captured more convincingly in *Apocalypse Now* (1979), directed by Francis Ford Coppola, based on the novel *Heart of Darkness* by Joseph Conrad, with a screenplay by Coppola and John Milius. Captain Willard (Martin Sheen) is ordered to find and 'terminate with extreme

prejudice' Colonel Kurtz (Marlon Brando), a Special Forces turncoat. Much has been written about the difficulties of filming this journey in war-torn Vietnam much of which was a 16 week shoot in the Philippines, during which time Martin Sheen suffered a near-fatal heart attack. Some of the scenes are horrific, and anyone who has ever read journalist Michael Herr's *Despatches* from the war will know what a nightmare it was. The scene which stays with you is the helicopter ride with the lunatic warmonger Kilgore (Robert Duvall) playing 'The Ride of the Valkyries' on the attack and declaring, 'I love the smell of napalm in the morning'. The demented Kilgore wears a Stetson, and following the obliteration of a village he drools, 'It smelled like…victory.' The film opens with the Doors' song 'The End', and the final ambiguous scene is Kurtz in deep shadow talking philosophically, much of which was improvised by Brando (which I guess made a welcome change from reading his lines from cue cards).

Platoon (1986) was written and directed by Oliver Stone, and it is semi-autobiographical as Stone was a soldier serving in Vietnam and experienced the horrors of that war. His alter ego in the film is 19-year-old Chris Taylor (Charlie Sheen), a young patriotic soldier who quickly becomes disillusioned with everything that he is fighting for.

The deliberate dehumanizing and conditioning of young men when preparing them for war is captured perfectly in Stanley Kubrick's *Full Metal Jacket* (1987). It begins with sixties long-haired young men being shorn by electric razors and reduced to an aggressive bald cloning, making them almost indistinguishable from one another, like the pawn chess pieces on a board. And then, half the film is taken up by their training by the drill sergeant who bullies with obscene and threatening rhetoric, and even resorts to physical violence. This character is brilliantly played by R. Lee Ermey, and his character is shot by one of the recruits who has been pushed too far by his ruthless bullying, and then the recruit turns the gun on himself. After Private Joker (Matthew Modine) discovers their bodies, the film almost jump cuts to Vietnam. The climax of the film is a skirmish in the ruins of Hue city when several of the platoon are killed by a sniper who turns out to be female. The final scene is when the troops leave the area singing 'The Mickey Mouse Club March'.

Kubrick was clearly fond of using sound dissonance, which he has used for many films, especially *Clockwork Orange* where Droog Alex (Malcolm McDowell) kicks a tramp to death while chanting 'Singin' In The Rain'.

Following their Vietnam debacle, America continued to fight many wars a long way from home, and filmmakers continued to make films about those wars. The Gulf War produced two well-made films: *Three Kings* (1999) and *Jarhead* (2005). But the film about the Iraq war which gained the most awards

was directed by Kathryn Bigelow. *The Hurt Locker* (2008) was written by Mark Boal, based on his observations when he was an embedded journalist in Iraq in 2004. The film stars Jeremy Renner who is a bomb disposal soldier for the Explosive Ordnance Disposal team, and the film's suspense hinges on the men attempting to defuse explosive devices. Some are killed, but what comes across in this film is the macho way many soldiers enjoy war and the push for the ultimate adrenaline experience. The title refers to a colloquialism for being injured and sent to 'the hurt locker'.

Perhaps the final word for this film (and other US wars) should come from a respected writer. John Pilger, journalist and documentarian, criticized the film in the *New Statesman* by writing that it 'offers a vicarious thrill via yet another standard-issue psychopath high on violence in somebody else's country where the deaths of a million people are consigned to cinematic oblivion.'

Action-Adventure & Disaster Movies

One of the earliest adventure and monster movies was *King Kong* (1933), remarkable for its special effects using early stop-motion techniques with impressive models, also using matte paintings on film, and combining live action and stop motion backed by rear screen projection. It was produced by RKO Radio Pictures and first distributed by them, and was directed by Merian C. Cooper and Ernest B. Schoedsack, from a story by Edgar Wallace. This now well-known story (following many remakes) of the trip to Skull Island by the wildlife filmmaker (Robert Armstrong) and the actress Ann Darrow (Fay Wray) who he takes with him is a remarkable monster film. After one of the ship's crew (Bruce Cabot) and Ann fall in love, then so does the giant gorilla Kong that they encounter on the island. The movie ends in tragedy back at New York, when the escaping monster ends up clinging to the Empire State Building, giving Ann a forlorn and loving look before being shot down by planes. Seeing the Kong's corpse in the street, a policeman remarks that the plane got him. To which Robert Armstrong has the film's last line: 'It wasn't the airplanes, it was beauty killed the beast.'

This is probably the first time the Empire State Building has been used in a fictional film as it hadn't long been open. The official opening ceremony was on 1st May 1931.

'Hell Upside Down. At Midnight on New Year's Eve the SS Poseidon was struck by a 90 foot tidal wave and capsized'. Those words on a poster for the 1974 disaster movie *The Poseidon Adventure* pretty much tells you everything about the film. The rest is the story of a disparate group of people trying to survive in a ship that is upside down. The film, directed by Ronald Neame, was tense and exciting and the art direction was superb as every scene inside the ship was topsy-turvy. (If you watch this film and find that unnerving, watch it by standing on your head. But then the characters will be upside down.)

Beyond the Poseidon Adventure, the sequel, starred Michael Caine and Sally Field, and only took 20% of its $10 million budget in box office receipts. It really was a disaster movie and sank without trace. Pardon the pun!

So much for disaster from water. Then came disaster from fire with *The Towering Inferno* (1974) where 'One Tiny Spark Becomes a Night of Blazing Suspense'.

162

It was co-directed by Irwin Allen, who had produced the *Poseidon* movie, and John Guillermin. Top of the billing are Steve McQueen, Paul Newman, William Holden and Faye Dunnaway, in this clichéd but highly entertaining film as one of the tallest of skyscrapers catches fire because someone has cut corners on the use of building materials. The inferno and action sequences are directed by Allen and the soap opera melodrama between the haggling characters was directed by Guillermin. In one scene Claiborne (Fred Astaire) is told by Security Chief Jerrigan that his love interest (Jennifer Jones) is dead. The Security Chief is played by disgraced baseball star O. J. Simpson. But having delivered the startling news of the death of Claiborne's love to him, the Security Chief says he has managed to rescue their cat and hands kitty over. Aaaw!

There was plenty of action in *Enter the Dragon* (1973) a Hong Kong, US co-production directed by Rober Clouse, and it is perhaps one of Bruce Lee's best martial arts films as he goes up against villains accompanied by John Saxon and Jim Kelly. But it is Lee who seems to sail through the air as he drop kicks and twirls, without the aid of wires. He had a likeable and charismatic presence in between and during all the action.

One of the finest action-adventure films is *The Raiders of the Lost Ark* (1981), directed by Steven Spielberg with a screenplay by Laurence Kasdan, George Lucas and Philip Kaufman. Harrison Ford plays Indiana Jones, an archaeologist who wears a fedora and carries a bullwhip, not only for showing off but for protection. Indiana, without losing his fedora, manages to outrun a huge speeding boulder in a cavern, escape a pit of deadly snakes, and has to grapple with a nasty-looking bloke wielding a sword in a market place. Rather than use his bullwhip, he takes out a gun and shoots the man. This was apparently the suggestion of Harrison Ford to keep the film running to schedule rather than having a lengthy choreographed fight sequence. The McGuffin in the film is a precious artefact, the Ark of the Covenant, which Indiana needs to discover before nasty Nazis get to it. And it makes a change that the heroine Marion (Karen Allen) isn't the typical female in distress relying on the hero to save her, but she is quite capable of saving herself. The film also has a great deal of humour, excellent dialogue, and led to three more *Indiana Jones* films. Then, twenty-seven years after the first *Lost Ark* film, in 2008 Harrison Ford donned his fedora once more for another outing in *Indiana Jones and the Kingdom of the Crystal Skull*. And that seemed to be that. But no, Lucasfilm was bought by the Walt Disney Corporation, along with the Indiana Jones rights, and they produced a fifth and final film with *Indiana Jones and the Dial of Destiny* (2023). This was the first in the franchise to lose money because it needed to take at least $600 million just to break even.

With mind-blowing aerial combat and fighter plane sequences, *Top Gun* hit the big screens in 1986, starring Tom Cruise, with Anthony Edwards as his best friend, and Kelly McGillis as his love interest. The film was directed by Tony Scott, and the screenplay was inspired by a magazine article about Top Gun fighter pilots. The film's aerial sequences are very redolent of the pop art scene and Roy Lichtenstein's fighter plane picture *Whaam!* (Tate Gallery, London). The film had enormous adolescent appeal at the box-office, and perhaps gamers were drawn to the combat images like the comics they may have read in their childhood, and they could now reenact dangerous fighter pilot combat on their computers without leaving the safety of their homes. The film was heavily criticized for being warmongering, and even Tom Cruise worried about making a sequel for those reasons. Matthew Modine was offered a role in the film and turned it down for that reason, as did Bryan Adams who was asked to contribute to the music. However, the music was one of the standout performances in the film, especially with 'Take My Breath Away' by Berlin. A sequel was eventually filmed and released more than thirty years later. *Top Gun: Maverick* (2022) and many critics praised it, saying it surpassed the original picture.

But as to the warmongering criticisms of the first film, it is worth bearing in mind that the US has been at war 93% of the time since 1776 and has never completed a decade without a war of some sort. But not in their own country!

The same year that *Schindler's List* was released, another film directed by Steven Spielberg which couldn't have been more different from the *Schindler* film, although it was very much the type of film people had come to expect of the director, was *Jurassic Park* (1993), with a screenplay by David Koepp and Michael Chrichton, from Chrichton's novel of the same name. Set on a remote island, millionaire John Hammond (Richard Attenborough) has created real life dinosaurs having discovered DNA in long buried amber. Palaeontologists Alan Grant (Sam Neill) and Ellie Sattler (Laura Dern) have been invited to the island to observe these fantastic creatures, which are safely tucked behind high electrified fences. Also on the island is mathematician Ian Malcolm (Jeff Goldblum), Hammond's young grandchildren and the game warden played by Bob Peck. All set to have themselves a ball until a storm ravages the island and blows down the protective barriers. But what is so clever in Spielberg's film is the way he builds the suspense. Huddled in a vehicle they don't see the Tyrannosaurus Rex at first but they hear its thunderous footstep. And then another footstep getting louder and closer as the intensity builds before the children see this monster. Unlike Peter Jackson's *King Kong* which reveals everything right away with no suspenseful build-up, many scenes in *Jurassic Park* have a creepy slow build which pays dividends when the action goes haywire. Even the scene with

Bob Peck, staring down the sight of his high velocity rifle as he attempts to focus on a shifty velociraptor. Then, realising the creature has outsmarted him, he acknowledges the velociraptor with an admiring 'Clever girl' just before his end. The film is an action-packed movie, using cleverly constructed CGI, with a climax as the creatures invade the kitchens where the children are hiding. It is possibly one of the very best adventure movies ever made, and led to quite a few sequels.

Possibly the biggest disaster movie of all time is *Titanic* (1997), written and directed by James Cameron. It is based on the true life sinking of what was claimed to be the unsinkable luxury liner in 1912. But there have been other films about the Titanic. One of them was a Nazi propaganda film of the same name. It was commissioned by Joseph Goebbels to show how British and American capitalism was responsible for the disaster. There was also a fictional German officer added to the crew to display his bravery and altruistic behaviour when compared to the cowardly British officers. Although the film was shown in German occupied territories, Goebbels banned it from being shown in Germany because of the allied aircraft bombings and the film depicted many frightened people panicking.

A Night to Remember (1958) was a black and white British film about the Titanic disaster. It was directed by Roy Ward Baker and starred Kenneth More as the Second Officer. It was an excellent version of the true event and many researchers have praised it for its accuracy.

It was the most expensive film ever made in Britain up to that time, costing £600,000 in what would be around £14 million today. But it is James Cameron's version that is epic and builds on the fictional stories of the passengers until the disaster happens and the ship hits an iceberg. The recreation of this event is spectacular and it is reported that this film had a budget of around $200 million, but worldwide it took £1 billion in ticket sales, and cinemas made a small fortune in popcorn and fizzy drinks.

Kate Winslet stars as Rose in *Titanic*, a high-born young woman set to marry reprehensible Cal (Billy Zane) until she falls for Jack (Leonardo DiCaprio), a steerage passenger. And then comes the tragedy, and the film shows some of the events that actually happened. As the mighty liner is sinking, the ship's musicians don't make a bolt for the lifeboats but stay behind and play music. And steerage passengers are locked into their part of the ship from where there is no escape. The film has a mix of fictional and historical characters, but what aids a disaster movie like this one, which could so easily have become merely an exercise in sheer spectacle, is the love story that carries audiences through

emotionally and also being able to identify with the many people caught up in this tragic event.

What is also so remarkable about *Titanic* is its score, written by James Horner. Try asking anyone what they remember about the film's music and they will probably tell you that it is Celine Dion's hit song 'My Heart Will Go On', written by Horner with lyrics by Will Jennings that brings back memories of this remarkable picture.

Over the years since its initial release, its reissues have taken the film to a gross of over $2 billion making it the (then) highest grossing film of all time, beating *Jurassic Park*, until James Cameron wrote and directed *Avatar* (2009) which was also made and shown in 3D, and this has hit the top spot as far as gross returns are concerned..

Children's & Family Films

One of the most popular family and children's films of the 1930s starred a female toddler. Shirley Temple, born in 1928, had by 1934 chalked up many film appearances, but it was during that year, when she was still only 5-years-old that she appeared in *Bright Eyes* singing what was to become her signature song 'On the Good Ship Lollipop'. She made dozens of films and was hugely successful. As an adult, known as Shirley Temple Black, she became a US Ambassador for Ghana and later Czechoslovakia.

There were many popular family films in the 1930s, such as *Babes in Toyland,* a Hal Roach musical comedy starring Laurel and Hardy and *The Adventures of Tom Sawyer* (1938) based on books by Mark Twain. Then in 1942, young Indian actor Sabu became a big star when he played Mowgli in *Rudyard Kipling's Jungle Book.* The film was made by the Korda brothers, Zoltan as director, Alexander as producer and Vincent as Art Director. Although they were a British film industry team, the *Jungle Book* film was made in Hollywood because of the war.

One of the biggest stars in the 1940s was a collie dog named Pal who played a dog character called Lassie, a canine who always managed to rescue a distressed human. The first film, based on a short story, later expanded into a novel, was by Eric Knight and was called *Lassie Come Home* (1943), although the story of Lassie was first written by Elizabeth Gaskell in 1859, and in her short story *The Half Brother*, Lassie is described as a female collie who rescues two half-brothers lost in the snow. Pal appeared in six more Lassie films, made by MGM, through to 1951. One wonders if this professional canine belonged to American Actors' Equity? But at least Lassie is one of several notable animals celebrated by a star in the Hollywood Walk of Fame.

But the Lassie story didn't end with Pal's portrayal and carried on with many other collies in TV versions, and a feature film of *Lassie Come Home* was remade in 2006, starring Peter O'Toole in a supporting role, with Samantha Morton and Steve Pemberton. It was favourably reviewed by the critics, and one reviewer, clearly taken by the dog, said that Lassie had enough facial expressions to put Jim Carrey to shame!

Horses are often upstaged by clever canines like Lassie, but Anna Sewell's 1877 novel *Black Beauty* has been made as a feature film at least four times, the second version in 1946, and then in 1971 starring Mark Lester, and in 2020 with Kate Winslet. But the horse story that made Elizabeth Taylor into a teenage star was *National Velvet* (1944) starring Mickey Rooney. In this story Taylor plays a young jockey who becomes the first female to ride in and win The Grand National.

The most popular family films of the late forties and fifties starred Danny Kaye, a brilliant performer who usually performed a quick fire delivery of tongue-twisting songs, and his films contained much of his well-timed slapstick, pantomime and physical knockabout. He starred in the title role in *The Secret Life of Walter Mitty, The Inspector General* and in the 1952 film *Hans Christian Anderson* which gave him quite a few hit records. His medieval comedic romp *The Court Jester* (1955) was one of his most successful films, and a great tribute to his talents as a performer. Written by Norman Panama and Melvin Frank, who gave Kaye some memorable lines, like the ones when he attempts to remind himself where the poison is. 'The pellet with the poison's in the vessel with the pestle. The chalice from the palace has the brew that is true!' But Kaye's most viewed film has to be the musical comedy *White Christmas* (1954), directed by Michael Curtiz, in which he starred opposite Bing Crosby, and the two female stars were Rosemary Clooney (George Clooney's aunt) and Vera Ellen. The Irving Berlin title song, incidentally, was first sung by Crosby in *Holiday Inn* (1942). Now sung every December at a shopping mall near you.

Perhaps sneaking in this British family film doesn't really belong in a history of cinema but *John and Julie* (1955) is interesting simply because it is about two young children, played by Colin Gibson and Lesley Dudley, who live in Dorset and are so determined to see the Coronation of Queen Elizabeth II that they take themselves off to London to watch the event. Sidney James is the grumpy father of John and Peter Sellers has a small cameo role as a policeman. They interspersed some footage of the Queen's coronation day in the film which I suppose was my reason for the film's inclusion into this history.

The Red Balloon (1956) is a 34 minute short French film directed, produced and with a screenplay by Albert Lamorisse, that tells the story of Pascal (Lamorisse's son) who when walking in a suburb of Paris is befriended by a bright red, helium-filled balloon that follows him around, and the brightness of the balloon contrasts with the drab dullness of the area. He also meets a young girl who is being followed by a blue balloon, and she is played by Pascal's sister. The balloon follows Pascal everywhere, into his classroom and church, but in one of the backstreets some uncouth boys shoot down the balloon with

catapults and destroy it. But a crowd of other balloons come to Pascal's rescue and he is then transported by cluster balloons flying over Paris. This delightful short film received many accolades, and some cinema historians and critics have interpreted the film as some sort of religious symbolism. Which may explain why this is perhaps the only short film to receive an Oscar for the Best Screenplay.

A musical children's film with a budget of six million dollars which rose to three times that amount when Fox made *Doctor Dolittle* (1967) directed by Richard Fleischer and starring Rex Harrison who created problems from the word go, and didn't get on with Anthony Newley. Samantha Eggar was the female star and her songs were dubbed . Leslie Bricusse wrote the screenplay, music and songs, adapted from the 1920s novels by Hugh Lofting, Financially the film was a failure and Fox reckoned they lost something like $11 million on the project.

A far happier and more successful children's musical comedy was released in 1968. *Chitty Chitty Bang Bang* was directed by Ken Hughes who co-wrote the screenplay with Roald Dahl, from the children's novel by Ian Fleming. It starred Dick Van Dyke, Sally Ann Howes and Lionel Jeffries, and Robert Helpmann played a baddie as the Child Catcher. The special effects for the film were great, especially when you consider there was no CGI back then, and there were many well-known actors in cameo roles. This has become a children's classic, with a score by Irwin Kostal and songs by the Sherman Brothers.

Many of Roald Dahl's children's books have been adapted for the screen. His *Charlie and the Chocolate Factory* had a name change and became *Willy Wonka & the Chocolate Factory* (1971). Perhaps it was because the war in Vietnam was still raging and US troops called the Vietcong 'Charlie'. The film was directed by Mel Stuart and starred Gene Wilder as Wonka with Peter Ostrum as Charlie, who finds a Golden Ticket in a chocolate bar and the prize is a visit to Wonka's chocolate factory, which he attends along with some undeserving grotty children. Roald Dahl wrote part of the screenplay, but because of the changes that were made and were so dissimilar to the book, he disowned the film. Which was a shame, because the film has a high entertainment value for children and adults of all ages, and has a wonderful entrance by Wilder when he launches himself into a forward roll. The musical numbers were written by Leslie Bricusse and Anthony Newley. The song 'Candy Man' came from the film and became a hit when it was recorded by Sammy Davis Jr.

The film was remade in 2015 with its original title, directed by Tim Burton and starring Johnny Depp as Wonka. It had a much higher approval rating from the Dahl Estate as it was faithful to the original story, and if box-office returns are anything to go by, it was more successful than its predecessor which is mainly what the Hollywood moguls care about. Ker- ching!

Another Roald Dahl story is *James and the Giant Peach* which was made into a mix of live action and stop motion animation in 1996, directed by Henry Selick, with Paul Terry as James and starring Joanna Lumley and Miriam Margolyes, with many well-known actors providing voice-overs for insects. The score was by Randy Newman, who had previously had a huge success with *Toy Story*, especially with his song, 'You've Got a Friend in Me'. Although the *James* film was reviewed positively, it lost money.

Steven Spielberg was attracted to a Roald Dahl story and directed and co-produced *The BFG* (2016), with an adapted screenplay by Melissa Mathison and a score by John Williams. Ruby Barnhill in her film debut played the leading role of Sophie, who befriends the Big Friendly Giant (Mark Rylance). He takes her to the Giant Country where they try to put an end to the man-eating giants who are invading the human world. They also visit Queen Elizabeth II played by Penelope Wilton. Mark Rylance's performance is enhanced by Motion Capture, and working with Spielberg again came only a year after he played the Russian spy in *Bridge of Spies*.

The British film industry in the seventies was awash with sexploitation films and TV comedy spin-offs, with very few family films being made. However, there was one family film, which has become one of the best-loved and a classic of its kind: *The Railway Children* (1970), written and directed by Lionel Jeffries. It was adapted from the novel by E. Nesbit published in 1906, and tells the story of a hard-up family whose father is in prison for being suspected of being a spy, and the mother and three children move to live in Yorkshire, where the children become heroic for flagging down a steam train with red petticoats to warn the driver of a landslide. Dinah Sheridan plays the mother, and her three children are played by Jenny Agutter, Sally Thomsett and Gary Warren, and there is a delightful performance from Bernard Cribbens as the railway porter. Sally Thomsett, who at the time was playing a child, was in fact 20-years-old, and it was stipulated in her contract that she was not to reveal her true age, and she was not allowed to be seen smoking or drinking alcohol during the shoot. Jenny Agutter, who was three years younger than her, played her older sister.

This is a wonderful family film and much loved by audiences both young and old. But you cannot please everyone. In 2013 the BBFC (British Board of Film Classification) received a complaint that the film would encourage children to trespass on railway tracks. Which idiot made that objection? Didn't whoever it was realise that not only was this fictional railway story set in the Edwardian era, but you would hear the chuffer train coming from a long way off? It was not a superfast diesel. If I had worked for the BBFC, I would have replied to the complaint with just three words: 'Get a life!'

One of the great family comedy films has to be *Home Alone* (1990), directed by Chris Columbus, and starring Macaulay Culkin who has mistakenly been left at home on his own and has to outwit two burglars, played by Joe Pesci and Daniel Stern. Most of the comedy comes from the ingenious ways this intelligent lad concocts many devices to trick the inept and crooked buffoons. It turned Culkin into a major star, and for *Home Alone 2: Lost in New York* he was paid $4.5 million, slightly up on the $110,000 for the first film. But that fame came at a cost when he fell out with his fame-jealous father over money in his trust fund.

When we think of Disney films the first ones that spring to mind are his brilliantly animated features, but in the 1960s Walt Disney made many live action films for family viewing, including *The Swiss Family Robinson* (1960) starring John Mills; the Robert Louis Stevenson yarn *Kidnapped* (1960) starring Peter Finch; and many starring Hayley Mills, including *The Parent Trap* (1961).

Gangsters, prohibition, speakeasys, mayhem and fights. Not a recipe for families and children you might think, but *Bugsy Malone* (1976) was a crime spoof and all the gangsters and gangsters molls were played by children in this musical comedy film, written and directed by Alan Parker, and the machinegun-like fights were with splurge guns firing cream and custard pies. Scott Baio played Bugsy, with Jodie Foster as his moll, and John Cassisi as crime boss Fat Sam. It became a hugely popular movie, and it led to a successful stage musical and many revivals.

Using many puppets, for which he was renowned, especially for his *Muppet* films and television shows, Jim Henson directed *Labyrinth* (1986), an adventure fantasy film starring Jennifer Connelly as the 16-year-old Sarah, and David Bowie as Jareth, the Goblin King. The film's screenplay was by Terry Jones of *Monty Python* fame, and told the story of Sarah entering the labyrinth to search for her brother. There were some excellent designs in the film, created by Brian Froud who was the Concept Designer. One of the scenes was in a room based on Netherlands artist M. C. Escher's *Relativity*. All his enigmatic designs looked realistic but look closer and they are disturbingly difficult to fathom and are totally impracticable. The film when it was released was mildly successful, but it was re-evaluated by many critics later on and has become something of a cult movie.

The Goonies (1985) is a comedy adventure, directed by Richard Donner, with a screenplay by Chris Columbus and based on a story by Steven Spielberg. The Goonies is the adopted name of a bunch of kids whose homes are threatened with foreclosure, and then they discover a map of pirate treasure and set out to find it, but a family of criminals also want the treasure, leading to all kinds

of exciting complications. When it came to the scene where the child actors discover the impressive pirate ship, Donner wanted a genuine reaction and kept it as a surprise without revealing the ship until the first take. Unfortunately, he didn't get the reaction he wanted and had to go for a second take.

Great family viewing came along in 1989 with a comedy sci-fi *Honey, I Shrunk the Kids*, directed by Joe Johnston, in which a struggling inventor (Rick Moranis) accidentally shrinks his children. The film, made by the Disney Company, was hugely successful and led to two more sequels. The next instalment in the franchise was *Honey I Blew Up the Kids*, a lousy title as it conjures up pictures of suburban carnage. The third and final film was *Honey We Shrunk Ourselves*, which didn't get a theatrical release and went direct to video.

The Chronicles of Narnia: The Lion, the Witch and the Wardrobe (2005) was the first instalment of the Narnia series directed by Andrew Adamson, faithfully adapted from the novels by C. S. Lewis. It tells the story of the Pevensie children, two brothers and two sisters, who are evacuated during the Blitz to a country house where, when playing hide and seek, they discover a wardrobe that leads them into the fantasy land of Narnia, where they encounter a friendly Lion (voiced by Liam Neeson) and a wicked witch (Tilda Swinton). The film was shot mainly in New Zealand, with other locations in the Czech Republic, Slovenia and Poland. The score for the film was by Harry Gregson-Williams who had previously worked with Adamson on *Shrek* (2001) and *Shrek 2* (2004*)*. The soundtrack received two Golden Globe Awards, one for Best Original Score and the other for Best Original Song for 'Wunderkind' sung by Alison Morissette. The following two films *Prince Caspian* and *The Voyage of the Dawn Treader* were equally successful.

Perhaps when people think of Martin Scorsese they have images of gratuitous violence from some of his films like *Goodfellas* and *Taxi Driver*, but he directed a stunning adventurous family film which was released in 2011, and was also made in 3D. *Hugo* was based on a marvellous children's book by American writer Brian Selznick, and is located in France in 1931, and tells the story of Hugo Cabret, who has been orphaned and has been left a mysterious automaton by his father which he attempts to repair. The film was adapted by John Logan and much of the action takes place at the Gare Montparnasse, and Hugo (Asa Butterfield) hides in the mechanism of the intricate station clock high above the concourse, and tries to avoid the station inspector Gustave (Sacha Baron Cohen) who tries to have him sent to an orphanage. In a brilliant scene where Hugo avoids him by climbing out onto the clock face and hanging from the large hand, it becomes reminiscent of the Harold Lloyd silent movie *Safety Last*. But then the film is paying homage to those silent days, and not

only is it a marvellous fictional story, it also contains many elements of truth. For instance, the man who runs a toyshop on the station concourse is none other than Georges Méliès (Ben Kingsley) whose contribution to the genesis of cinema has been overlooked. And on the station concourse, among all the crowds of non-speaking actors, are many wonderful cameos. Frances de la Tour is Madame Emile, an elegant lady with two little lapdogs, and every time she is approached by the friendly Monsieur Frick (Richard Griffiths), the dogs snap and bite him. Other non-speaking characters we glimpse in passing are Salvador Dali, Django Reinhardt and James Joyce. And Hugo at one stage is on the railway line and a train is hurtling towards him, as he leaps out of the way it smashes through the buffer stop, runs across the concourse, crashes through a tobacco kiosk and slams through a window onto the street below. It turns out to be Hugo's nightmare. But nightmare or not, this train crash actually happened on 22 October 1895. From photographs of the crashed locomotive hanging on its nose in the street, the film's designers and engineers built large accurate models and the crash was re-enacted from the real-life crash, only now it is used as fiction in Hugo's nightmare.

And into this spectacular story comes Méliès' goddaughter (Chloe Grace Moretz), who has a heart-shaped key that fits into the automaton and gets it working. The automaton draws on paper a diagram of the iconic rocket crash into the man in the moon, and they discover the incredible past profession of Georges Méliès and his contribution to cinematic history. After everything is resolved in the story, what is so wonderful about this picture is that we are shown actual clips from the Méliès films, including *A Trip to the Moon*. At the start of this book, I wrote in the Birth of Cinema about that very first science-fiction film; but how fantastic it is that anyone can view scenes from that film by watching *Hugo*.

Animated Films

When we were young we called them cartoons, mainly because we watched so many short cartoons, and at first they seemed similar to many of the comics we read. Although short cartoons were around in the silent era, and what is now considered one of the oldest surviving animated films was made in 1926 by German animator Lotte Reiniger, it was in 1928 that the most iconic cartoon character was born. Walt Disney created Mickey Mouse who first appeared in *Plane Crazy,* on which Disney worked with his collaborator Ubbe Iwerks, who did most of the illustrations while Disney provided the story and jokes. But it was their next production that really took off, and in *Steamboat Willie,* Disney's anthropomorphic rodent became an overnight star and went on to appear in many Disney short films. Soon Disney was employing dozens of illustrators for his animations, but he thankfully didn't heed the advice of many people who thought he was making a grave error by making a feature-length animated film for children. In 1937 he made *Snow White and the Seven Dwarfs,* and this became a global success. It has everything a Grimm brothers fairytale should have: a dashing hero, attractive heroine, a scary villainous queen, cute animals, and of course Dopey, Sneezy, Happy, Grumpy, Doc, Bashful and Sleepy, who when they march off to work sing 'Heigh-Ho!' which has been sung by many generations of children all over the world. And German Expressionist films also inspired a darker scene in the *Snow White* film when Disney's animators showed the heroine fleeing from huntsmen through a nightmarish forest where trees try to grab hold of her. Following the success of his first full-length animated feature, Disney then brought out *Pinocchio* (1940), *Fantasia* (1940), *Dumbo* (1940) and *Bambi* (1942).

During the 1930s Fleischer Studios made the excellent animated shorts featuring *Betty Boop,* and her occasionally controversial character sometimes fell afoul of the Hays Code. The studio also created the tattooed strong seaman, starting with *Popeye the Sailor* (1933), who gets his strength from eating spinach. But, while the Disney Studios had produced the first full-length animated feature, the Fleischer Studios came a close second with *Gulliver's Travels* (1939), but the success of this film didn't succeed in saving the studios from insolvency.

Throughout the forties and fifties, short cartoons became hugely popular, and MGM and Warner Brothers produced more anarchic and less sentimental animated short films than Disney, with characters such as Tom and Jerry, Bugs Bunny, and Daffy Duck. Warner Brothers created Looney Tunes, and many of these crazy and highly inventive shorts were voiced by Mel Blanc and created by animators like Chuck Jones and Friz Freleng.

During the fifties and sixties there were London cinemas that had continuous hour long programmes, showing short films on a loop, mainly cartoons. There was a famous cartoon cinema, The Eros Cinema, on the corner of Piccadilly Circus and Shaftesbury Avenue, and there was one which was called The Cartoon Cinema in Victoria Station, and if someone had a long wait for a train, they could spend an hour at the cinema and be entertained by the short-sighted Mr Magoo, Bugs Bunny or Road Runner and Wile-E-Coyote.

The Disney Company produced many great animated features in the fifties and sixties, such as *Cinderella* (1950), *Alice in Wonderland* (1951), *Peter Pan* (1953), *The Lady and the Tramp* (1955), *Sleeping Beauty* (1959) and *One Hundred and One Dalmatians* (1961). The final film to be produced by Walt Disney was *The Jungle Book* (1967) as he died during the making of the film. But his legacy continued well into the new millennium with animated features being produced by the Walt Disney Company.

Yellow Submarine (1968) was the animated film contribution to the Swinging Sixties, with the Beatles depicted as cartoon caricatures in this psychedelic pop art story that appealed to children and adults alike, with its story set in Pepperland where the Blue Meanies ban music until the Beatles save the day as they voyage in their submersible. The Fab Four's songs are slotted into the story including 'Eleanor Rigby', 'When I'm Sixty-Four', 'Nowhere Man' and many others. But the Beatles did not provide their own voices for the soundtrack, their voices were provided by John Clive as Lennon, Geoffrey Hughes as McCartney, Paul Angelis as Ringo and the Chief Blue Meanie, with Peter Batten as George Harrison, but he is uncredited as he was a deserter from the British Army and was arrested halfway through the recording, and Paul Angelis took over as Harrison.

Not all animated features are aimed at children. Based on a satirical novel about Stalinism and dictatorship, George Orwell's *Animal Farm* was made into an animated feature in 1954 by John Halas and Joy Batchelor. Maurice Denham voiced all of the animals. It was probably the first animated film to be given an X-certificate, and could only be viewed by anyone over the age of eighteen, although years later it was rated as a U-certificate, suitable for audiences of all ages.

When the rights to the novel were purchased from Orwell's widow, by agents working for the Office of Policy Co-ordination, little did she realise they were

undercover agents for a branch of the CIA to combat communism, and it was the CIA who financed the picture. The film took 15 years to break-even but earned profits in the next five years.

Another animated film aimed mainly at adults is *When the Wind Blows* (1968), based on illustrator and writer Raymond Briggs' graphic story set after a nuclear holocaust about a rather sweet elderly couple Joe Bloggs (John Mills) and his wife Hilda (Peggy Ashcroft) who live in a cottage in rural south east England and there has been a nuclear strike not very far from their home. They attempt to survive while they run out of food and water, hoping the authorities will come to their rescue, but eventually succumb to radiation sickness as Hilda's hair falls out, and they huddle together waiting for the end. This film is the polar opposite of Briggs' famous *The Snowman* (1982) usually shown every Christmas.

One of the most stunning and moving of adult animated pictures is *Persepolis* (2007) which is a biographical drama based on a graphic novel by Marjane Satrapi, about her childhood in Iran during the 1979 revolution when the Shah of Iran was deposed and Islamic fundamentalists won the election. The film begins in the present day with 'Marji' at Paris-Orly Airport about to board a plane for Teheran, but she changes her mind and instead reflects on her life, which becomes a flashback to her sometimes terrifying story in the harsh fundamentalist regime in Iran, where several of her relatives lose their lives. Her sad story ends with her getting into a taxi at the airport, with the driver asking her where she is from, and she replies, 'Iran.'

The film was a French Iranian co-production, and was worked on by many animators alongside Satrapi, and was made in black and white in the style of the original graphic novel.

It received many awards worldwide, and was awarded a co-Jury Prize at the Cannes Film Festival in 2007.

Another biographical animated film is *Waltz With Bashir* (2008), written by Ari Folman about his time in the Israeli Defence Force during the Israeli-Lebanon war when the Israelis shot flares into the sky so that the Lebanese Christian Phalangists had enough light to massacre refugees in the Sabra and Shatila refugee camps. The film shows Ari, whose memory has been wiped by this atrocity in the past, seeking psychiatric help to reveal his no longer functioning history as his story of those events unfolds. This is a powerful anti-war film, and at the end it reverts from animation to actual film footage of the aftermath of the massacre. Truly shocking.

Appealing perhaps to older children and adults is the live action and animated comedy starring Bob Hoskins as private eye Eddie Valiant in *Who Framed Roger Rabbit* (1988), where he appears with every 'toon' in Hollywood, and it was

the first time that Disney toons worked with Warner Brothers toons. Roger Rabbit suspects his wife is being unfaithful to him and his boss hires Eddie to obtain the evidence. But when his boss is murdered, Roger becomes the suspect. The film was great fun and expertly directed by Robert Zemeckis who used Christopher Lloyd as the villainous Judge Doom, with whom he had worked in *Back to the Future*. But what is such great fun in this film is the clever mix of live action and animation, like the cartoon cabbie driving a real taxi.

One of the most successful and best-loved Disney animated productions is *The Lion King* (1994), that was loosely based on *Hamlet*, telling the story of Simba, whose Lion King's father has been murdered by his uncle. The film was phenomenally successful (the merchandising alone ran into billions of dollars), and this musical fantasy had great music and songs, including the hit 'Can You Feel the Love Tonight?' by Elton John and Tim Rice. And then the Disney Company must have thought that was the end of hand drawn animated films when CGI became all the rage, and they remade the film in 2019 recreated by CGI, but it turned out to be not that different from the 1994 version.

It was in 1995 that the first major computer generated film burst onto the cinema screens with Pixar's *Toy Story*. There had been other CGI films before then, and Pixar had experimented with this new form of animation and produced an excellent CGI short in 1986 with the five-minute *Luxor Jr.* showing a desk lamp behaving in bizarre ways. But when *Toy Story* was completed and it opened, it started a new wave of CGI animated films. It was directed by John Lasseter and the story captured what children have imagined for years, that their toys come to life when they are asleep in bed. And the film appealed to adults as well, because we have all owned some of the toys portrayed in the film, and there were often adult jokes thrown in which may have gone over the heads of younger children. One of the main toys is the cowboy Woody (Tom Hanks) who is no longer such a relevant toy, and is being surpassed by the spaceman Buzz Lightyear (Tim Allen), and the joke here is that he is delusional and doesn't accept that he is merely a toy and thinks he is a real astronaut. Woody is the rather sedate character, and becomes the bureaucrat of toys when he says, 'Staff meeting, everyone.' Andy is the child who owns the toys, and there is conflict with the boy next door who likes to torture toys. Although it is Andy who doesn't realise he is being unkind to Woody by ignoring his worth. *Toy* Story is a great film and Pixar managed to make two excellent sequels in 1999 and 2010.

Pixar was now owned by the Disney Company, but worked independently of Disney and continued to made excellent computer generated films for the family market, such as *Finding Nemo* (2003) and *Ratatouille* (2007). Also Pixar

didn't avoid some more serious subjects, and two films moved away from the anthropomorphic animals with the apocalypse story of *E-Wall* (2008) and dealing with old age when the grumpy old man takes to the skies accompanied by an 8-year-old boy in *Up* (2009).

However, one of the most successful animated films of this century is the DreamWorks 2001 *Shrek*, directed by Andrew Adamson and Vicky Jenson, based on the children's book by William Steig, with a screenplay by a team of four writers. Shrek, the anti-social ogre who lives in a swamp is voiced by Mike Myers, who brought the ogre to life with a Scottish accent. Cameron Diaz plays Princess Fiona with whom Shrek falls madly in love, although there are many complications along the way. Clinging to his friendship with Shrek is the often annoying Donkey, brilliantly voiced by Eddie Murphy in a great fast-talking and scene-stealing fashion. The villain of the fairytale is Lord Farquaad, voiced sardonically by John Lithgow. The other comedy characters have a great deal of adult appeal because they are a spoof of what everyone remembers from their childhood stories by the Grimm brothers and Hans Christian Anderson, and they become a send-up of many of Disney's fairytale characters. For instance, the Three Blind Mice are seen to hobble along in their dark glasses with little white sticks. And most of our childhood memories make an appearance, everyone from the Three Little Pigs to Puss in Boots, cleverly incorporated into the story. There were three more sequels in this franchise: *Shrek 2* (2004), *Shrek the Third* (2007) and *Shrek Forever After* (2010). Then came two spin-off films, *Puss in Boots* (2011) and *Puss in Boots: The Last Wish* (2020).

From Blue Sky Studios there came in 2002 the start of another successful animation franchise with *Ice Age* all about many zany animals trying to survive in the Palaeolithic era. In fact, many fantasy films released in the nineties and this century are much too numerous to include in this book's animation chapter. There have been dozens upon dozens of excellent animated movies, and animators have shown such devoted expertise in wonderful storytelling, and skills in creating such a sense of wonderment for millions of children all over the world, often children of all ages.

Walk into stores selling DVDs, and you will usually find a shelf full of Japanese animated films in the Anime section, mainly aimed at adults. Japan has a long history of animation but it took up until the last twenty or more years for them to become admired and accepted in Europe and America when a few great Japanese animated films became popular and won many awards. From Japan's Studio Ghibli, the first to catch on in the West was the eco-fantasy *Princess Mononoke* (1997) and then *Spirited Away* (2001), both written and directed by Miyazaki Hayao.

Although computer generated animation seemed to be dominant in the nineties and the new century, a successful animation company that used the more traditional stop motion animation that had been worked so successfully by animators like Ray Harryhausen and Oliver Postgate, were Peter Lord and David Sproxton who were co-founders of Aardman Animation, located in Bristol. Nick Park, whose hometown was in Preston, Lancashire, joined the staff at their Bristol studio in 1985 and created and directed the Wallace & Gromit series of films. The stop motion technique using plasticine figures introduced a new word into the English language in the 1980s: Claymation.

Wallace was passionately fond of cheese, and was also an inventor whose inventions sometimes had catastrophic results, and he is a Northerner, voiced by Peter Sallis originally, but since the actor's retirement and death, Wallace is now played by Ben Whitehead. Gromit is his faithful, non-speaking dog, who usually bails his master out of trouble. The first short film featuring this incomparable pair of accident-prone nitwits was *A Grand Day Out* (1989) in which Wallace finding his fridge bereft of cheese, and believing that the moon is made of cheese builds a rocket taking the pair to see if Buzz and Neil got it wrong. But the film that catapulted the pair to fame (and eventual fortune) was the hilarious *The Wrong Trousers* (1993) where a villainous penguin, disguised as a cockerel by wearing a rubber glove on his head, involves Wallace in a diamond heist, and the film culminates in a brilliant high speed chase on a train set in their living room.

The next outing for Wallace and Gromit was *A Close Shave* (1995) in which the two pals are running a window cleaning service and Wallace falls for the owner of the wool shop, the gorgeous Wendolene. But wool is in short supply because sheep are being rustled. This is the film in which we are introduced to Shaun the Sheep, who in 2015 stars in his own feature length film, written and directed by Mark Burton and Richard Starzak, based on Shaun the Sheep by Nick Park and Bob Parker. But Aardman made a successful feature length animation in 2000 with *Chicken Run,* with Mel Gibson as an American rooster, Rocky Rhodes, who is helping the chickens to escape before they are made into pies. It was written and directed by Peter Lord and Nick Park, and it was a spoof perhaps inspired by *The Great Escape.*

Another clever spoof used the cheese-loving gadget inventor and his faithful hound in *Wallace & Gromit: The Curse of the Were-Rabbit* (2005) which is a parody of monster movies and Hammer Horror films, in which the duo are now pest control agents trying to stop the town from being overrun by rabbits before the Giant Vegetable Growing Competition. Peter Sallis is again Wallace, and Ralph Fiennes plays Lord Victor Quartermaine, a cruel upper-class bounder,

with Helena Bonham Carter as Lady Tottington and Peter Kay as Police Constable Albert Mackintosh.

What is always so clever about the Aardman films is their attention to detail, and how they appeal to adults too. They returned to another Wallace and Gromit short in 2008 with *A Matter of Loaf and Death*, in which the bungling twosome are now running a bakery, delivering loaves of bread in their van which has 'From Dough to Door' written on it. But what they don't realise is that all the bakers in the town are being murdered by a 'cereal' killer. Wallace falls in love with Piella Bakewell, a former pin-up model for the Bake-O-Lite Bread Company. This is where one of the adult gags is slipped into a scene. They are sitting on a park bench, with Wallace about to kiss and cuddle Piella, when the scene cuts away to show Gromit's loaves of bread rising!

These sorts of naughty but nice scenes may just nudge us into thinking of just how much cinema has changed over the years, and perhaps transformed our lives. I am certain that many cinemagoers can recall their earliest visits to a picture house and the excitement of waiting for the house lights to dim and then that magical moment when the images flicker to life. Movies have inspired us, sometimes disgusted us, attempted to manipulate our minds with propaganda films, entertained us, and given us a broad outlook on life; sometimes baffled us or challenged us to think about the lives of others, helping us to imagine stepping into someone else's shoes. Now, of course, many films are made for home viewing, and so many people miss out on that collective experience of sitting in the darkened auditorium, and if it's a comedy, sharing the laughter which is an experience in itself. Let us hope that visits to the cinema continue for many years to come.

> *A visit to the cinema is a little outing in itself. It breaks the monotony of an afternoon or evening; it gives a change from the surroundings of home, however pleasant.*
>
> Ivor Novello

Now imagine what it was like one hundred and twenty-eight years ago when in 1895 the Lumière brothers gave a paying audience their earliest experience of watching films, and they are shown a train approaching a station, Many in the audience screamed and some fainted. But it wasn't long before those early films changed into a narrative structure and soon audiences flocked to cinemas all over the world.

Documentary Films

Many documentary and semi-documentary films were made in the silent era, and even the Mexican Revolution (1911-1917) was filmed over many years by various film crews, who occasionally used actors, but the most important feature length documentary was *Nanook of the North* (1921), directed by Robert Flaherty who filmed in the frozen landscapes of northern Alaska, focusing mainly on Nanook, a hunter of an Eskimo tribe, and showed his tribe's battle to survive the harsh elements. Flaherty said he wanted audiences to see the former majesty of those people before the white man destroyed their character. Although the Eskimo tribe now used guns to hunt and kill walruses, Flaherty semi-staged some of these events to show them as they were in the past, and had the hunting of a walrus killed with a harpoon. The film was successful internationally, but when Nanook died of starvation two years after the film was released, his death made headlines around the world.

Flaherty continued to make documentaries well into the forties, and lived to see the growth of this important genre which his *Nanook* film had helped to initiate.

Newsreels were popular in cinemas in the 1930s, and these were extended in *March of Time* into short feature films in the US by the production company Time Inc., and their editors described the films as 'pictorial journalism'. These films ran to just over 30 minutes and were popular in cinemas between 1931 and 1945. They were subjective documentaries and were typically propagandist.

Hollywood director Frank Capra, during his American Army stint during World War II, was tasked by the Department of War to make seven films to be seen by American soldiers to help them to understand why America was involved in the war, and these were called *Why We Fight* between 1942-45. Capra didn't think soldiers would respond well to speeches and instead incorporated German and Japanese propaganda films into his documentaries, so that soldiers could see for themselves the fascist state and their fanatical efforts to become the master race. He used extracts from filmmakers such as Leni Riefenstahl, whose *Triumph of the Will* (1935) showed 30,000 of Hitler's followers lined up and at least a million people attending the rally at Nuremberg only a year after

he came to power. The opening title in the film boasts that it was 'Produced by Order of the Fuhrer'.

During World War II John Huston also made war documentaries. One he made in 1946 was called *Let There Be Light*. The film was intended to inform the public about the post-traumatic stress syndrome of shell-shocked soldiers, but it caused the US government to suppress the film and it was not released until 1980. Huston's father Walter Huston was the narrator.

As technology improved, a documentary using a hand held 16mm camera was used to make *Primary* (1960), about the Wisconsin Primary election to nominate the democratic candidate, and followed Hubert Humphrey and John F. Kennedy around. Unlike many other documentaries, there were no staged scenes and it was shot objectively, almost as seen by a 'fly on the wall'.

In Britain the GPO (General Post Office) commissioned *Night Mail* (1936), a black and white film documenting the nightly postal train from London Euston to Aberdeen via Edinburgh. It was directed by Harry Watt and Basil Wright and showed postal workers sorting mail throughout the night, occasionally dropping off mailbags which were snatched by mechanical devices from the train as it hurtled along. There were aerial shots of the countryside, and the staff inside the train's sorting office were actual postal workers not actors, although some of their scenes had to be recreated in a studio setting due to technical difficulties. Benjamin Britten wrote the score accompanying W. H. Auden's *Night Mail* poem towards the end of the picture, which worked brilliantly as it captured the rhythm of the speeding train. If you would like to watch this 24 minute documentary, which I can thoroughly recommend, you can watch it on YouTube. Just search for Night Mail, and you will also hear W. H. Auden's poem, spoken by the poet himself. The film premiered at the Cambridge Arts Theatre on 4 February 1936, then went on general release and became very popular.

Wildlife documentaries have always been popular, but are mainly shown on television. A husband and wife team, Armand and Michaela Denis were hugely successful, and made many that were shown on BBC TV in the fifties. But their earlier success was with a feature-length wildlife documentary that had theatrical showings. *Below the Sahara* (1953) was made by RKO Radio Pictures, was directed by Armand Denis, and followed the couple on their adventures from British East Africa to the Victoria Falls, then down to South Africa, encountering many tribes, and indulging in some safaris along the way. It is somewhat doubtful if this would stand up against the many David Attenborough wildlife documentaries of more recent years.

One of the most well-attended documentary films that swept through cinemas in the early sixties was *Mondo Cane (A Dog's Life* 1962), perhaps for voyeuristic

reasons. It was an Italian production shot in Technicolor, a film which wasn't always truthful in separating fact from fiction. And it came to be known as a 'shockumentary', often showing faked footage of lurid and sensational material. The film was the brainchild of a one-time war correspondent, Gualtiero Jacopetti, who travelled the globe in search of scandalous events, and it was sometimes difficult in knowing what was real and what was staged.

Many documentaries are produced about big music events, although most are now made for television. One of the most successful for cinema showings was *Gimme Shelter* (1970) about The Rolling Stones in the US. It was directed by brothers David and Albert Maysles and Charlotte Zwerin, and chronicled the final weeks of the Stones' tour, with a concert at Madison Square Garden, in which Ike and Tina Turner also appeared. The film also showed much backstage footage before culminating in the free concert at Altamont in which Meredith Hunter was stabbed to death in mid-concert. Security for the event was provided by Hells Angels armed with pool cues, and the concert soon descended into chaos, all of which was captured in the final cut of the film.

Apart from the entertainment value of music documentaries, the genre in general documents history. And none more so than *Shoah* (1985), a French documentary about the holocaust directed by Claude Lanzmann, which took eleven years to make and the documentary runs to just over nine hours. Over the years he interviewed and recorded the tragic histories of survivors, witnesses to the atrocities, and some of the perpetrators, but didn't use any historical footage of the holocaust. The interviews took place during visits to German holocaust sites across Poland. Some of the Nazi perpetrators he interviewed with hidden cameras. One of these was Henry Schubert, an SS officer who was sentenced to death in 1948 but his sentence was commuted to ten years in prison. When Lanzmann's covert recording of the Schubert interview was discovered by his family, the filmmaker was attacked and spent a month in hospital. The film's poster shows the Polish train driver, Henryk Gawkowski, his head peering from the train's footplate. According to Lanzmann's interview of the driver, he drank a great deal of vodka enabling him to stomach the job of transporting hundreds of thousands of Jews to the death camps.

This is a great documentary about the evil of modern times, and some of these heartbreaking stories should be made compulsory viewing for holocaust deniers. The film received many awards, and the BFI and *Sight and Sound* have listed it as the second best documentary of all time, and *Time Out* and *The Guardian* as the best documentary of all time.

One of the most controversial documentaries was *Fahrenheit 9/11* (2004) directed and written by Michael Moore, which showed footage of George

W. Bush reading a children's story to a classroom of young children when he receives news that the second of the Twin Towers has been hit. He then continues reading the story about a pet goat for another seven minutes. And what do his eyes reveal, that here is a guilty man who has a lot to hide, or a man who is at a loss without any advisors at that precise moment to guide him? We will never know. But Moore's documentary goes on to reveal that despite every plane in America being grounded, just one has been given permission to leave, and that is the plane of the bin Laden family of Saudis, hurrying to take them home to Saudi Arabia. And it is also revealed that the Bush father and son had big financial connections to the Saudi Royal Family.

The Miramax film, having been funded to the tune of $6 million by Disney for their distribution rights, now encounter major problems. Disney want the film dropped and they are the parent company of Miramax. So, after much wrangling, Harvey and Bob Weinstein of Miramax pay Disney back the money and go ahead to personally release the film, eventually getting a deal with Lions Gate Films for theatrical showings, and when it's released the film becomes one of the highest grossing documentaries of all time. Part of this, according to Michael Moore, was attributed to the fact that so many right wing conservative groups tried to get the film banned, giving it so much extra publicity. And as it has been said many times: Any publicity is good publicity.

One of the most successful nature documentaries was all about penguins. Well, we love the little rascals, don't we? *March of the Penguins* (2005) was a French production directed by Luc Jacquet. It is a film about an arduous and yearly journey of the emperor penguins from the ocean, travelling over sixty miles across the frozen Antarctic to their traditional breeding grounds, where they mate and hopefully produce a chick. Then the parents waddle across the vast distance to the sea and back to get food, taking it in turns to look after the chicks, who are often in danger of predatory birds. It took the cinematographers over a year to shoot the film, as they were unable to stay outside for longer than three hours, wearing six layers of clothing, because of the extreme freezing temperatures of -50 and -60°C. The narration for the French version is told in the first person as if it is being narrated by the penguins themselves. The English version is in the more traditional third person narrative, voiced by Morgan Freeman. This was the second most successful documentary, beaten only by *Fahrenheit 9/11* a year earlier. I suppose there is very little skulduggery in the world of penguins as there is in the world of the Bushes and bin Ladens, so the attraction may seem obvious. Until you learn in the penguin film that a mother who loses a chick will kidnap another mother's chick. Now that's what I call penguin skulduggery.

The highest grossing concert documentary of all time was mainly of a rehearsal for many sold out concerts at the 02 Arena in London. *This Is It* (2009) was Michael Jackson's final appearance and the 02 concerts were cancelled because of his death. But the director, Kenny Ortega, had shot much footage of the rehearsals in Los Angeles, as well as using footage from some of his earlier concerts. Once the film was edited, the theatrical showings were limited to two weeks but proved so popular that the run was extended to many more weeks. Sony paid $50 million for the world rights. However, the film opened shouldering a great deal of controversy as the Jackson family claimed that it was cashing-in on the singer's death, and many Mchael Jackson fans also boycotted the film.

Another concert film which came seven years later had the blessing of Paul McCartney, Ringo Starr, Yoko Ono and Olivia Harrison. This was the Beatles' film with the lengthy title, *The Beatles: Eight Days a Week – The Touring Years* (2016). It was directed by Ron Howard and most of the film footage was remastered and restored, including 30 minutes of footage from the band's appearance in the Shea baseball stadium at Queens in New York City. The sound was remastered by Giles Martin, the son of the Beatles' record producer George Martin.

Director Clio Barnard's debut feature film was perhaps one of the most highly original and memorable semi-documentaries ever made, very different from standard documentaries with third person commentary. *The Arbor* (2010) was shot in and around the Buttershaw Estate in Bradford, West Yorkshire. Using audio recordings of playwright Andrea Dunbar's daughter Lorraine, and other members of the Dunbar family, actors lip-synched to their voices, using verbatim theatre, a type of documentary using pre-existing documentary material of stories about real events and people, without altering the text in performance. This was the tragic story of Andrea Dunbar, and her strained relationship with Lorraine, and the film included extracts from her autobiographical play which is performed on the Brafferton Arbor green outdoors by a mixture of actors and local residents, using furniture as if some of the scenes are located indoors. This fascinating device sparks new life into the documentary genre, and this highly inventive and original film is always worth watching again. It had a limited theatrical release, mainly to a few selected arthouse cinemas. But it is a highly regarded film, and deservedly so.

Subliminal Cinema

Films usually run at 24 frames a second, unless the action requires a speeded up scene, which then runs at around 16 frames a second, and in slow motion upward of thirty frames. In the forties and fifties filmmakers had the bright idea of manipulating their audiences by embedding into a one second slot of 24 frames, two frames with written messages. This, it was thought at the time, would seep into an audience's subconscious without them being consciously able to read the message. It was rumoured that many horror B-movies which were not sufficiently scary might edit two frames out of 24 inserting words like 'Fear', giving the audience the feeling that they had felt genuinely scared by what was really an inferior movie.

One of the earliest experiments in subliminal messaging was in 1945, in an animated short featuring Daffy Duck, the words 'Buy Bonds' appears briefly on the screen. Nobody at the time thought it might work, but went ahead with the experiment anyway.

In the 1950s advertisers in the UK were rumoured to use subliminal messaging as a selling tool. If for instance an ad agency was trying to promote a soft drink, two or three frames of the film might sneak in the word 'thirsty' or 'drink' which an audience would not consciously see in that fraction of a second.

But these were rumours, and the advertisers maintained that it was doubtful that this sort of subliminal messaging worked, and so there was no point in doing it. But were they protesting too much? Many scientific studies of subliminal messaging from the 1960s – 1980s discredited this form of manipulation as a fallacy. But then in the early 2000s research showed that subliminal messages do influence our perceptions, but with a more subtle effect.

In the 1950s, though, it was considered sufficiently worrying, and it led to a ban in advertising in the UK from 1957, following a letter from the Duchy of Lancaster to the Postmaster General concerning the newly established independent television company TWW (Television Wales and West) who were using subliminal messaging by flashing up for fractions of a second the words 'Keep Watching'. Following these concerns to the Postmaster General,

the Independent Television Authority subsequently decreed that subliminal messaging would be banned from television.

But there is another form of subliminal messaging in film, and this is product placement. While we are involved in a the James Bond plot, watching the action and listening to the dialogue in (say) *Tomorrow Never Dies*, are we really conscious of the masses of products being fed into our brains? And in the Daniel Craig version of *Casino Royale*, do we really notice the myriad products they are peddling, which helps to finance the film? Do we consciously notice the Smirnoff Vodka, L'Oreal, Heineken, Avis, Nike, Ted Baker, Armani, Sony and many more? And there are at least 35 product placements in *Spectre*.

So subliminal messaging is still around then, only in another form. Product placement.

And they still get away with subtle forms of manipulation in television advertising. Picture a very attractive woman, enjoying a Lindt chocolate, licking the oozing chocolate as if she is having an orgasm. Then a jump cut to a male chocolatier pouring chocolate into a receptacle.

You don't have to be Sigmund Freud to work that one out!

Afterword

I may have left out some of your favourite films from this history, but had I included what I guessed might be everyone's favourite film, it would have run into thousands and many more volumes. I guess the whole point of this cinema history was to touch upon the innovative films, and some of the pictures in which the filmmakers were influenced by directors and writers from years ago, or used a new technique or a different way of shooting, including dramas or comedies with some famous lines of dialogue.

Over many years the technology has changed radically. For the first thirty years there was no sound, and then along came the Talkies. At first the sound was recorded onto a Vitaphone disc and accompanied the screen visuals. But using sound in those early days created problems with location shoots because of all the extraneous sounds being picked up by their microphones. And so they built the studios, and these now became known as sound stages. Then in only a few years sound became a great deal more sophisticated, especially when the sound strip was added to the celluloid film, and directors discovered innovative ways of using sound creatively. Then along came colour. Wide screen. Cinemascope. Cinerama. 3D. And then digital in the nineties. Many films now shown in modern cinemas are digital. One of the major benefits of digital is the speed with which films can be edited, and so post production becomes a lot quicker. A good example of this is Ridley Scott's film *All The Money in the World* about the kidnapping of John Paul Getty III, and his grandfather's refusal to pay the ransom. Kevin Spacey was cast as Getty senior, and the shooting was complete. Then there were allegations about Spacey's sexual misconduct, and he was replaced by Christopher Plummer. Spacey's 22 scenes were reshot over a week in November 2017, and the film still opened on time in early December 2017. That is how quickly things can be done now because of the advance in technology.

But despite innovation in technology, the basic structure of a film's narrative hasn't changed much since the silent days. We still get master shots, wide shots establishing the location, and close-ups and split-screen and zooming in and out of focus. All of these narrative devices have been around for more than a hundred years.

Nowadays, though, some CGI special effects can be almost alarmingly stunning. But next time you visit a cinema, spare a thought for Georges Méliès the stage magician who not only built his own movie camera, but used trick photography, such as having someone's head appear or disappear from their torso. And his discovery of this innovative film technique was quite simple: stop the camera, reposition the performer for how he wanted them, rewind the film back a bit, then continue with the shooting. And he was doing this well over a century ago.

Rene Tabard, a French writer who in the 1930s documented the early pioneers of cinema, called this new way of telling stories THE INVENTION OF DREAMS.

Glossary

Anime
Japanese animation which originated in comic books and has become extremely popular.

Art House Film
Non-commercial independently made films as opposed to mainstream popular movies.

Blimp
A thick padded jacket that is used to wrap around a camera to prevent the whirring noise it makes.

Boom
A long pole with a microphone on the end, so that sound recordists can distance themselves from the action.

Cinéma-vérité
French for cinema of truth.
It usually refers to a style of documentary film that appears to be realistic using a minimum of filmmaking techniques, almost like newsreel footage.

CinemaScope
A copyrighted widescreen filming process in which panoramic large scale scenes were squeezed horizontally to fit into 35mm cameras then stretched onto the cinema projectors.

Cinematographer
The person who plans the lighting and exposure of a scene and supervises the camera moves, often from the instructions of the director. Also known as Director of Photography or D.O.P.

Close-up
A tight shot enlarging the image it is photographing, such as an actor's face or a prop.

Closed Romantic Realism

The conventional style of mainstream cinema, such as Hollywood movies. In 'Closed' films the actors never look at the camera and the stories are rarely open-ended. They are called 'Romantic' because the emotions in the stories are usually intensified and the protagonists are heroic. And 'Realism' because the people in these movies are recognizable and have similar problems to our own.

Cross-cutting

Editing as a way of linking shots that occur side by side, and the pace of cutting between shots can create dramatic tension.

Deep focus

A technique for shooting scenes where everything is sharply focused from the foreground to the background. It was used a great deal in the film noir genre.

Dolly shot

For tracking shots the camera is mounted on a truck and moves along tracks. For student films and low budget films, a child's pushchair can be used for a dolly shot, though the camera operator can't be overweight.

Establishing shot

This is usually a scene-setting shot, showing perhaps a location before a scene begins so that the audience know where the scene is taking place.

Expressionism

A style developed in Germany with dark images, shadowy lighting, weird sets, and actors with striking make-up, sometimes performing melodramatically (what is often called 'hamming it up'). The stories are usually about the darker side of life and full of symbolism.

Film Noir

Genre of films made between the mid-thirties and the late sixties in the US with dark themes of betrayal and greed. They are usually shot in black and white and many noir films are influenced by German Expressionism. Neo-noir films came a little later and were shot in colour.

Gaffer

The chief electrician on a film crew

Grip

A technician who sometimes operates the dolly, and also positions the lights, and opens or closes the 'flags' which are the little doors in front of the lights, and this will determine how much illumination is required.

Jump cut

A cut in the same scene of a film which suddenly cuts out extraneous action to another part of the scene. For instance we see a car pull up outside a building, we then see the characters in the car at the door of the building, we do not see them getting out of the car and walking up to the building.

Master shot

A wide shot, usually showing the entire scene prior to shooting the closer images of the actors in the scene and some of the close-ups.

Method acting

Realistic styles of acting based on the theories of Stanislavski, developed by the Actors' Studio in New York and used by many film actors. From the way many method actors performed on camera, in a realistic style, mumbling, dropping their heads and shuffling their feet, they were often referred to by the pejorative term of 'shit kickers.'

Montage

From the use of editing, montage influences the way a scene will look artistically, and expresses the mood in the field of interest, piecing together the shots to make a whole scene.

Nouvelle Vague

French new wave films were made by filmmakers in the late fifties and sixties, and they were influenced by Italian Neo-Realism. The directors were usually at the heart of the action, and the films were mainly shot in real locations rather than being studio-based. From around the world there were also New Wave films, including British New Wave.

Pre-Code films

Movies made in the 1920s, mainly the silent era, were far more risqué and often contained some nudity. Then the Hays Code was formed in the 1930s and censorship began, when there were guidelines for what could and couldn't be shown in films. For example, at the end of crime films it always had to be shown that 'crime doesn't pay.'

Schlock

This is a word that is used to describe exploitative and cheaply made films, such as schlock horror films.

Set piece

This is used to describe arresting scenes, such as car chases – which usually crash through fruit and veg stalls!

Stop-motion animation
A technique using models, some made of clay or plasticine (Claymation), which are photographed frame by frame as the models are moved bit-by-bit. Not a career for people who easily become bored.

Wuxia
Chinese martial arts films, usually based on mythology, with a high degree of swordsmanship and flying combat.

Index of Films

Also from David Barry

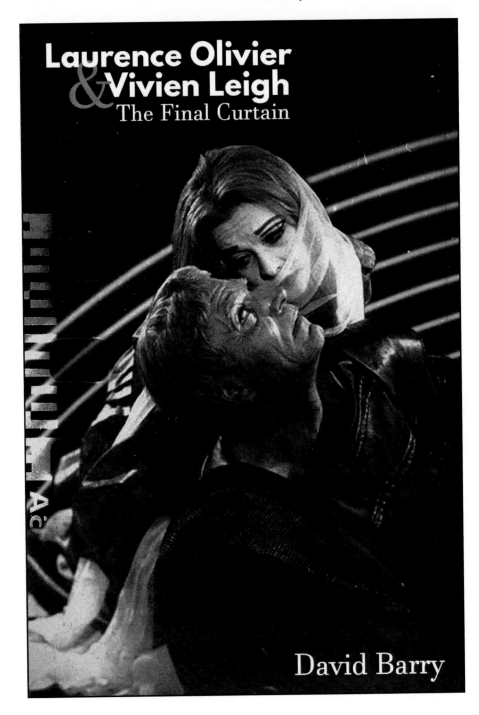

Laurence Olivier
&Vivien Leigh
The Final Curtain

David Barry

Printed by BoD™in Norderstedt, Germany

9 781837 915125